ICONS

LOADING...

LOADING...

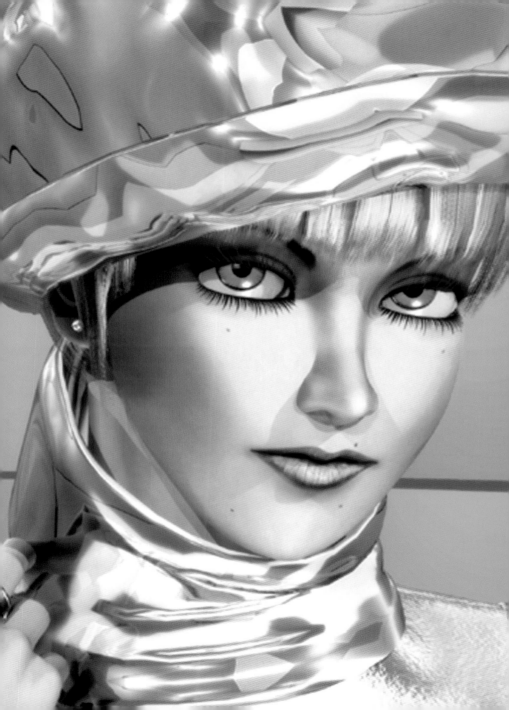

JULIUS WIEDEMANN

DIGITAL BEAUTIES

2D & 3D COMPUTER
GENERATED DIGITAL MODELS,
VIRTUAL IDOLS
AND CHARACTERS

TASCHEN

KÖLN LONDON LOS ANGELES MADRID PARIS TOKYO

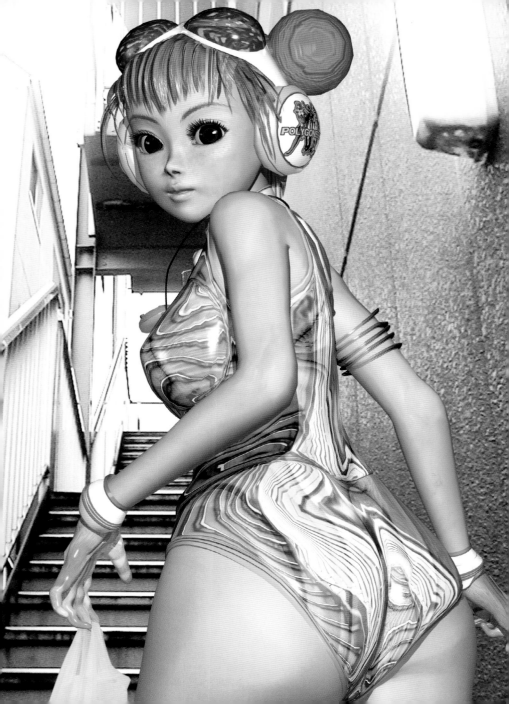

CONTENTS

3D TAKES OFF

Sunday morning. Lisa had a dream about Bob last night and can't wait to put her hands on him. She sits at the table, moves his body, rotates him, shifts around again and finally finds a comfortable position. She is just warming up. She downloads new underwear for him as well as some accessories. Bob doesn't talk, complain or show gratitude for anything. Lisa is ready to create her new masterpiece. The concept may sound scary or strange but this is just the beginning of the digital revolution. A whole new world that is virtual, to be sure, but real to those involved. Starting from the graphic interface, the production of illustrations, art, advertisements, and designs, digital capabilities have evolved dramatically in the past 2 decades. It is not the creation itself, but the process that has revolutionized the way professionals do their jobs. In the beginning, they had to rely on the resources of computers…or as likely as not suffer from the lack of them. High prices, little available software, few tools, slow machines, bad monitors and horrible output quality were standard. It was just the starting point. But the coming revolution wasn't a matter of "if", but a matter of "when". Professionals invested time, money, and brainwork in improving the new media, and their efforts began to bear fruit over time. Although the computer graphics revolution has been seen as an area for younger people, mainly in arts, many traditional professions have now adopted the computer and its burgeoning resources. As digital resources become available for almost everyone, professionals and artists can now concentrate on personal expression through digital media without being limited by the available technology. There are still gaps to fill, but the revolution is here.

With accelerating improvements in the technology, digital design begins to touch more areas of everyday life. In arts and design, technology has changed not only the process of working, but also the way we see and feel. Today, a digital model in an advertisement brings as much emotion to the job as a real one. Differences between the real and the virtual break down. The digital crosses the divide between what were once separate fields. We have seen "virtual idols" in Japan become game characters, singers, and models, with careers more meteoric than those of human media darlings. In the entertainment industry- arguably the fastest growing industry on the planet- computer graphics and digital manipulation are standard tools of the trade. But we have yet to see interactivity in its extreme. With digital models popping up (some already contracted to renowned modeling agencies such as Elite), a whole new approach will be taken in the coming years. In Japan, so-called "virtual idols" ("idol" being the operative term in Japan for bright young faces in the middle of their 15 seconds of allotted fame) have been doing advertising campaigns for automobile companies and internet service providers. They are no longer the exclusive properties of computer graphics magazines. With the vast increase of capabilities of even home computers and their software in the past few years, computer graphics have become accessible to all. Many Hollywood effects of one or two years ago can be done at home on a laptop. Professionals in the industry are pushed to move towards an even higher quality every year. The realism of the new graphics in the movies and games becomes so immediate to our senses that our minds start losing points of reference. At home, and in the movie industry, professionals take months and sometimes years to develop their creations since they seek the highest quality possible and use hardware and software on the cutting edges of technology.

Digital Beauties is the first worldwide printed

reference for creations of female digital characters (and their variations) using computer graphics. Some artists are dedicated to fine art, some to producing cutting edge digital models for fashion, and others to creating virtual idols to appeal and interact with people. Their creators design virtual beauties to tell stories, entertain and excite. In the world of cyber and virtual sex, digital characters have been used to appeal sexually to the public, mainly on the Internet.

3D media is now gaining momentum and is sure to be the medium of the next generation of computer graphics. The techniques and the technology of making characters using 3D software are much more complex than using 2D. But as the technology becomes more accessible there will be endless possibilities. Games, movies, presentations, architecture and much more will be taken to another phase of production and interaction. 3D allows artists to create infinite characters, keeping full control of their creation and playing with them when they are done. Nearly everything is possible with CG - and this may just be the beginning.

This publication is a statement about the digital progress that has taken place in computer graphics since the 1980s. Almost 100 artists enrich Digital Beauties with their creations, in more than 500 pages of illustrations on the theme of the female form. The variety of techniques and routes to creation are apparent in the abundant variations of the finished art. Printing these images in book form brings another dimension to many artists and their artwork, as they have, until now, for the most part used the Internet to exhibit their pieces. Thanks also to the net it is possible to sample such art from around the world and highlight how cultures express themselves differently, even with the same available tools. The anime and manga culture in Japan, the entertainment industry in the US, the romanticism of Europe, all contribute to making art different in each region and country. Computer graphics are not narrowing the possibilities, but expanding them, and helping creative people to find common interests with other like-minded individuals in other parts of the globe. Moreover, the Internet has allowed thousands of artists to talk to each other, share experience and share the works they create. In the 3D communities on the Web, you can download clothing, accessories, and other accoutrements and add them to your artwork. Not just for computer fans, the characters are becoming part of everyday commerce. Digital Beauties is not a technical "how to" book. It is an inspirational guide to the digital creation of feminine subjects. It has very rich information on how artists from all around the world created their masterpieces. This information is not as technical as a software command; rather, it is a signpost for creative exploration.

Julius Wiedemann

LE DÉCOLLAGE DE LA 3D

Lundi matin. Lisa a rêvé de Bob la nuit dernière et elle a hâte de lui mettre la main dessus. Assise à la table, elle déplace son corps, le fait tourner, le déplace encore et l'installe finalement dans une position confortable. Elle ne fait que s'échauffer. Elle lui télécharge de nouveaux sous-vêtements ainsi que des accessoires. Bob ne parle pas, il ne se plaint pas non plus et ne témoigne aucune gratitude pour quoi que ce soit. Lisa s'apprête à créer sa nouvelle œuvre.

Le concept peut paraître effrayant ou étrange, mais ce n'est que le début de la révolution numérique. Un nouvel univers entièrement virtuel, mais bien réel pour ceux qui sont impliqués. Les possibilités numériques ont radicalement évolué ces deux dernières décennies, depuis l'interface graphique suivie de la production d'illustrations, de dessins et de publicités. Ce n'est pas la création mais le processus qui a révolutionné la manière dont travaillent les professionnels. Au début, ils étaient dépendants des ressources des ordinateurs… ou plutôt essayaient de ne pas souffrir de leur manque. Des prix élevés, peu de logiciels disponibles, peu d'outils, des machines lentes, de mauvais moniteurs et une qualité de sortie horrible étaient dans l'ordre des choses. Ce n'était que le début.

La révolution n'était pas une question de « si » mais de « quand ». Les professionnels ont investi du temps, de l'argent et de la matière grise pour améliorer les nouveaux supports. Le temps aidant, leurs efforts ont commencé à porter leurs fruits. Bien que la révolution graphique ait été perçue comme un domaine réservé aux jeunes, de nombreuses professions traditionnelles ont maintenant adopté l'ordinateur et ses ressources naissantes. Grâce à l'existence des ressources numériques, les professionnels et les artistes peuvent maintenant se concentrer sur l'expression personnelle sans être limités par la technologie disponible. Il existe toujours des fossés à combler, mais on n'arrête pas le progrès.

Grâce aux améliorations de plus en plus rapides de la technologie, le dessin numérique commence à toucher plus de domaines de la vie quotidienne. La technologie a transformé non seulement les méthodes de travail, mais aussi notre manière de voir et ressentir les choses. Aujourd'hui, un modèle numérique dans une publicité éveille autant d'émotions qu'un modèle « de chair et d'os ». Les différences entre le réel et le virtuel disparaissent. Le numérique comble le fossé entre deux domaines jusqu'à présent bien distincts. Nous voyons des « idoles virtuelles » au Japon devenir des personnages de jeux, des chanteurs ou des modèles, dont la carrière progresse plus rapidement que celle des stars humaines chéries des médias. Dans l'industrie des loisirs – celle qui évolue le plus rapidement sans doute –, le graphisme et les manipulations numériques sont monnaie courante, mais nous devons encore voir l'interactivité poussée à son maximum. Avec l'apparition de nouveaux modèles numériques (certains « travaillent » déjà pour des agences de mannequins renommées, telle qu'Elite), une nouvelle approche sera utilisée dans les années à venir. Au Japon, les « idoles virtuelles » (une « idole » est le terme employé ici pour décrire des visages jeunes et rayonnants pendant leurs quinze minutes de gloire) ont participé à des campagnes publicitaires pour des constructeurs automobiles et des fournisseurs de services Internet. Elles ne sont plus la propriété exclusive des magazines de graphisme.

Avec le développement des possibilités des ordinateurs, même personnels, et des logiciels ces dernières années, le graphisme est aujourd'hui accessible à tous. De nombreux effets spéciaux de Hollywood datant d'il y a deux ans peuvent être désormais réalisés sur un ordinateur portable à la

maison. Les professionnels de ce domaine sont contraints d'atteindre des niveaux de qualité supérieurs chaque année. Le réalisme des nouvelles images dans les films et les jeux devient si immédiat à nos sens que notre esprit commence à perdre ses points de référence. Qu'ils travaillent chez eux ou dans l'industrie cinématographique, les professionnels passent des mois, voire des années à développer leurs créations, pour atteindre la meilleure qualité possible et ils utilisent du matériel et des logiciels de pointe.

Digital Beauties (Beautés Numériques) est le premier ouvrage mondial de référence consacré à la création de personnages féminins numériques (et de leurs variations) sur ordinateur. Certains artistes s'orientent vers les beaux-arts, d'autres vers la production de modèles numériques pour la mode, et d'autres encore vers la création d'idoles virtuelles pour attirer les gens et interagir avec eux. Leurs créateurs conçoivent des beautés virtuelles pour raconter des histoires, amuser ou exciter. Dans le monde du sexe virtuel, les personnages numériques sont utilisés pour attirer sexuellement le public, principalement sur Internet.

Les supports 3D prennent maintenant de l'élan et deviennent le support de choix de la nouvelle génération du graphisme sur ordinateur. Les techniques et les technologies de création de personnages à l'aide de logiciels 3D sont bien plus complexes qu'en 2D. La technologie devenant plus accessible, les possibilités sont illimitées. Les jeux, les films, les présentations, l'architecture et d'autres domaines sont portés à une étape suivante de production et d'interaction. La 3D permet aux artistes de créer un nombre infini de personnages, de les contrôler et de les modifier à volonté lorsqu'ils sont terminés. Presque tout est possible en graphisme, et ce n'est que le début. Le présent ouvrage illustre le progrès numérique

du graphisme sur ordinateur depuis les années 1980. Près de 100 artistes enrichissent Digital Beauties de leurs créations dans plus de 500 pages d'illustrations sur le thème de la femme. La variété de techniques et de possibilités de création apparaît dans les différentes variations des œuvres présentées. Ce livre ouvre une autre dimension à de nombreux artistes et à leurs travaux, car ils ont pour la plupart jusqu'à présent exposé leurs œuvres sur Internet. Grâce au Net, il est également possible de voyager et de mettre en évidence les manières différentes dont les cultures s'expriment, même lorsqu'elles utilisent les mêmes outils. La culture des mangas et des animations au Japon, l'industrie des loisirs aux Etats-Unis, et le romantisme en Europe contribuent aux différences culturelles de chaque région et pays. Le graphisme ne restreint pas les possibilités, mais les étend, au contraire, et aide les créatifs à trouver des intérêts communs avec des individus vivant dans d'autres endroits du globe et qui partagent les mêmes opinions. De plus, Internet permet à des milliers d'artistes de communiquer entre eux, de partager leurs expériences et leurs travaux. Avec les communautés présentes sur le Web, il est possible de télécharger des vêtements, des accessoires et autres équipements, et de les ajouter aux œuvres. Non plus seulement réservés aux fans d'ordinateurs, les personnages sont devenus une partie intégrante de la vie quotidienne.

Digital Beauties ne présente pas de méthodes techniques. C'est un guide d'inspiration à la création numérique de sujets féminins. Il contient de nombreuses informations sur la manière dont les artistes du monde entier créent leurs œuvres. Ces informations ne sont pas aussi techniques que des commandes logicielles, elles forment plutôt un ensemble de jalons guidant l'exploration créative.

Julius Wiedemann

Sonntag Morgen. Lisa hat gestern Nacht von Bob geträumt und kann es gar nicht erwarten, ihn wieder zu bearbeiten. Sie sitzt am Tisch, spielt ein wenig mit ihm, dreht und wendet ihn, schiebt ihn ein Stück, bis sie eine gute Stellung gefunden hat und schließlich alles passt. Erst allmählich wird sie warm. Sie lädt neue Dessous und ein paar Accessoires für ihn herunter. Bob sagt nichts, beschwert sich nicht und zeigt auch keine Dankbarkeit. Nun ist Lisa bereit, ihr neues Meisterwerk zu erschaffen. Die Vorstellung mag beängstigend oder merkwürdig erscheinen, doch dies ist erst der Beginn der digitalen Revolution. Eine ganz neue Welt entsteht, die natürlich virtuell ist, aber denjenigen, die mit ihr zu tun haben, durchaus real erscheint. Ausgehend von der grafischen Oberfläche, der Produktion von Illustrationen, Kunst, Anzeigen und Entwürfen hat sich die Leistungsfähigkeit digitaler Hilfsmittel in den letzten beiden Jahrzehnten dramatisch entwickelt.

Nicht die Ergebnisse, sondern die dazu führenden Produktionsprozesse haben die Arbeitswelt der CG-Designer revolutioniert. Anfangs waren die verfügbaren Computer alles andere als leistungsfähig. Hohe Preise, wenige Programme und Tools, langsame Geräte, schlechte Monitore und eine unbefriedigende Ausgabequalität waren Standard. Man steckte noch in den Kinderschuhen.

Aber die Revolution sollte kommen – es war nur noch eine Frage des Wann. Profis investierten Zeit, Geld und Energie in die Verbesserung der neuen Medien und konnten nach und nach die Früchte ihrer Anstrengungen ernten. Obwohl die Revolution der Computergrafik – vor allem im Bereich der Kunst – eher etwas für jüngere Leute zu sein schien, sind viele traditionelle Berufsgruppen auf den Rechner und seine schnell wachsenden Fähigkeiten umgeschwenkt. Jetzt, da digitale Hilfsmittel fast für jedermann erschwinglich sind,

können Designer, Grafiker und Künstler sich ganz auf ihre individuelle Handschrift konzentrieren, ohne dass ihnen die Technologie Beschränkungen auferlegt. Es bleiben noch Lücken zu füllen, aber die Revolution hat stattgefunden.

Mit wachsendem technischen Fortschritt gerät das digitale Design mit dem Alltagsleben immer stärker in Berührung. In Kunst und Design hat die Technologie nicht nur den Arbeitsprozess verändert, sondern auch unser Sehen und Fühlen. Ein digitales Model in der Werbung bringt heute nicht weniger Emotionen in die Arbeit ein, als es bei ihrem realen Pendant der Fall ist. Die Unterschiede zwischen der realen und der virtuellen Welt verschwinden, und das Digitale schließt die Kluft zwischen zwei ehemals voneinander getrennten Bereichen. Wir haben miterlebt, wie Virtual Idols in Japan als Spielehelden, Sängerinnen und Models einen kometenhaften Aufstieg erlebten; ihre Karriere dazu steiler als bei jedem menschlichen Medienstar. In der Unterhaltungs-Industrie – dem wohl am schnellsten wachsenden Wirtschaftszweig – sind Computergrafik und digitale Manipulation inzwischen zum Standard geworden. Aber wir haben noch nicht erlebt, wozu die Interaktivität führen kann. Digitale Models, die aus dem Boden schießen (einige von ihnen sind bereits bei renommierten Modelagenturen wie Elite unter Vertrag), werden in den kommenden Jahren den Markt vollständig verändern. In Japan treten solche Virtual Idols („Idol" verweist auf das Strahlen junger Gesichter während ihrer 15 Sekunden im Rampenlicht) in Werbekampagnen für Autohersteller und Internet-Provider auf. Ihr Wirkungsfeld beschränkt sich nicht mehr nur auf die Computergrafik-Magazine.

Mit der enormen Zunahme der Möglichkeiten, die Computer selbst für den Hausgebrauch und deren Software bieten, wurde die Computergrafik in den vergangenen Jahren für jedermann zugänglich –

ein oder zwei Jahre alte Hollywood-Effekte lassen sich heute auf jedem Laptop reproduzieren. Designer und Grafiker sind gezwungen, sich jedes Jahr aufs Neue selbst zu übertreffen. Der Realismus der neuen Grafiken in Kinofilmen und Spielen wirkt so unmittelbar auf unsere Sinne, dass unser Verstand allmählich seine Bezugspunkte verliert. Zu Hause dagegen – und in der Filmindustrie – lassen sich die CG-Designer Monate und manchmal Jahre Zeit, um ihre Arbeiten zu entwickeln mit innovativster Hard- und Software höchste Qualität zu erreichen.

Digital Beauties ist das erste internationale Referenzwerk über digitale weibliche Charaktere (samt Variationen) und ihre Erschaffung mittels Computergrafik. Einige Künstler haben sich den schönen Künsten verschrieben, andere produzieren innovative digitale Models für den Modebereich, und wiederum andere kreieren Virtual Idols, die den Menschen gefallen und mit ihnen interagieren sollen. Die Aufgabe dieser Idols ist es, Geschichten zu erzählen, zu unterhalten und zu faszinieren. In der Welt des Cybersex schließlich entfalten digitale Charaktere, vor allem im Internet, ihren mitunter kühlen erotischen Reiz. 3D takes off und wird sicherlich das Medium der nächsten Computergrafik-Generation werden. Die Techniken der Charakterproduktion sind mit 3D-Software wesentlich komplexer als in 2D. Mit der Verfügbarkeit weiterer Technologie werden sich jedoch unbegrenzte Möglichkeiten eröffnen. Spiele, Filme, Präsentationen, Architektur etc. werden in eine neue Phase der Produktion und Interaktion eintreten. Im 3D-Bereich können Künstler den Herstellungsprozess bis ins Detail selbst bestimmen und beliebige Charakter schaffen. Fast alles ist mit Computergrafik möglich – und das ist vielleicht nur der Anfang.

Das vorliegende Buch ist ein Lagebericht über den digitalen Fortschritt, der seit den achtziger Jahren in der Computergrafik stattgefunden hat. Fast 100 Künstler haben auf mehr als 500 Seiten mit ihren Illustrationen zum Thema Digital Beauties beigetragen. Die Vielfalt der Techniken und Schaffensprozesse werden in der Fülle unterschiedlicher Arbeiten sichtbar. Die Veröffentlichung dieser Bilder in einem Buch bringt für viele Künstler eine neue Dimension ins Spiel, da die meisten von ihnen bisher nur das Internet als Ausstellungsforum genutzt haben. Dem Netz ist es jedoch auch zu verdanken, dass es überhaupt möglich ist, solche Arbeiten aus aller Welt zu versammeln. So wird deutlich, wie unterschiedlich sich die Kulturen ausdrücken, selbst wenn sie die gleichen Werkzeuge benutzen. Die Anime- und Manga-Kultur in Japan, die Unterhaltungsindustrie in den USA, der europäische Sinn für Romantik – all dies hat dazu beigetragen, dass sich Kunst je nach Region und Land anders entwickelt hat. Die Computergrafik erweitert unsere Möglichkeiten und hilft kreativen Menschen, in aller Welt Gleichgesinnte zu finden. Und das Internet gestattet es einer riesigen Anzahl von Künstlern, miteinander zu kommunizieren und ihre Erfahrungen und Arbeiten auszutauschen. In den 3D-Communities kann man Kleidung, Accessoires und anderes Zubehör herunterladen und der eigenen Arbeit hinzufügen. Die Charaktere werden mehr und mehr Teil des alltäglichen Umgangs – und das nicht nur der Computerfans. Digital Beauties ist keine technische Gebrauchsanleitung, sondern eine anregende Einführung in die Welt digital erstellter weiblicher Figuren. Der Leser erfährt, wie Künstler aus aller Welt ihre Meisterstücke geschaffen haben. Dabei geht es jedoch nicht um Programmbefehle; das Buch versteht sich vielmehr als Wegweiser auf einer kreativen Entdeckungsreise.

Julius Wiedemann

ARTISTS

AKIHIKO KAMETAKA

e-mail:	http://www.	Country:	Contact:	Copyright:	Software:
akihiko @kametaka.com	kametaka.com	Japan	1542-392-516 Gakuendaiwa 6chome, Nara-shi, Japan 631-0041	© Akihiko Kametaka	Shade R4 Adobe Photoshop

MEDIEVAL LADIES IN PIXELS

Akihiko Kametaka was born in 1959 in Japan, and studied mass communications and economics at university. During the 90s he began to work with computer graphics, exploring the two-dimensional possibilities offered by Adobe Photoshop. By 1995, he had advanced to develop three-dimensional program-based creations. Today, his main focus is on utilising 3-D software to produce freeze-frame works, which have come to be highly admired in Europe as well as in Japan.

Kametaka uses digital technology as a tool to express the beauty of women in his own personal way. His work with 3-D software has progressed significantly, and this is still an area that remains especially attractive to him. He generally uses Shade Professional R4 — a 3D software originating from Japan and a favourite among professionals — to model and render his creations. Adobe Photoshop is then used for fine adjustments of the colour tone.

All images are modelled from scratch, even the facial details. Kametaka has never used a photograph, not even as a reference. The artistic process consists in repeatedly overlaying images in order to create a delicate texture. He also uses an array of lighting sources combined with natural light to bring out the 3-D effect to the fullest, giving his works the appearance of real photographs and the attributes of a true work of art. One piece can take ten days or more before it is finished.

Akihiko Kametaka est né en 1959 au Japon. Il a étudié les communications et les économies de masse. Vers 1990, il commence à travailler en graphisme 2D sur Photoshop. En 1995, il travaille déjà en 3D. Aujourd'hui, son but est d'utiliser des logiciels 3D pour produire des images dans un style hautement apprécié en Europe et au Japon.

Kametaka utilise la technologie numérique pour exprimer la beauté des femmes à sa manière. Ses travaux effectués avec des logiciels 3D ont progressé de manière significative. Ils restent dans un domaine qui l'attire beaucoup. Il utilise généralement Shade Professional R4, un logiciel de 3D japonais original utilisé par de nombreux professionnels. Ses créations sont modelées et les rendus effectués dans Shade Professional, puis ouvertes dans Photoshop pour ajuster finement les couleurs.

Toutes ses images sont modelées à partir de zéro, même les détails faciaux. Il n'utilise jamais de photo, même en tant que référence. Le processus artistique implique de placer des images sur de nombreux calques pour créer une texture délicate. Il utilise également plusieurs sources de lumière combinées à de la lumière naturelle pour faire ressortir les effets de 3D, ce qui donne à ses travaux l'aspect de photos réelles et les attributs de véritables œuvres d'art. Une image peut prendre dix jours de travail ou plus.

Akihiko Kametaka wurde 1959 in Japan geboren und studierte Kommunikations- und Wirtschaftswissenschaften. Etwa um 1990 begann er mit Computergrafik – zunächst in Photoshop und 2D – zu experimentieren. 1995 erstellte er bereits Grafiken, die auf 3D-Programmen basieren. Heute benutzt er für die Produktion von Freezeframe-Arbeiten, wie sie in Europa und Japan sehr populär sind, vor allem 3D-Software.

Akihiko Kametaka verwendet die digitale Technologie, um weibliche Schönheit auf seine ganz persönliche Weise auszudrücken. Sein Hauptinteresse gilt der 3D-Software, deren Anwendung er kontinuierlich verfeinert hat. Zum Modellieren und Rendern seiner Objekte benutzt er normalerweise Shade Professional R4, eine von vielen Profis bevorzugte 3D-Software aus Japan. Mit Adobe Photoshop bearbeitet er anschließend die Feinabstimmung der Farbtöne.

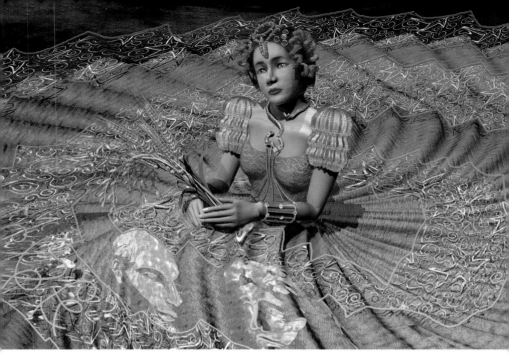

Sämtliche Bilder modelliert er völlig neu, selbst die Gesichtsdetails. Fotos hat Akihiko Kametaka noch nie in seine Arbeit einbezogen – nicht einmal als Referenz. Ein wichtiges Element in seinem Schaffensprozess ist das Überlappen zahlreicher Schichten von Texturen, was eine höchst subtile Oberflächen (Istruktur) ermöglicht. Außerdem nutzt er ein ganzes Spektrum von künstlichen Lichtquellen und kombiniert diese mit natürlichem Licht, um den 3D-Effekt zu erzeugen und seinen Arbeiten das Aussehen echter Fotografien und den Charakter eines wahren Kunstwerks zu verleihen. Es kann mitunter zehn Tage und länger dauern, bis er eine Arbeit fertig gestellt hat.

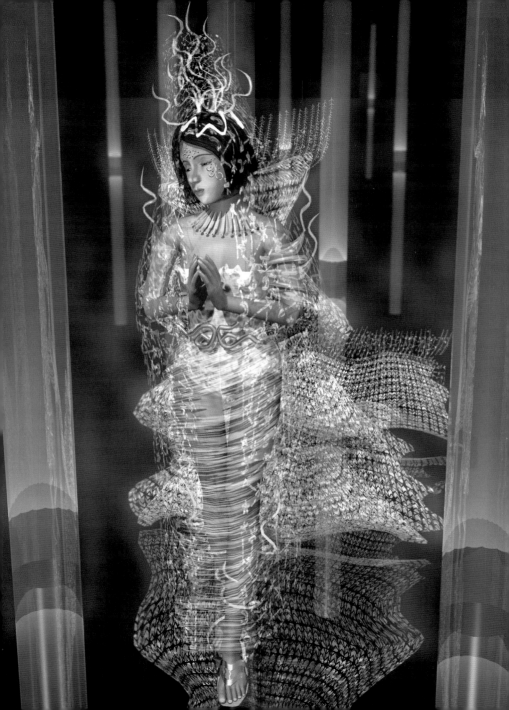

ALCEU M. BAPTISTÃO

e-mail:	http://www.	Country:	Contact:	Copyright:	Software:
alceu@	vetorzero.com/	Brazil	R. Gomes de	© 2001 Alceu	Maya
vetorzero.com.br	crew/alceu		Carvalho, 1356	Baptistão	Adobe
			12th F São Paulo		Photoshop
			SP 4547-005		

HYPER REALISTIC WOMEN POWER

Alceu M. Baptistão was born in 1960 in São Paulo, Brazil, where he has really succeeded as an animator and special effects man, mainly for commercial movies. Since childhood he followed in the steps of his father, a portrait painter, and studied art at the main university in his hometown. He divided his time between as many fields as he could, from oil painting and sculpture to theatre, cinema and television. Shortly after he began to work in traditional illustration and typesetting for advertising companies, specializing in hyper-realistic imagery. In 1985 he was introduced to computer graphics in training sessions for the main TV channel in Brazil, and right away built his own company with Sergio Salles. Called Vetor Zero, the company was aimed at producing digital special effects for commercials and TV programs. Today, with the help of leading creativity and technology, Vetor Zero is a reference in the Brazilian market and serves most of the international advertising agencies operating on the Latin-American market. Alceu Baptistão started with an Amiga computer and today works with cutting-edge equipment and software, leading a team that produces everything from flying logos to animated digital environments. Kaya, his model presented in the next pages, is a project in its early stages. She has appeared as an attempt to create a virtual singer with an aura of grace and light, rather than the stereotypes that surround many digital and human models. The modelling took many months in order to establish the fine details and perfect the texture mapping in the face. With Kaya, the intention has been to create a performer that combines magic of heroines with the strength of the cartoon fighters. Certain details, such as her large mouth and teeth, her far-apart eyes and thick eyebrows, were done on purpose to create a realistic woman with slight imperfections. Alceu Baptistão used Maya for modelling, rendering and animation (on the Web site), and created the textures in Adobe Photoshop. The short movie has taken a month to complete and features detailed facial expressions, textures and lighting.

Alceu M. Baptistão Junior est né en 1960 à São Paulo au Brésil, où il est reconnu en tant qu'animateur et expert en effets spéciaux pour des publicités. Il a suivi les traces de son père, un portraitiste, et a étudié les beaux-arts dans sa ville natale. Il a approfondi autant de domaines qu'il a pu, qu'il s'agisse de peinture à l'huile et de sculpture au théâtre, au cinéma et à la télévision. Il débute dans l'illustration traditionnelle et la composition pour des agences de publicité, se spécialisant dans l'imagerie hyper-réaliste. En 1985, il découvre le graphisme sur ordinateur au travers de sessions de formation pour la principale chaîne de télévision brésilienne, et crée immédiatement avec Sergio Salles sa société Vetor Zero, dans le but de produire des effets spéciaux pour la publicité et les programmes télé. Grâce à sa créativité et à la technologie, Vetor Zero est aujourd'hui une référence sur le marché brésilien et travaille pour la plupart des agences de publicité internationales présentes sur le marché d'Amérique latine. Alceu Baptistão a fait ses débuts sur Amiga. Il travaille aujourd'hui avec des équipements et des logiciels de pointe, et dirige une équipe dont les travaux couvrent de nombreux domaines, des logos aux environnements numériques animés.
Kaya, son modèle, est un projet en cours de création. Elle tente de reproduire une chanteuse virtuelle sans les stéréotypes des modèles numériques et réels, mais avec grâce et légèreté. Le modelage a pris plusieurs mois de travail pour établir les détails et la texture du visage. Avec Kaya, son intention est de créer une artiste dotée de la magie des héroïnes et de la force des personnages de dessins animés. Certains détails tels qu'une grande bouche et de grandes dents, les yeux espacés et des sourcils épais sont intentionnels pour faire de Kaya un personnage ressemblant à une femme véritable, donc imparfaite. Alceu Baptistão utilise Maya pour le modelage, le rendu et l'animation (sur le site Web), et crée les textures dans Photoshop. La réalisation du court métrage a

demandé un mois de travail, pour obtenir des expressions faciales et des textures détaillées, et un éclairage parfait.

Alceu M. Baptistão wurde 1960 in São Paulo, Brasilien, geboren und ist ein erfolgreicher Animator und Special-Effects-Profi für Werbefilme. Er trat in die Fußstapfen seines Vaters, eines Porträtmalers, studierte Kunst an der Universität seiner Heimatstadt und beschäftigte sich mit Ölmalerei, Bildhauerei, Theater, Film und Fern-sehen. Bald begann er mit Illustrationen und Typografie für Werbeagenturen und spezialisierte sich dabei auf hyperrealistische Grafik. 1985 kam er über Schulungen für Brasiliens größten Fern-sehsender mit Computergrafik in Kontakt und gründete mit Sergio Salles zusammen Vetor Zero, eine Firma für digitale Special Effects, die in Werbefilmen und Fernsehsendungen eingesetzt werden. Heute gilt Vetor Zero dank des kreativen und technologischen Potenzials als Referenz-adresse auf dem brasilianischen Markt und beliefert die meisten in Lateinamerika tätigen
internationalen Werbeagenturen. Alceu Baptistão begann mit einem Amiga und arbeitet heute mit innovativem Equipment und neuester Software als Leiter eines Teams, dessen Repertoire von Flying Logos bis zu animierten digitalen Welten reicht.

Kaya, sein auf den folgenden Seiten abgebildetes Modell, befindet sich noch in der Gestaltungs-phase; das Projekt ist der Versuch, eine virtuelle Sängerin mit einem Hauch des Graziösen, jedoch ohne die Stereotypen digitaler oder echter Models zu erschaffen. Das Modellieren dauerte aufgrund der subtilen Details und des perfekten Textur-Mappings im Gesicht mehrere Monate. Kaya soll eines Tages eine Künstlerin mit der magischen Ausstrahlung eines echten Stars und der Kraft einer Cartoon-Kämpferin werden. Bestimmte Details, wie der große Mund und die etwas zu großen Zähne, die weit auseinander stehenden Augen und dicken Augenbrauen, wurden eigens mit dem Ziel gestaltet, eine natürliche und folglich nicht perfekte Frau zu erschaffen. Alceu Baptistão benutzte Maya zum Modellieren, Rendern und zur Animation (auf der Website) und erstellte die Texturen in Adobe Photoshop. Es dauerte einen Monat, bis er den kurzen Film mit seinen detaillierten Gesichtsausdrücken, Texturen und Lichteffekten fertig gestellt hatte.

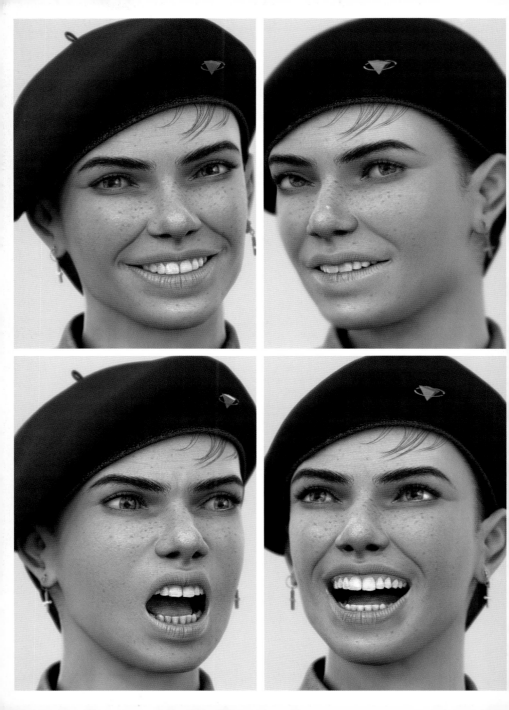

ALIHAHD

e-mail:	http://www.	Country:	Contact:	Copyright:	Software:
andrae.martyna	dreamland	Germany	Ützenpfuhl 19	© Andrä Martyna	Poser
@t-online.de	works.com		D-31789 Hameln		3D Studio Max
					Bryce
					Painter, Paint
					Shop Pro

SEXY WOMEN AND FANTASY

Andrä Martyna (Alihahd) was born in Hanover, Germany, in 1958. After finishing school, he worked intensively with photography, and at that time he also discovered his passion for writing and started publishing his stories in newspapers. Along with writing he also started doing computer graphics on a Sinclair ZX81, later moving on to a Commodore C64 and then finally to the PC we know today.
Martyna works with three computers at home to produce his artwork. He first began to produce erotic images and become familiar with 3D software such as Poser and 3D Studio Max in 1999. In comparison to the art he had done in traditional media, using digital resources has allowed him to feel much freer to realize his ideas. After a lot of research in reference websites such as *www.renderotica.com* and *www.3dcommune.com*, he learned a large number of techniques and started developing, together with a partner, the web site *www.dreamlandworks.com*. The site today has become a point of reference and is visited by numerous artists. Though still a hobby, their graphics have achieved a highly professional level.
Martyna starts his images directly on the computer. For the first stage the most important software is Poser. He sets the models in the positions he wants, adjusts cameras and lights, and renders the still images. If the final artwork is not too complex, it is completed in Poser. Otherwise the models are exported to Bryce, where they are mixed with backgrounds and other 3D and 2D elements. He combines the figures with elements such as clothes and accessories that he has found all over the web. Hair is done as part of the post-production in Photoshop to achieve a more natural look. For touch-ups, he will occasionally use Paint Shop Pro or Painter. One piece of artwork usually takes 2 to 3 days to complete.

Andrä Martyna (Alihahd) est né en 1958 à Hanovre en Allemagne. Après avoir terminé l'école, il travaille intensivement en photographie. C'est à cette époque qu'il se découvre une passion pour l'écriture et décide de publier ses histoires dans les journaux. Il commence également à travailler sur des images numériques avec un ordinateur Sinclair ZX81, puis utilise un Commodore C64 et finalement un PC tel qu'on les connaît aujourd'hui. Martyna travaille chez lui sur trois ordinateurs pour produire ses images. Il commence par produire des images érotiques puis se familiarise avec les logiciels 3D tels que Poser et 3D Studio Max en 1999. En comparaison des dessins qu'il faisait sur support traditionnel, il se sent maintenant beaucoup plus libre de concrétiser ses idées grâce aux ressources numériques.
Après de nombreuses recherches sur les sites Web de référence tels que *www.renderotica.com* ou *www.3dcommune.com*, il apprend de nombreuses techniques et développe le site Web *www.dreamlandworks.com* avec un partenaire. Le site est aujourd'hui devenu une référence et de nombreux artistes lui rendent visite. Bien que ce soit toujours un hobby, leurs images ont atteint un niveau très professionnel. Martyna crée ses images directement sur ordinateur. Poser est le plus important logiciel utilisé lors de la première étape. Il place les modèles dans les positions souhaitées, ajuste les caméras et les éclairages, puis effectue le rendu. Lorsque l'image n'est pas complexe, elle est finalisée dans Poser, sinon les modèles sont exportés dans Bryce, puis agrémentés de fonds et d'autres éléments 2D et 3D. Il combine aux personnages des éléments tels que vêtements et accessoires trouvés sur le Web. Les cheveux sont traités en post-production dans Photoshop pour leur donner l'aspect le plus naturel possible. Paint Shop Pro ou Painter sont occasionnellement utilisés pour les retouches. Une image est habituellement terminée en deux ou trois jours.

Andrä Martyna (Alihahd) wurde 1958 in Hannover geboren. Nach dem Schulabschluss beschäftigte er sich

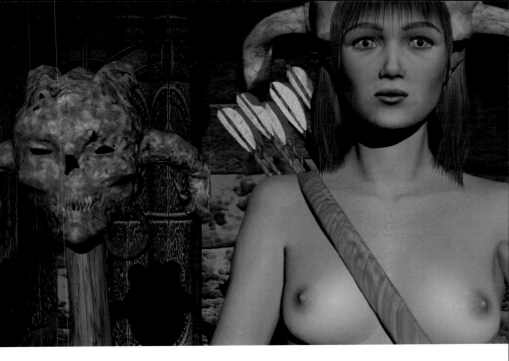

intensiv mit Fotografie. Zugleich entdeckte er seine Leidenschaft für das Schreiben und veröffentlichte seine ersten Geschichten in Zeitungen. Außerdem begann er damals mit Computergrafik zu arbeiten – zunächst auf einem Sinclair ZX81, später auf einem Commodore C64 und schließlich auf einem PC heutigen Standards. Martyna erstellt seine Arbeiten zu Hause auf drei Computern. 1999 produzierte er zunächst erotische Bilder und vertiefte sich in die Arbeit mit 3D-Software wie Poser und 3D Studio Max, wobei sich zeigte, dass er seine Ideen mit digitalen Mitteln sehr viel freier als mit den klassischen Medien umsetzen konnte. Er recherchierte auf Referenz-Websites wie *www.renderotica.com* und *www.3dcommune.com* und erlernte viele verschiedene Techniken. Gemeinsam mit einem Partner begann er, die Site *www.dreamlandworks.com* zu entwerfen, die inzwischen zu einer Referenz geworden ist und von zahlreichen Künstlern besucht wird. Die Grafiken der beiden Partner besitzen heute ein höchst professionelles Niveau.

Martyna beginnt seine Bilder direkt am Computer. In der ersten Phase setzt er Poser als wichtigste Software ein. Er positioniert die Modelle, passt Kamera und Lichteffekte an und rendert die Standbilder. Ist die Arbeit nicht sehr komplex, stellt er sie in Poser fertig. Andernfalls exportiert er die Modelle nach Bryce und mischt sie mit Hintergründen und anderen 3D- und 2D-Elementen. Er fügt den Figuren Elemente wie Kleider und Accessoires hinzu, die er im Internet gefunden hat. Das Haar gestaltet er während der Nachbearbeitung in Photoshop, damit es möglichst natürlich aussieht. Für den letzten Feinschliff benutzt er gelegentlich Paint Shop Pro oder Painter. Für ein Bild benötigt Martyna etwa zwei bis drei Tage.

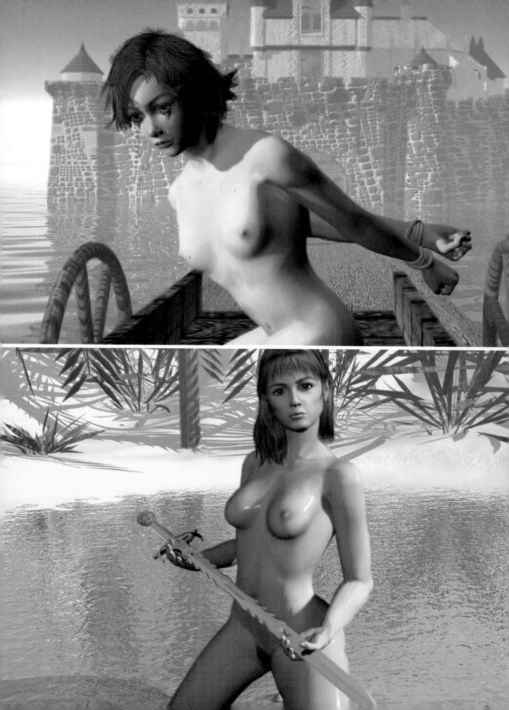

ANDY SIMMONS

e-mail:	http://www.	Country:	Contact:	Copyright:	Software:
ans	andysplace	England	91 Silkman Road	© Andy Simmons	Poser
@cwcom.net	.cwc.net		Oxted, Surray,	2000 - 2001	Bryce
			RH8 ONS, UK		Adobe
					Photoshop

WARRIORS AND LANDSCAPES

Andy Simmons was born in England in 1963, where he was raised and currently resides. At school he never studied art, nor did he enjoy the way it was presented; he did not take to simply drawing an orange or a crumpled rag, but instead preferred sketching fantasy castles and imagintive landscapes. Up the age of 30, Simmons had dedicated his life to music, which had brought him professional success with a rock band, and later with the release of several instrumental library music albums for radio and television. It was not until his early 30s that he discovered his passion for visual art. In 1994 he started learning to work with traditional media and studied portrait and landscape painting in oils. Although Simmons has always favoured fantasy as a genre, he is inspired by artists who paint with great realism, such as John Constable and David Sheppard. Through his study of the landscape painters he gained a knowledge of light and contrast that has allowed him to achieve an impressive degree of realism and accuracy in his own work. In 1997 Simmons discovered computer art. He began with Bryce 3D and was instantly hooked. At first he never believed that it would become his everyday canvas, and thought of it more as an aid to his traditional painting. Creating fantasy and realistic landscapes has become easier with the advance of computer technology, so as more and more software and hardware became available to him, he put the canvas and oils aside to learn and study computer art. Up to the present his main successes have been with CD cover art and illustrations, and he has received numerous digital artwork awards. He uses 3 main programs: Bryce for scene creation, Poser for modelling figures, and Photoshop in conjunction with a Wacom tablet for post-production detailing. Most of his images, themes, and figures start life as pencil sketches. He creates the scene and works on the composition before he takes it to the computer. There he begins the figures and poses in Poser, after which the figures are exported for texturing in Bryce. The rest of the scene is also built and rendered in Bryce. At this point he takes the rendered image to Photoshop for post-production, where with the use of a graphics tablet he adds details such as hair, skin and foliage, and enhances the focal points.

Andy Simmons est né en 1963 en Angleterre, où il a grandi et réside actuellement. Il n'a jamais étudié le dessin ou apprécié la manière dont il était présenté. Il n'a jamais aimé simplement représenter une orange ou un chiffon froissé, mais préfère dessiner des châteaux ou des paysages imaginaires. Simmons consacre sa vie à la musique. Il obtient du succès avec un groupe de rock et la sortie de plusieurs albums instrumentaux pour la radio et la télévision. Ce n'est qu'à l'âge de 30 ans qu'il se découvre une passion pour les arts visuels. En 1994, il apprend à travailler avec les supports traditionnels et étudie la peinture à l'huile. Bien que Simmons ait toujours préféré l'imaginaire, il s'inspire des artistes qui peignent avec un grand réalisme, tels que John Constable ou David Sheppard. En étudiant des peintres paysagistes, il s'initie aux techniques de l'éclairage et du contraste, ce qui lui permet d'atteindre un degré impressionnant de réalisme et de précision dans son travail. En 1997, Simmons découvre le graphisme sur ordinateur. Il commence à travailler avec Bryce 3D et est instantanément captivé. Il ne croyait pas que cet outil deviendrait sa toile, le considérant plutôt comme une aide à sa peinture traditionnelle. La création de paysages imaginaires et réalistes a été simplifiée grâce à l'avancée de la technologie informatique. De plus en plus de matériels et de logiciels devenant disponibles, il met de côté ses toiles et ses huiles pour étudier le graphisme. Il a réalisé jusqu'à présent des jaquettes de CD et des illustrations, et a reçu de nombreux prix pour ses créations numériques. Il utilise 3 programmes principaux : Bryce pour la création des scènes, Poser pour modeler les personnages et Photoshop, utilisé en conjonction avec une tablette Wacom, pour régler les détails de post-production. La plupart de ses images, thèmes et personnages sont d'abord dessinés au crayon. Il crée ensuite la scène et travaille sur la composition avant de travailler sur ordinateur. Il produit les personnages et leur donne des poses dans Poser.

Les personnages sont ensuite importés et habillés de textures dans Bryce. Le reste de la scène est également constitué et le rendu effectué dans Bryce. A partir de là, il ouvre l'image dans Photoshop pour effectuer la postproduction et ajouter des détails tels que cheveux, peau et feuillage à l'aide d'une tablette graphique, et améliorer les points de convergence.

Andy Simmons wurde 1963 in England geboren, wo er aufwuchs und noch heute lebt. Während seiner Schulzeit beschäftigte er sich nicht mit Kunst; außerdem gefiel ihm die Art und Weise, wie Kunst im Unterricht vermittelt wurde, nicht. Statt einer Orange oder eines zerknitterten Lumpens zeichnete er lieber Fantasieschlösser und imaginäre Landschaften. Zunächst widmete sich Simmons der Musik und hatte Erfolg mit einer Rockband sowie mehrerern Instrumentalalben für Radio und Fernsehen. Erst mit Anfang dreißig entdeckte er seine Leidenschaft für visuelle Kunst. 1994 begann er mit traditionellen Techniken zu arbeiten und übte sich in Porträt- und Landschaftsmalerei. Obwohl Simmons immer Fantasy als Genre bevorzugt hat, faszinieren ihn Künstler wie John Constable und David Sheppard, die sehr realistisch malen. Von den Landschaftsmalern lernte er viel über Licht und Kontrast und hat so in seiner eigenen Arbeit ein beeindruckendes Maß an Realismus und Detailtreue erreicht. 1997 entdeckte Simmons mit Bryce 3D die Computerkunst und war davon sofort fasziniert. Anfangs glaubte er nicht, dass dieses Tool seine Alltagsleinwand werden würde; vielmehr sah er es eher als Hilfsmittel auf dem Weg zur klassischen Malerei an. Als jedoch immer mehr Soft- und Hardware auf den Markt kam und sich fantastische wie realistische Landschaften immer einfacher darstellen ließen, legte Simmons Pinsel und Öl beiseite und wandte sich komplett der Computerkunst zu. Heute ist er mit CD-Cover und Illustrationen erfolgreich und hat zahlreiche Auszeichnungen für digitale Arbeiten bekommen. Er benutzt vor allem drei Programme: Bryce für den Szenenaufbau, Poser für die Modellierung der Figuren und Photoshop in Verbindung mit einem digitalen Zeichenstift für die detaillierte Nachbearbeitung. Die meisten seiner Bilder, Themen und Figuren entwirft der Künstler als Bleistift-skizzen. Er gestaltet den Aufbau der Szenen, bevor er sie am Computer bearbeitet. Die Figuren und Posen entstehen – wie auch die übrige Szene – in Poser und werden dann nach Bryce importiert und dort texturiert. Zur Nachbearbeitung überträgt Simmons das gerenderte Bild nach Photoshop, wo er mit Hilfe eines Grafiktabletts Details wie Haare, Haut und Blattwerk hinzufügt und die Blickpunkte betont.

CHANTAL JONGELEEN

e-mail:	http://www.	Country:	Contact:	Copyright:	Software:
angel @dutchangel.com	dutchangel.com	Netherlands	Bosboon Toussaintplein 181-2624DL Delft	© Dutch Angel	Bryce

TEENAGERS' SEXY DREAMS

Chantal Heijinen, also known as Dutch Angel, was born in the Netherlands in 1973 and lives in Delft. She first started doing computer graphics in 2000, when she acquired Bryce and started teaching herself the program, doing thousands of renderings and digital landscapes along the way. From there, she has worked tirelessly and produced numerous erotic images, and has developed a quite distinct digital style of poses. She renders a huge quantity of still images, from which she selects the best ones for exhibition on the Web site. Chantal begins the images, which are usually derived from real life situations, directly on the computer, where the work is 100 percent digitally produced. Many props serve, however, to inspire the beginnings and the composition of the images. Once the models are in the right positions, she applies the lighting, concentrating as much as possible on natural lights so as to give a more realistic effect to the picture. After Chantal grew more experienced in 3D, she found less need to do post-production in photo editing. Nowadays she uses it only if an image needs retouching in imperfectly rendered textures. Sometimes she uses a filter to enhance the artwork. An image can take 2 to 3 days to complete when it involves a large number of objects and a series of test renderings.

Chantal Heijinen, connue également sous le nom de Dutch Angel, est née en 1973 aux Pays-Bas et vit aujour-d'hui à Delft. Elle fait du graphisme sur ordinateur pour la première fois en 2000, après avoir acquis Bryce et appris seule à utiliser le programme, faisant des milliers de rendus et de paysages au passage. Elle travaille sans relâche, produit de nombreuses images érotiques et développe un style de poses particulier. Elle crée de nombreuses images mais ne sélectionne que les meilleures pour les publier sur son site Web. S'inspirant d'une situation réelle, Chantal crée ses images directement sur ordinateur. Ses travaux sont produits exclusivement sur ordinateur. De nombreux accessoires inspirent la création et la composition de ses images. Une fois les modèles placés dans la bonne position, elle détermine l'éclairage, utilisant une lumière aussi naturelle que possible pour rendre l'image plus réaliste. L'expérience de la 3D aidant, Chantal a de moins en moins recours à la post-production dans les logiciels de retouche d'image, et ne les utilise que lorsque les textures ne sont pas correctement traitées par le logiciel de rendu. Elle utilise quelquefois des filtres pour améliorer les images. Une image peut demander deux à trois jours de travail en fonction du nombre d'objets et de rendus nécessaires.

Chantal Heijinen, alias Dutch Angel, wurde 1973 in den Niederlanden geboren und lebt in Delft. Sie beschäftigt sich seit dem Jahr 2000 mit Computergrafik. Damals kaufte sie sich Bryce, erlernte das Programm als Autodidaktin und renderte eine Vielzahl digitaler Landschaften. Seitdem hat sie kontinuierlich gearbeitet, zahlrei-che erotische Bilder geschaffen und dabei einen unverwechselbaren Posenstil entwickelt. Sie rendert eine Vielzahl von Standbildern, aus denen sie die besten auf ihrer Website präsentiert. Chantal entwirft die Bilder gewöhnlich aus einer Situation des wirklichen Lebens heraus direkt auf dem Computer, wo sie zu 100 Prozent digital erstellt werden. Dabei lässt sich die Künstlerin für den Ausgangspunkt und die Komposition der Bilder durch zahlreiche Props inspirieren. Befinden sich die Modelle in der richtigen Position, fügt sie die Lichteffekte hinzu. Um dem Bild einen realistischeren Effekt zu geben, arbeitet Chantal besonders intensiv daran, natürliches Licht zu erzeugen. Je mehr Erfahrung sie im 3D-Bereich sammelte, desto seltener bearbeitete sie ihre Grafiken in anderen Programmen nach; heutzutage geschieht dies nur noch, wenn sie fehlerhaft gerenderte Texturen eines Bildes retuschieren muss. Manchmal benutzt sie einen Filter, um die Arbeit abzurunden. Die Arbeit an einem Bild kann zwei bis drei Tage dauern, wenn es viele Objekte enthält und eine Reihe von Tests-Renderings nötig sind.

e-mail:	http://www.	Country:	Copyright:	Software:
momcat	purr3d.com	United States	© 2000	Poser
@purr3d.com			Cassandre	Painter
			C. Laurie/Purr3D	Paint Shop Pro

LUXURIOUS DIGITAL SCULPTURES

Cassandre C. Laurie is a self-educated CG artist from Boston, Massachusetts. She has featured her works on the Web for the past two years. She first became interested in CG when a friend told about her Web graphics Web sites. She had been creating CG for a year when she acquired Poser and developed a taste for Japanese animation-style erotica. She wanted to branch out into less abstract forms of expression but had no talent for figure drawing. With Poser's 3D character creation, animation, and rendering, it was easier to explore these avenues, without the frustration of trying to get her hand to properly translate between her imagination and a piece of paper.

Laurie views 3D character creation as digital sculpting. Since Poser creates 3D style renders, and as she works in a Japanese animation oriented style, she creates figures by thinking what people might look like if they were anime characters. She adheres to the basic style of big eyes, with a small nose and mouth, and then mixes it with elongated legs and funky hair colours. Once she has created a new character, or chosen one from her library, she is ready to start creating the image. For 2D manipulation, Paint Shop Pro and Painter are always useful for polishing up an image and removing any unwanted artefacts that occur, such as when the mesh of a figure crinkles and becomes misshapen during posing. Special effects are often done with filters such as Spome, Eyecandy and Kai's Power Tools. Since most of the post-rendering work involves smoothing out bumps and adding texture to hair and skin, most of the tools are Photoshop's retouch tools. The clone tool is used to resample one part of an image and apply it to another part. 3D renders often have a plasticky look to them, and whenever this happens touch-ups are required. Once she has everything the way she wants, a sheer weave filter, which makes the image look like it's made of woven strands, is applied. Also a certain amount of fine-tuning is done for opacity, hue, saturation, brightness and noise, so as to give the image a bit of softness and depth.

Cassandre C. Laurie est une artiste autodidacte de Boston dans le Massachusetts. Elle expose son travail sur le Web depuis deux ans. Elle a commencé à s'intéresser au graphisme sur ordinateur lorsqu'une amie lui parla de ses sites Web sur le graphisme. Elle fait du graphisme depuis un an lorsqu'elle acquiert Poser et développe son goût pour le style érotique utilisé dans les animations japonaises. Elle souhaite se diriger vers un style moins abstrait mais n'a aucun talent pour dessiner des personnages. Cependant, les possibilités de création de personnages 3D, d'animation et de rendu de Poser, lui permettent d'explorer cette direction sans avoir à subir la frustration liée à la traduction correcte de ses idées sur papier.

Laurie considère la création de personnages 3D comme de la sculpture numérique. Elle crée des personnages dans Poser en pensant à ce à quoi ils ressembleraient s'ils étaient des personnages d'animations japonaises. Elle dessine de grands yeux, de petits nez et de petites bouches, puis allonge les jambes des personnages et leur donne des couleurs de cheveux funky. Une fois le personnage créé ou choisi à partir d'une bibliothèque, elle crée le reste de l'image.

Paint Shop Pro et Painter sont utilisés pour les manipulations 2D lors de la finition des images et pour ôter les parasites qui apparaissent, par exemple, lorsque la peau du personnage se ride excessivement pendant la pose. Des effets spéciaux sont souvent ajoutés avec des filtres tels que Spome, Eyecandy ou Kai's Power Tools. De nombreux outils de retouche de Photoshop sont utilisés après le rendu pour lisser les bosses ou ajouter de la texture pour les cheveux et la peau. L'outil de clonage est utilisé pour copier une partie de l'image à un autre endroit. Une fois les retouches terminées, un filtre est appliqué pour donner à l'image l'aspect d'un tissu et éviter qu'il ne ressemble trop à du plastique. Les niveaux d'opacité, de nuance, de saturation et de luminosité sont

ajustés pour donner de la profondeur à l'image et adoucir les textures.

Cassandre C. Laurie, Amateurgrafikerin aus Boston (Massachusetts), präsentiert ihre Arbeiten seit 1999 im Internet. Eine Bekannte mit eigenen Grafik-Websites weckte ihr Interesse an Computergrafik. Laurie fand Gefallen an japanischen Animations-Erotika und erwarb bald darauf Poser. Sie wollte ihre Arbeit auf weniger abstrakte Ausdrucksformen ausdehnen, hatte jedoch wenig Talent für das figürliche Zeichnen. Mit Poser und den darin enthaltenen Möglichkeiten, Charaktere in 3D zu erstellen, zu animieren und zu rendern, konnte sie Alternativen einfacher erproben und war weit weniger frustiert als mit der Umsetzung ihrer Fantasie von Hand auf Papier. Laurie betrachtet die Charaktererstellung in 3D als digitale Bildhauerei. Da Poser im 3D-Stil rendert und Laurie in einer japanischen, animationsorientierten Stilrichtung arbeitet, stellt sie sich vor, wie Menschen aussehen würden, wenn sie Anime-Charaktere wären – und entsprechend gestaltet sie ihre Figuren. Sie behält die typischen großen Augen, die kleine Nase und den Mund bei und mischt sie dann mit langen Beinen und flippigen Haarfarben. Sobald sie eine neue Figur geschaffen oder aus ihrem Archiv ausgewählt hat, beginnt die Arbeit am Bild. Bei der 2D-Manipulation bieten sich Paint Shop Pro und Painter zum Aufpolieren des Bildes an und zur Entfernung von Unebenheiten an den 3D Modellen, die während des Erstellens von Posen zerknittern und aus der Form geraten können. Spezielle Effekte erzielt sie mit Filtern wie Spome, Eyecandy und Kai's Power Tools. Da die Nachbearbeitung vor allem darin besteht, Beulen zu glätten und an Haut und Haaren Texturen hinzuzufügen, sind die meisten Werkzeuge Retuschiertools von Photoshop. Mit dem Stempel-Werkzeug zum Beispiel kopiert sie Teile eines Bildes und fügt sie an anderer Stelle wieder ein. Materialien in 3D-Renderings sehen oft billig und „plastikartig" aus – ist dies der Fall, ist ein Touch-up nötig. Wenn die Künstlerin zufrieden ist, kommt ein Weave-Filter zum Einsatz, der dem Bild eine gewebte Struktur verleiht. Schließlich passt Laurie Transparenz, Farbe, Grauanteil, Helligkeit und Störungen an, so dass das Bild eine weiche Textur und Tiefe bekommt.

CHRISTIAN FRÖHLICH

e-mail:	http://www.	Country:	Copyright:	Software:
chris@ grafxcreations.com	grafxcreations.com	Germany	© Christian Fröhlich	Poser Bryce Adobe Photoshop Rhino 3D

FASHIONABLE MODELS IN POLYGONS

Christian Fröhlich was born in Augsburg, Germany, in 1969. Encouraged by his family, he started studying the visual arts and music at an early age. His introduction to computer graphics was with AutoCad. Soon realizing his passion for 3D art, he continued in this vein, searching for the best tools for his artwork until he found Bryce and Poser. Fröhlich works currently as a Web designer and in addition to 3D applications, he uses 2D tools such as Photoshop.
Using his own textures in Poser, Fröhlich renders the characters and takes them to Bryce for further composition, while for modelling he also uses Rhino 3D. The combination of 3D tools with Photoshop has become his standard procedure. Poser allows him to position the models very easily, usually using the Morph Targets technique. Once the scene has been planned, Bryce is his main tool for composing the environment. The models and objects are imported and put together, after which the junctions of the characters often need some correction where rendering has omitted details. The 2D post-production is always done with Photoshop.
To find resources and improve his skills, the 3D forums on the Internet have been a constant and invaluable reference. With time, he has dedicated more of his time to digital art, exploring influences from many different painters, photographers and illustrators. Fröhlich's models and pictures are currently available on his Web site for download. He works from 3 to 4 days on each piece. Many of his models have a strong appeal as fashion beauties, and no less than Helmut Newton has helped inspire him. He has been featured in several Internet galleries and 3D Forums.

Christian Fröhlich est né en 1969 à Augsbourg en Allemagne. Encouragé par sa famille, il étudie les arts visuels et la musique dès son plus jeune âge. Ses débuts sur ordinateur se font avec Auto Cad. Réalisant sa passion pour la 3D, il poursuit dans cette direction, recherchant le meilleur outil de dessin, jusqu'à ce qu'il trouve Bryce et Poser. Fröhlich travaille actuellement comme designer Web et utilise des outils 2D tels que Photoshop en plus d'applications 3D.
Utilisant ses propres textures, Fröhlich crée les personnages dans Poser et les ouvre dans Bryce pour composer les scènes. Il utilise également Rhino 3D pour le modelage. La combinaison d'outils 3D et de Photoshop est devenue pour lui une procédure standard.
Poser lui permet de positionner très facilement les modèles. Une fois la scène fixée, Bryce devient l'outil principal de composition de l'environnement. Les modèles et les objets sont importés et mis en place. Les articulations des personnages nécessitent souvent des corrections aux endroits où des détails ont été omis dans le rendu. La post-production 2D est toujours faite avec Photoshop.
Les forums 3D sur Internet sont une référence constante et inestimable pour Fröhlich afin de trouver des ressources et enrichir ses connaissances. Il consacre désormais plus de temps aux arts numériques, explorant les influences de nombreux peintres, photographes et illustrateurs. Les modèles et les images de Fröhlich sont actuellement disponibles en téléchargement sur son site Web. Il travaille entre trois et quatre jours sur chaque création. Helmut Newton l'a inspiré, et la plupart de ses modèles ressemblent beaucoup à des mannequins de mode. Ses travaux ont également été publiés dans de nombreuses galeries Internet et forums 3D.

Christian Fröhlich wurde 1969 in Augsburg geboren. Schon in jungen Jahren beschäftigte er sich, angespornt durch seine Familie, mit visuellen Medien und Musik. Über Auto Cad kam er zur Computergrafik und entdeckte schnell seine Leidenschaft für die 3D-Kunst. Auf der Suche nach den besten Tools für seine Arbeiten stieß er auf

Bryce und Poser. Zurzeit arbeitet Fröhlich als Webdesigner und verwendet neben 3D-Anwendungen auch 2D-Tools wie Photoshop.

Fröhlich benutzt seine eigenen Texturen in Poser, rendert seine Figuren und überträgt sie für die weitere Komposition nach Bryce. Zum Modellieren mimmt er außerdem Rhino 3D. Die Kombination von 3D-Tools mit Photoshop ist mittlerweile zu seinem Standardverfahren geworden. Mit Poser kann er die Modelle sehr einfach positionieren; häufig arbeitet er mit Morph-Objekten. Sobald er eine klare Vorstellung von der Szene hat, ist Bryce das wichtigste Tool für die Komposition der Umgebung. Fröhlich importiert Modelle und Objekte und fügt sie zusammen, wobei er die Gelenke der Figuren oft dort korrigieren muss, wo beim Rendern Details ausgelassen wurden. Die 2D-Nachbearbeitung erfolgt immer mit Photoshop.

Bei seiner Suche nach Ressourcen und Möglichkeiten, seine Fähigkeiten zu erweitern, haben sich für Fröhlich die 3D-Foren im gesamten Netz als zuverlässige Quellen von unschätzbarem Wert erwiesen. Er widmet der Digitalkunst mehr und mehr Zeit und erkundet die Einflüsse unterschiedlicher Maler, Fotografen und Illustratoren. Da ihn auch Helmut Newton beeinflusst hat, wirken viele Modelle wie Modeschönheiten. Er benötigt drei bis vier Tage für seine Arbeiten, die in verschiedenen Internetgalerien und 3D-Foren zu finden sind. Fröhlichs Modelle und Bilder können von seiner Website heruntergeladen werden.

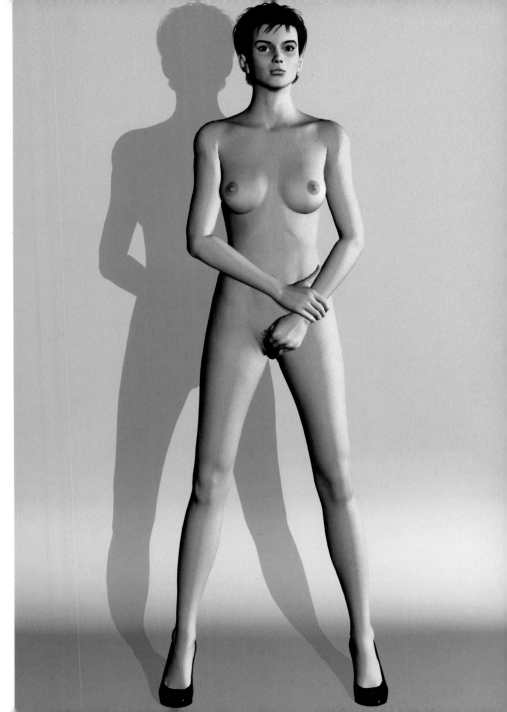

DAN A. CORTOPASSI

e-mail:	http://www.	Country:	Contact:	Copyright:	Software:
dac @dacort.com	dacort.com	United States	PO BOX 7716 Freemont, CA 94537	© 2001 Daniel A. Cortopassi	Poser Bryce Adobe Photoshop

FANTASY STYLE DIGITAL PHOTOGRAPHS

Daniel A. Cortopassi had been interested in both art and computers from an early age, but the opportunity work on a computer game project that introduced him to computers as a means of creating art. Since then, he has created both finished images as well as a lot of the 3D models he uses. Many of his models and characters are available commercially, and are frequently used by other computer artists in their own work.

Fantasy and science fiction motifs have a definitive influence on his art, and he is often inspired by writers and other artists. He devotes much time to producing a finished image based on his personal visualization of a scene. For Cortopassi, computer-generated 3D art combines the photographer's ability to work a scene from different angles and with different lighting with the painter's ability to create things that never existed. This has brought a tremendous artistic freedom to his work.

Cortopassi generally starts from a mental image. If the piece is to contain one or more figures, he begins in Poser to create the poses and apply clothing and any props. Sometimes he uses Poser to render the final image, but more often he moves the figure into another application, in which he adds objects and background elements to the scene. Figures and objects must first be given texture, colour, and patina. Then, each object is placed and scaled to fit the other objects in the scene. Once that is done, he adjusts the lighting of the scene and places the virtual camera that will render the final image.

After rendering, he brings the scene into Photoshop to fix any flaws and add any painted-in elements. Hair he usually paints by hand. One scene can take one or two days to complete, not counting the time it takes to make any of the 3D models, which can take much longer. Once a 3D model is created, he can use it an endless number of times.

Daniel A. Cortopassi s'intéresse au dessin et aux ordinateurs depuis son plus jeune âge. Il ne commence à utiliser l'ordinateur pour dessiner que lorsqu'il peut travailler sur un projet de jeu sur ordinateur. Depuis, il crée des images ainsi que les nombreux modèles 3D qu'il utilise. La plupart de ses modèles et personnages sont en vente et d'autres artistes les utilisent couramment pour leurs propres travaux. Les motifs de fantasy et de science-fiction ont une influence sur son art, et il s'inspire souvent d'auteurs et d'autres artistes. Il consacre une grosse partie de son temps à la production d'une image découlant de sa propre visualisation d'une scène. Pour Cortopassi, le dessin numérique 3D combine la capacité du photographe à travailler sur une scène sous différents angles et sous différents éclairages, et celle du peintre à créer des choses qui n'existent pas. Ceci donne une grande liberté artistique à son travail.

Cortopassi commence généralement son travail à partir d'une image mentale. Si elle doit contenir un ou plusieurs personnages, il compose d'abord leurs poses, les habille et ajoute les accessoires dans Poser. Il utilise quelquefois Poser pour finaliser l'image, mais la transfère le plus souvent dans une autre application, dans laquelle il ajoute les objets et les éléments du décor. Les personnages et les objets doivent d'abord disposer d'une texture, d'une couleur et d'une patine. Chaque objet est ensuite placé et redimensionné en fonction des autres objets de la scène. Une fois l'image terminée, il ajuste l'éclairage de la scène et place la caméra virtuelle qui effectue le rendu final. Le rendu effectué, il ouvre l'image dans Photoshop pour corriger les imperfections et ajouter des éléments. Les cheveux sont souvent dessinés à la main. Il faut entre un et deux jours de travail pour terminer une scène, sans compter le temps nécessaire à la création des modèles 3D, ce qui peut prendre un temps beaucoup plus long. Une fois créé, un modèle peut être réutilisé un nombre infini de fois.

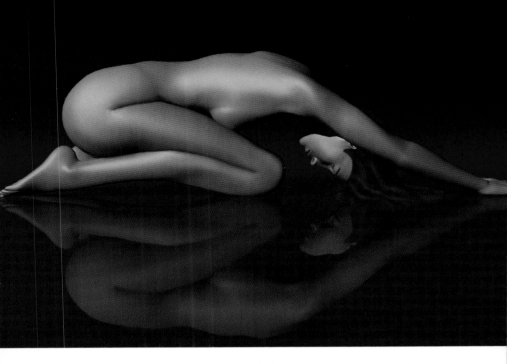

Daniel A. Cortopassi interessiert sich seit frühester Jugend für Kunst und Computer, aber erst als er die Gelegenheit bekam, bei einem Computerspiel-Projekt mitzuarbeiten, begann er, den Computer für seine künstlerische Arbeit zu benutzen. Inzwischen sind Bilder und zahlreiche 3D-Models entstanden. Viele seiner Models und Figuren werden verkauft und von anderen Computerkünstlern für die eigene Arbeit genutzt. Motive aus Fantasy und Sciencefiction beeinflussen Cortopassi Kunst entscheidend; oft wird er von Schriftstellern und anderen Künstlern inspiriert. Der Herstellung eines Bildes – von der Visualisierung einer Szene bis zur Fertigstellung – widmet er viel Zeit. Für Cortopassi vereint 3D-Kunst die Fähigkeit des Fotografen, sich eine Szene aus unterschiedlichen Blickwinkeln und mit unterschiedlichen Lichteffekten zu erarbeiten, mit der Fähigkeit des Malers, Dinge zu erzeugen, die nie existiert haben. Dies verschafft ihm in seiner Arbeit eine enorme künstlerische Freiheit.

Cortopassi beginnt in der Regel mit einem geistigen Bild. Soll es eine oder mehrere Figuren enthalten, erstellt er in Poser zunächst die Posen und fügt dann Bekleidung und eventuelle Props hinzu. Manchmal benutzt er Poser, um das fertige Bild zu rendern, aber meistens überträgt er die Figur in eine andere Anwendung und fügt der Szene Objekte und Hintergrundelemente hinzu. Figuren und Objekte benötigen zunächst Textur, Farbe und Patina. Dann wird jedes Objekt in Relation zu den anderen in der Szene platziert und skaliert. Sobald dies geschehen ist, passt Cortopassi die Lichteffekte an und bringt die virtuelle Kamera in Stellung, die das fertige Bild anschließend rendert.

Nach dem Rendern überträgt er die Szene in Photoshop, um eventuelle Mängel zu korrigieren und gegebenen-falls weitere Elemente einzuarbeiten. Haare malt er gewöhnlich von Hand. Es kann ein bis zwei Tage dauern, bis eine Szene fertig ist; das Erstellen eigener 3D-Models nimmt bisweilen noch weitaus mehr Zeit in Anspruch. Ist ein 3D-Model einmal fertig gestellt, kann Cortopassi es immer wieder verwenden.

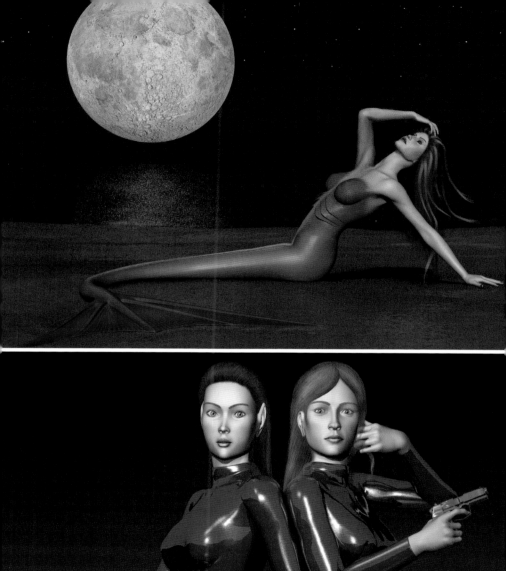
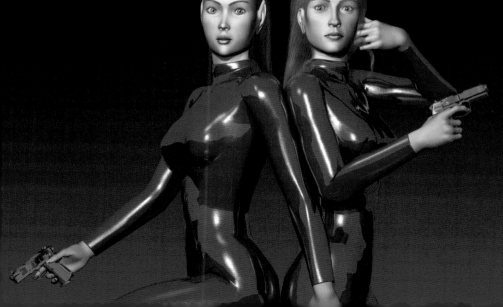

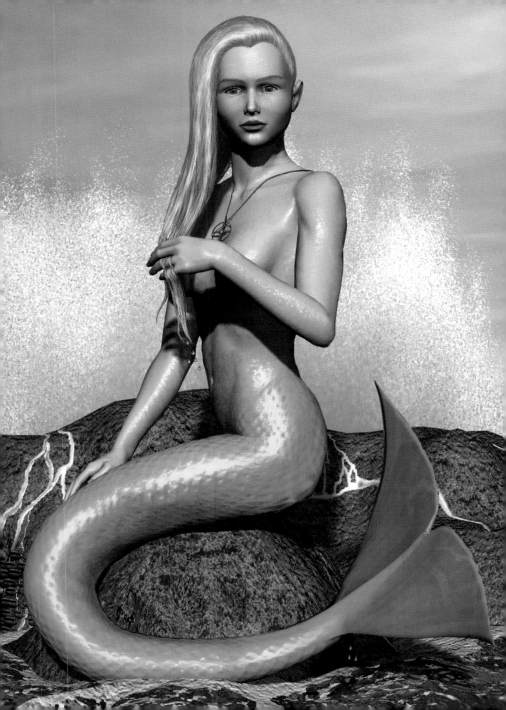

DANIEL D. VAN WINKLE

e-mail:
dandvan
@home.com

Country:
United States

Contact:
559 Loganberry
Drive, San Rafael,
CA 94903

Copyright:
© Mobius
Graphics

Software:
Poser
Bryce
Adobe
Photoshop

UNDRESSED WOMEN IN OUTLINES

Dan Van Winkle was born in 1962 in California, where he works and lives. He holds a Bachelor of Science from California Polytechnic State University and a Master of Science in Electrical Engineering from Santa Clara University, and works as an RF design engineer at a large communications technology company. Computers were just becoming household items when he was in high school, and he started to learn programming on a Commodore Pet. As soon as he could afford one, he bought a Commodore 64 with a whole 64 Kbytes of memory, and began programming fractal landscapes. His dream was to write a program that could be used to create 3D scenes. Alias, from AutoDesk (and others), beat him to it, and once he found 3D Studio Max he realized that he was a software user, not a writer.
Van Winkle begins either from a photograph or from scratch. Depending on the complexity he wants, he uses Poser 4 alone for simpler renderings, or in conjunction with 3D Studio Max for more complex effects. Afterwards, there is almost always touch-up work to be done in Photoshop. Usually it will take 20 to 30 renderings before he is sufficiently satisfied to make the final rendering. One of the most important aspects of Van Winkle's 3D work is its emphasis on lighting. Above all he tries to achieve realism in his images. Since bad lighting can take a perfectly good idea and turn it into something not worth looking at, he spends a great deal of time manipulating the shadows and subtle nuances so that the image looks as if it were real. An image can take anywhere from 1 to 3 weeks to complete, depending on his dedication and the image's complexity.

Dan Van Winkle est né en 1962 en Californie, où il travaille et vit actuellement. Il a obtenu un diplôme de sciences de la California Polytechnic State University et un Master of Science en ingénierie électrique de la Santa Clara University. Il travaille en tant qu'ingénieur auprès d'une importante société de technologies de communication. Les ordinateurs devenant communs lorsqu'il était au lycée, il apprend la programmation sur un Commodore Pet. Dès qu'il le peut, il s'achète un Commodore 64 doté de 64 Ko de mémoire et se met à la programmation de paysages en fractales. Son rêve était d'écrire un programme capable de créer des scènes 3D. Alias, de la société AutoDesk (et d'autres produits) le prendront de vitesse. Après avoir découvert 3D Studio Max, il réalise qu'il est un utilisateur et non un programmeur.
Van Winkle commence son travail à partir d'une photo ou de zéro. Selon le niveau de complexité qu'il souhaite atteindre, il utilise Poser 4 seul pour effectuer des rendus simples ou en conjonction avec 3D Studio Max pour obtenir des effets plus complexes. Il reste quasiment toujours des retouches à effectuer dans Photoshop. Il lui faut en général entre 20 et 30 rendus pour être satisfait et finaliser l'image.
Un des aspects les plus importants des travaux 3D de Van Winkle est sa mise en valeur de la lumière. Il essaie avant tout de rendre ses images réalistes. Sachant qu'un mauvais éclairage peut abîmer une bonne idée, il passe une grande partie de son temps à manipuler les ombres et les nuances subtiles afin de rendre les images plus réelles. Créer une image peut lui prendre d'une à trois semaines, en fonction de la complexité de celle-ci et du temps qu'il peut y consacrer.

Dan Van Winkle wurde 1962 in Kalifornien geboren, wo er noch heute lebt und arbeitet. Er studierte Naturwissenschaften an der California Polytechnic State University und Elektrotechnik an der Santa Clara University und ist HF-Entwicklungsingenieur bei einem großen Unternehmen für Kommunikationstechnologie. Als er zur Highschool ging, wurden Computer gerade Alltagsgegenstände und er erlernte das Programmieren auf einem Commodore PET. Sobald er es sich leisten konnte, kaufte er einen Commodore 64 mit 64 Kbyte Speicher

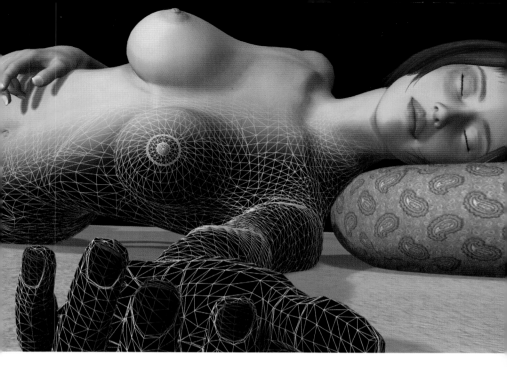

und begann, fraktale Landschaften zu programmieren. Er träumte davon, ein Programm zu schreiben, mit dem man 3D-Szenen entwerfen kann. Alias (von AutoDesk) und andere waren schneller. Als er 3D Studio Max entdeckte, erkannte Van Winkle, dass er eher Software-Anwender als Software-Programmierer war.

Van Winkle geht bei seine Arbeit entweder von einer Fotografie aus oder beginnt ohne jegliche Vorgaben. Zum Rendern benutzt er Poser und für komplexere Effekte zusätzlich 3D Studio Max. Fast immer folgt eine Retusche in Photoshop. Gewöhnlich ist er erst nach 20- bis 30-maligem Rendern mit dem Ergebnis zufrieden.

Einer der Schwerpunkte in Van Winkles 3D-Arbeiten ist die Gestaltung des Lichteffekte. Da er in seinen Bildern vor allem nach Realismus strebt und eine schlechte Ausleuchtung selbst eine ausgezeichnete Idee in ein mittelmäßiges Bild verwandeln kann, verwendet er viel Zeit auf die Bearbeitung von Schatten und feinen Nuancen, bis das Bild realistisch wirkt. Wenn Van Winkle mit viel Hingabe an einem komplexen Bild arbeitet, kann die Fertigstellung bis zu drei Wochen dauern.

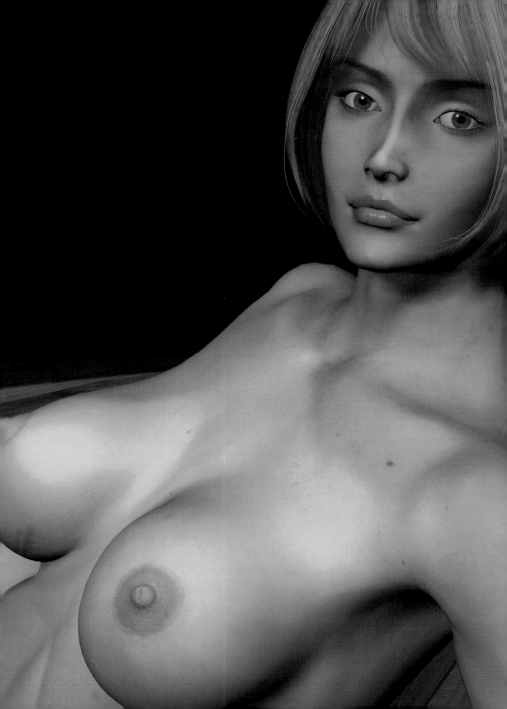

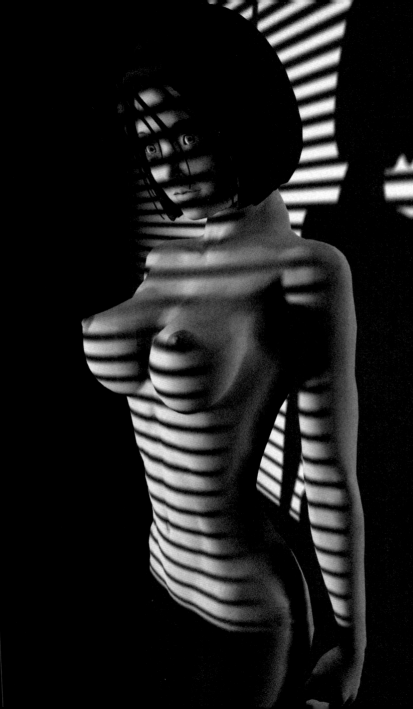

DANIEL ROBICHAUD CA

e-mail:	http://www.	Country:	Contact:	Copyright:	Software:
danielr @attbi.com	daniel robichaud.com	Canada	3675 Empire Drive Suite 102, Los Angeles CA, 90034	© Marlene, Inc/VCP	Softimage Shake Amazon 3D Paint

DIGITAL SUPREME FROM HOLLYWOOD

Daniel Robichaud is originally from Montreal, Quebec, and most of his childhood was spent travelling around the world before returning home and finally settling down at the age of 9. He discovered computer graphics in the early 1980s, and realized that this medium would soon open up fascinating creative horizons and revolutionize the art of animation. Upon graduation in 1984 from the University of Quebec with a Bachelor's degree in Graphic Design, Robichaud joined the computer graphics department at the Canadian Broadcasting Corporation (CBC) as a Designer and Art Director. During that time, he taught digital animation at the renowned National Animation and Design Centre in Montreal. After nine years at the CBC, Daniel accepted a position as Director of Animation at The Film & Tape Works in Chicago, where he built up an animation department, directed commercials, and developed several independent animation projects.

In 1994, Robichaud moved to Los Angeles to work for Digital Domain as an Animation Supervisor. At DD, he contributed to such projects as *Apollo 13*, *Terminator 2-3D*, The *Fifth Element,* and *Titanic*; he also created, wrote and directed the award-winning short animation film *Tightrope*.

The voice, the attitude, the timeless beauty: defining characteristics not only of a movie star, but of the entire era in which she lived. Jean Cocteau once said of Marlene Dietrich: "Whoever knows her has experienced perfection itself." The "Digital Marlene" (with images presented in the next pages) was created as an experimental project to develop a new generation of facial animation systems. Brought back to life using computer animation, she seduces us with her trademark cool and sophisticated style. The team of highly skilled professionals also included Michelle Deniaud, Stéphane Couture, Jeff Wagner and Gonzalo Garramuno. The movie, also presented on his Web site, was produced by Jeff Lotman. The software used consisted of Softimage, Shake and Amazon 3D Paint.

Daniel Robichaud est originaire de Montréal au Québec. Il a passé la plus grande partie de son enfance à voyager autour du monde avant de revenir chez lui à l'âge de neuf ans. Au début des années 1980, il découvre le graphisme sur ordinateur et réalise que ce support peut rapidement lui ouvrir des horizons fascinants et révolutionner l'art de l'animation.

Après avoir obtenu en 1984 son diplôme Bachelor of Arts en graphisme de l'université du Québec, Robichaud rejoint le département graphique de la Canadian Broadcasting Corporation (CBC) en tant que designer et directeur artistique. Pendant ce temps, il donne des cours d'animation numérique au National Animation and Design Centre de Montréal. Après avoir passé neuf ans chez CBC, Daniel accepte un poste de directeur d'animation au Film & Tape Works de Chicago, où il crée un département d'animation, dirige des publicités et développe plusieurs projets indépendants d'animation.

En 1994, Robichaud s'installe à Los Angeles pour travailler chez Digital Domain en tant que superviseur d'animation, et contribue à des projets tels qu'*Apollo 13*, *Terminator 2-3D*, *Le Cinquième Elément* et *Titanic*. Il crée, écrit et dirige également le court métrage d'animation *Tightrope* qui a remporté un prix.

La voix, l'attitude et la beauté intemporelle définissent non seulement une star de cinéma, mais aussi toute l'époque à laquelle elle a vécu. Jean Cocteau dit un jour de Marlene Dietrich : « Quiconque la connaît fait l'expérience de la perfection. » La « Marlene numérique » a été créée dans le cadre d'un projet expérimental de développement d'une nouvelle génération de systèmes d'animation faciale. Ramenée à la vie grâce à l'animation numérisée, elle nous séduit par son style froid et sophistiqué. L'équipe de professionnels de grand talent réunis sur le projet comprend également Michelle Deniaud, Stéphane Couture, Jeff Wagner et Gonzalo

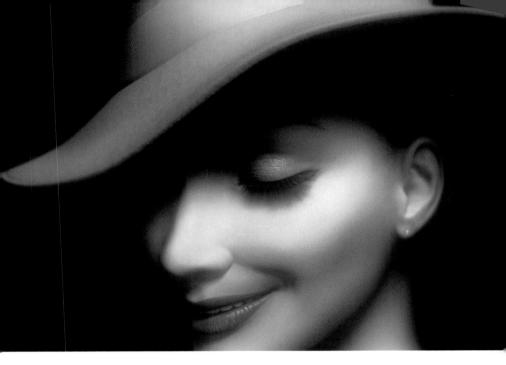

Garramuno. Le film, présenté sur son site Web, a été produit par Jeff Lotman. Les logiciels utilisés sont Softimage, Shake and Amazon 3D Paint.

Daniel Robichaud stammt aus Montreal, Kanada. Anfang der Achtziger Jahre entdeckte er die Computergrafik und erkannte, dass dieses Medium schon bald neue kreative Horizonte eröffnen und die Kunst der Animation revolutionieren würde.
1984 schloss er sein Grafikdesign-Studium an der Universität Quebec ab und begann mit seiner Arbeit als Designer und Artdirector in der Computergrafik-Abteilung des kanadischen Fernsehsenders CBC. Gleichzeitig unterrichtete er am angesehenen National Animation and Design Centre in Montreal digitale Animation. Nach neun Jahren bei der CBC wurde Robichaud Leiter der Animation bei den Film & Tape Works in Chicago, baute dort die Abteilung Animation auf, führte Regie bei Werbefilmen und entwickelte diverse eigene, nichtkommerzielle Animationsprojekte.
1994 ging er als Leiter der Animation zu Digital Domain nach Los Angeles. Dort wirkte er an Kinoprojekten wie Apollo 13, Terminator 2-3D, Das fünfte Element und Titanic mit und war außerdem beim preisgekrönten computergenerierten Kurzfilm Tightrope für Idee, Skript und Regie verantwortlich.
Stimme, Haltung, zeitlose Schönheit – diese Eigenschaften stehen nicht für einen Kinostar, sondern auch für die gesamte Ära, in der dieser lebte. Jean Cocteau sagte einmal über Marlene Dietrich: „Wer sie kennt, hat erfahren, was Perfektion ist." „Digital Marlene" (s. Abb.) wurde als Experimentalprojekt konzipiert, um neue Möglichkeiten der Animation menschlicher Mimik zu entwickeln. Auch die durch Computeranimation wieder zum Leben erweckte Marlene verführt uns mit ihrem typischen kühlen und damenhaft-eleganten Stil. Zum Profi-Team gehörten neben Robichaud auch Michelle Deniaud, Stéphane Couture, Jeff Wagner und Gonzalo Garramuno. Der Film, der auch auf Robichauds Website zu sehen ist, wurde von Jeff Lotman produziert. Als Software benutzte die Gruppe Softimage, Shake und Amazon 3D Paint.

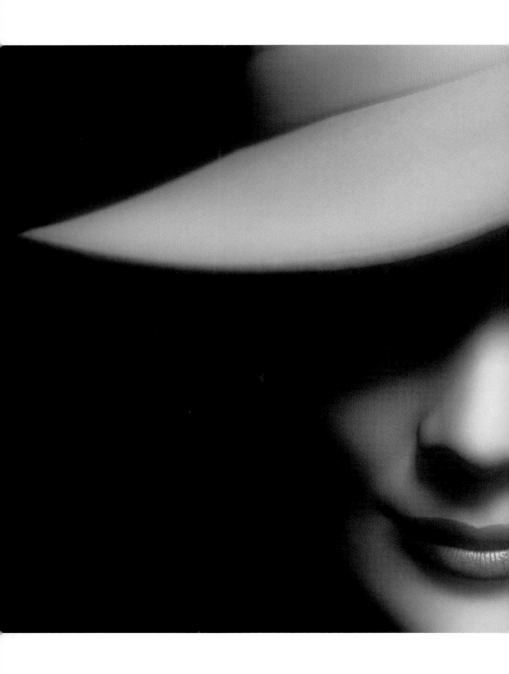

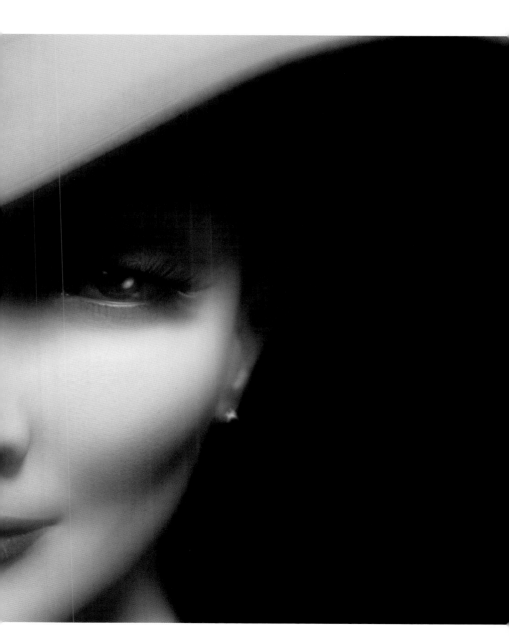

DANIEL SCOTT MURRAY

e-mail:	http://www.	Country:	Contact:	Copyright:	Software:
kahuna	alpc.com	United States	41 Maple st.	© 1999-2001	3D Studio
@alpc.com			Gardiner Me.	Daniel Scott	Bryce
			04345	Gabriel	Poser
				Murray	Adobe
					Photoshop

WOMEN VIRTUALLY DRESSED TO KILL

Daniel Scott Murray was born in 1961 and raised in the small town of Gardiner, Maine USA. He attended the College of Art and Design in Philadelphia and works today as a web and graphic designer. As with many character creators, his abilities spread from 2D and 3D to the web. His characters display a mix of techniques that gives his artwork an intriguing style. His works have been featured on several music CD releases and in film projects internationally.

Murray worked for years with traditional media, but with the advent of the PC as a consumer product, he fell in love with digital tools and their nearly limitless possibilities. The aesthetic sensibility gained from his traditional background facilitates the work process for him. Designing and shaping forms, determining lights and cameras, and applying colours always require much more art knowledge than computer graphics expertise. Murray's characters are almost always fully preconceived. Once he has the concept, the actual work begins: the struggle to bring it to a state of reality. Here volumes, accurate lighting, shadows and forms come into play.

His images are created on an Athlon 1Ghz Thunderbird, running 256 meg RAM on a Win2000 Pro platform with a colour/contrast corrected monitor with a 32 bit colour display.

The work begins in one of several 3D platforms, such as 3D Studio, Bryce or Poser. This is where the core definitions take place. From that point the rendered image is imported into Photoshop and the post-production starts - the refining, adding and removing of the parts brought from the other software. Photoshop allows him to do precise rendering and colouring. One image can take up to several weeks to be completed, depending on the process required and the complexity of the environment.

Daniel Scott Murray est né en 1961 et a grandi dans la petite ville de Gardiner dans le Maine. Il a étudié au College of Art and Design de Philadelphie et travaille aujourd'hui comme graphiste Web. Comme c'est le cas pour beaucoup de créateurs de personnages, ses compétences couvrent la 2D, la 3D et le Web. Ses créations illustrent un ensemble de techniques qui donnent à son art un style intriguant. Ses travaux sont apparus sur de nombreux CD musicaux et dans des projets cinématographiques internationaux.

Murray a travaillé des années sur support traditionnel, mais depuis l'avènement des ordinateurs personnels, il est tombé amoureux des outils numériques et de leurs possibilités quasi illimitées. La sensibilité esthétique de sa formation traditionnelle facilite son processus de travail. Concevoir et créer des formes, déterminer l'éclairage et les angles des caméras, et appliquer les couleurs requiert toujours beaucoup plus de connaissances artistiques que d'expertise graphique.

Les personnages de Murray sont quasiment toujours préconçus. Dès qu'il tient le concept, le travail peut commencer, c'est-à-dire la lutte pour les rendre réels. C'est ici que les volumes, l'éclairage, les ombres et les formes prennent tout leur sens. Ses images sont créées sur un ordinateur Athlon 1GHz Thunderbird équipé de 256 Mo de RAM, de Windows 2000 Pro et d'un moniteur couleur 32 bit calibré. Le travail débute sur un outil 3D tel que 3D Studio, Bryce ou Poser, pour définir la scène de base. L'image rendue est ensuite importée dans Photoshop pour effectuer la post-production, c'est-à-dire la finition, l'ajout ou la suppression d'éléments provenant d'autres logiciels. La mise en couleur et le dessin peuvent être également effectués précisément dans Photoshop. La création d'une image peut prendre des semaines de travail, en fonction du processus requis et de la complexité de l'environnement.

Daniel Scott Murray wurde 1961 geboren und wuchs in der Kleinstadt Gardiner in Maine auf. Er besuchte das

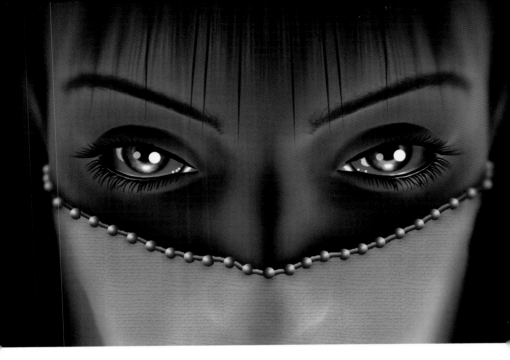

College of Art and Design in Philadelphia und arbeitet heute als Web- und Grafikdesigner. Wie bei vielen Künstlern, die Charaktere entwerfen, erstrecken sich seine Fähigkeiten von 2D über 3D bis zum Internet. Seine Charaktere zeigen eine Kombination verschiedener Techniken, die ihnen eine besondere Faszination verleiht. Murrays Arbeiten sind international auf diversen CD-Covern und in Filmprojekten zu finden.

Murray hat jahrelang mit traditionellen Techniken gearbeitet; mit dem Auftauchen des PCs als Gebrauchsgegenstand fand er Gefallen an den digitalen Tools und ihren fast grenzenlosen Möglichkeiten. Das ästhetische Gespür seiner klassischen künstlerischen Ausbildung erleichtert ihm den Arbeitsprozess. Der Entwurf und das Gestalten von Formen, das Einrichten der Lichteffekte und Kameras und der Gebrauch von Farben erfordern mehr Kunstverstand als Kenntnisse der Computergrafik. Murrays Figuren sind fast immer vollständig vorkonzipiert. Sobald er einen Entwurf angefertigt hat, beginnt die mitunter schwierige Realisierung. Hier kommen Intensität, präzise Lichteffekte, Schatten und Formen ins Spiel.

Seine Bilder erstellt er auf einem Athlon 1-Ghz-Thunderbird mit 256 MB RAM auf einer Win2000-Pro-Plattform. Er hat einen Monitor mit eingebauter Farb- und Kontrastkorrektur sowie 32-Bit-Farbauflösung. Die Arbeit beginnt in einem von mehreren 3D-Programmen, wie zum Beispiel 3D Studio, Bryce oder Poser; hier nimmt Murray die Schlüsseldefinitionen vor. Das gerenderte Bild importiert er in Photoshop, wo er es weiter nachbearbeitet, Elemente hinzufügt oder ungewollte Details der zuvor benutzten Software entfernt. In Photoshop lassen sich Zeichnung und Farbe besonders präzise anpassen. Die Fertigstellung eines Bildes kann, abhängig von der Komplexität der Umgebung und dem benötigten Verfahren, mehrere Wochen dauern.

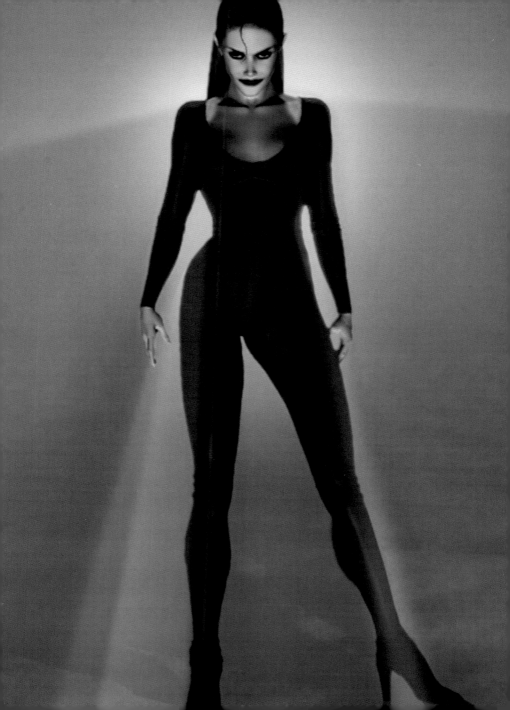

e-mail:
dglidden67
@yahoo.com

Country:
Canada

Copyright:
© D. Glidden

Software:
Poser
Rhino, Bryce
Adobe
Photoshop

MERMAIDS IN THE PIXEL OCEAN

Though Darrell Glidden has been drawing ever since he could hold a pencil, he first took it really seriously after he discovered computer graphics and the amazing works that could be created using digital resources. He has been working with 3D graphics now for about two years and has found his true calling. With 3D graphics he is free to use his imagination. With no limits to what images he can create, he can explore programs to their utmost. By working with a variety of programs, he exploits the potential of the computer as a powerful graphics tool.

He always works with characters, so his starting point is usually Poser, in which he sets the pose and facial expression of the model. If more than one character is used, he also sets the scene of the interaction between them. If he needs special props or accessories, he uses a modelling program, frequently Rhino, to build them. He then constructs the complete scene in Bryce, building the environment around the characters and then setting the lighting and atmosphere. Once the scene is done and a satisfactory result is achieved, a 2D graphics program is required, usually Photoshop, to strengthen the scene by adjusting the colors, painting, clothing and hair, or to touch up any flaws in the characters created by extreme posing.

Si Darrell Glidden dessine depuis qu'il sait tenir un crayon, ce n'est qu'après avoir découvert le graphisme sur ordinateur et les possibilités de création offertes par les ressources numériques qu'il s'y est mis sérieusement. Travaillant depuis deux ans en 3D, il a trouvé sa véritable vocation. Libre d'utiliser son imagination grâce au graphisme en 3D, il explore les possibilités des programmes pour créer des images sans limitations, et exploite le potentiel de l'ordinateur en tant qu'outil graphique.

Il travaille toujours avec des personnages et commence habituellement son travail dans Poser, où il fixe les poses et les expressions faciales du modèle. S'il utilise plus d'un personnage, il met également la scène en place et l'interaction entre eux. S'il a besoin d'objets spéciaux ou d'accessoires, il les réalise avec un programme de modelage, souvent Rhino. Il termine ensuite la scène dans Bryce autour des personnages, et place l'éclairage et l'atmosphère. Une fois la scène terminée et le résultat désiré obtenu, il utilise un programme 2D, habituellement Photoshop, pour renforcer la scène et ajuster les couleurs, la peinture, les vêtements et les cheveux, ou retoucher les défauts des personnages dus à des poses trop extrêmes.

Darrell Glidden zeichnet, seit er einen Stift halten kann. Er begann seine Arbeit jedoch erst ernst zu nehmen, als er die Computergrafik und die unglaublichen Möglichkeiten digitaler Hilfsmittel entdeckte. Er arbeitet seit etwa zwei Jahren mit 3D-Grafik und hat damit seine „wahre Berufung" gefunden. Mit 3D-Grafik kann er seine Fantasie unbegrenzt und ohne Einschränkungen ausleben. Indem er mit einer Vielzahl von Programmen arbeitet, nutzt er das Potenzial des leistungsstarken Computers restlos aus.

Er arbeitet immer mit Charakteren und beginnt daher gewöhnlich in Poser, wo er Pose und Gesichtsausdruck des Modells festlegt. Wird mehr als ein Charakter benötigt, legt er auch die Interaktionsszene zwischen ihnen fest. Braucht er spezielle Props und Accessoires, setzt er zu deren Erstellung ein Modellierprogramm ein, meist ist dies Rhino. Dann konstruiert er die gesamte Szene in Bryce, indem er die Umgebung um die Charaktere herum gestaltet und Licht und Stimmung festlegt. Sobald die Szene fertig ist und ihm gefällt, verwendet er ein 2D-Grafikprogramm, normalerweise Photoshop, um die Szene durch Feinabstimmung der Farben, Kleidung und Haare zu optimieren oder bei den Charakteren kleinere Fehler zu korrigieren, die eventuell durch extreme Posen entstanden sind.

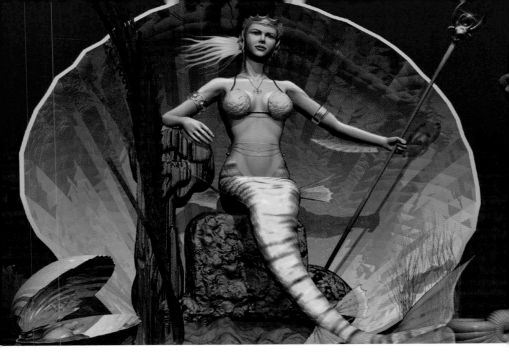

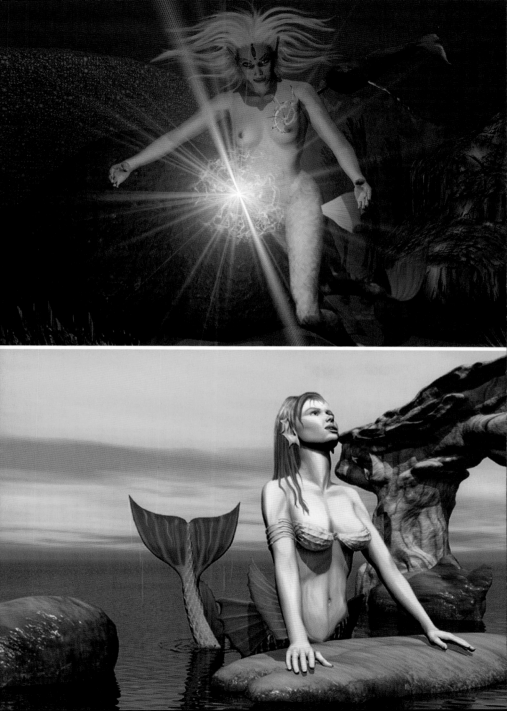

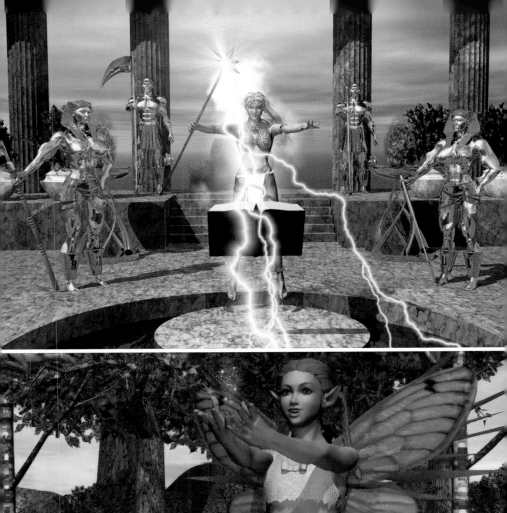
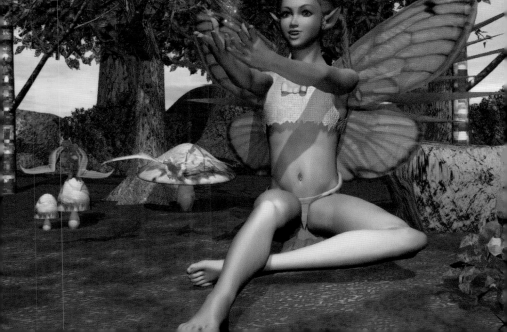

ELLIE MORIN

e-mail:	http://www.	Country:	Contact:	Copyright:	Software:
artofspirit @aol.com	members. aol.com/Artof Spirit/index.htm	United States	2400 Fillmore RD Richmond, VA 23235	© 2000-2001Ellie Morrin Art of Spirit	Poser Adobe Photoshop

SEDUCTION IN 3 DIMENSIONS

Art has been Ellie Morin's hobby for over 30 years. She began painting in watercolours and oils, and then progressed to sculpting. At an early age, inspired by the artists of the Renaissance, she began her journey into the field of art. When she was 17, her work was exhibited in the Schubert Theatre in Cincinnati Ohio, USA, and some went on to be shown on the Good Ship Hope, which at that time travelled to third world countries. Morin's sculpture, which focuses on Inca and Mayan busts and talking sticks, has been shown at the Soul Mate Gallery in Plantation, Florida. While working for the Boys Clubs of Northern Kentucky, she was asked to develop an art program for the young boys, and for the next few years she helped children to develop their creative side. It wasn't until reading an article about Poser in 1996 that she became interested in digital art. She started searching the Internet for tutorials about lighting and texturing. She began by concentrating on spiritual themes and then expanded her artwork to include the human anatomy.

Most of her works start from scratch, working on compositions that show the human anatomy. She challenges the digital media to create life-like compositions that convey emotions, feelings and tenderness to the viewer. As a result she concentrates on the eyes, mouth, or the general way the character is presented. Her primary software is Poser, in which she applies customized textures and lighting to 3D figures, and also finds the best poses for the characters. Once the images have the right lighting and textures, she exports them to Photoshop and post-production can begin. She uses the blending tool to correct any joint, hair, and clothing problems. One image can take up to 36 hours to complete. She uses a 100 to 115 mm camera shot, which aids in bringing the character to life.

L'art est le hobby d'Ellie Morin depuis plus de 30 ans. Elle a débuté par la peinture à l'huile et l'aquarelle, puis est passée à la sculpture. Inspirée par les artistes de la Renaissance dès son jeune âge, elle fait son chemin dans le domaine de l'art. A 17 ans, ses travaux sont exposés au théâtre Schubert de Cincinnati dans l'Ohio, et certaines de ses œuvres sont intégrées au Good Ship Hope, une exposition itinérante en visite alors dans les pays du tiers-monde. Ses sculptures composées de bustes incas et mayas et de bâtons parlants ont été exposées à la Soul Mate Gallery de Plantation en Floride. Lorsqu'elle travaillait pour le Boys Clubs du Kentucky, on lui a demandé de développer un programme artistique pour jeunes garçons. Elle aide alors pendant quelques années les enfants à développer leur fibre créatrice.

Après avoir lu un article sur Poser en 1996, elle s'intéresse aux arts numériques et recherche sur Internet des travaux dirigés sur l'éclairage et l'habillage de textures. Elle se concentre au départ sur des thèmes spirituels puis intègre l'anatomie humaine.

La plupart de ses travaux débutent à zéro et sont des compositions montrant l'anatomie humaine. Elle repousse les limites des supports numériques pour créer des compositions qui communiquent des émotions, des sentiments et de la tendresse au spectateur. Ainsi, elle se concentre sur les yeux, la bouche ou même la manière dont le personnage est présenté. Poser est son logiciel principal, elle y applique des textures personnalisées, l'éclairage et détermine les meilleures poses de ses personnages 3D.

Lorsque ses images ont la texture et l'éclairage appropriés, elle les exporte vers Photoshop pour effectuer la post-production et corriger les problèmes d'articulation, de cheveux et de vêtements. Une image peut demander jusqu'à 36 heures de travail. Elle prend ensuite une photo de la scène pour donner plus de vie aux personnages.

Kunst ist schon seit über 30 Jahren Ellie Morins Hobby. Den Zugang dazu fand sie über die Künstler der

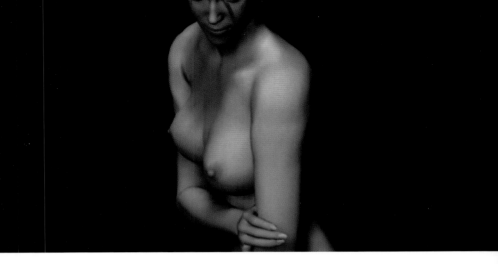

Renaissance. Zunächst malte sie in Aquarell und Öl und ging dann zur Bildhauerei über. Mit 17 hatte sie ihre ersten Ausstellungen im Schubert Theatre in Cincinnati, Ohio, und auf dem *Good Ship Hope,* das damals zu Ländern der Dritten Welt unterwegs war. Morins Skulpturen, die Inca- und Maya-Büsten sowie „Talking Sticks" thematisieren, wurden in der Soul Mate Gallery in Plantation, Florida, gezeigt. Als Morin später in der Jugendarbeit tätig war, bat man sie, ein Kunstprogramm für Jugendliche zu entwickeln, und es ergab sich eine längere pädagogische Arbeit.

Erst als sie 1996 einen Artikel über Poser las, begann Morin sich für digitale Kunst zu interessieren und suchte im Internet nach Tutorials über Beleuchtung und Texturierung. Zunächst konzentrierte sie sich auf spirituelle Themen, erweiterte ihre Arbeit dann aber auch auf den Bereich der menschlichen Anatomie.

Meist beginnt sie ihre Arbeiten mit anatomischen Skizzen. Sie entwickelt mithilfe der digitalen Medien lebensechte Kompositionen, die Emotionen und Zärtlichkeit vermitteln. Daher konzentriert sie sich auf Augen und Mund oder auf den Gesamteindruck eines individuellen Charakters. Sie arbeitet zumeist mit Poser, in dem sie ihre 3D-Figuren mit eigenen Texturen und Lichteffekten versieht und auch die besten Posen für ihre Charaktere findet. Wenn Beleuchtung und Texturen ihrer Bilder stimmen, importiert Morin sie in Photoshop und beginnt mit der Nachbearbeitung; mit dem Blending-Tool korrigiert sie zum Beispiel Gelenke, Haare und Kleidung. Es kann bis zu 36 Stunden dauern, bis sie ein Bild fertig gestellt hat. Morin arbeitet mit einem 100- bis 115-mm-Kamerashot, wodurch ihre Charaktere besonders lebendig wirken.

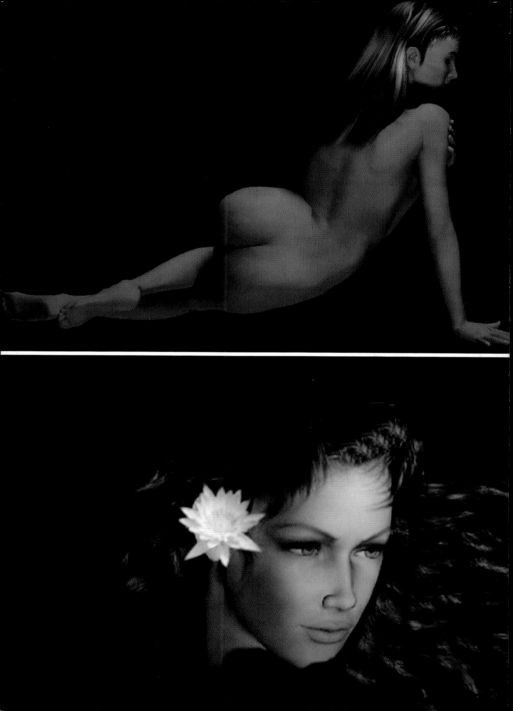

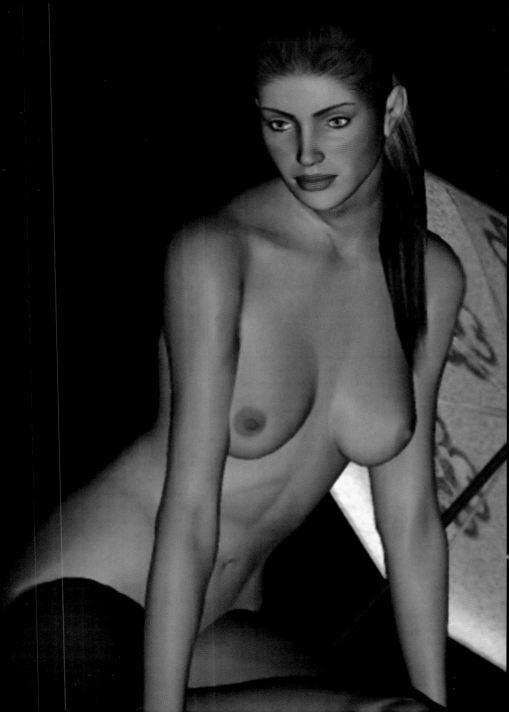

GEOFF RIDGWAY UK

e-mail:	http://www.	Country:	Contact:	Copyright:	Software:
geoff @eros5.co.uk	eros5.co.uk	United kingdom	44a Town Street, M/Bridge Stockport SK65AA	© Geoff Ridgway	3D Studio Max

S & M AND MOTORBIKES

Geoffrey Ridgway was born in the United Kingdom and lives in Manchester. At school, he was good at nothing but metalwork and art. As a teenager, he went to Openshaw Technical College to study panel beating, but enlisted himself for the sign-writing and painting course. During this period he started custom painting motorcycles and scooters. Specialist's materials were very rare and had to be imported from America, so he decided to develop his own, and still uses them to this day. While he was at college, one of the tutors asked if he would be interested in a job sign-writing and coach-painting. As this was a way to study a dying art hands-on, he jumped at the chance and gained three years of valuable experience.

The era of the custom show was just starting and customers were pestering him for award-winning paint jobs. Later on, he was commissioned for a paint job by a powerboat team sponsored by Budweiser. He has since worked for companies such as Coca-Cola, British Leyland, Harrods, McLaren and Ford. His art has been exhibited in such motor shows as Earls Court and Geneva, and featured on the *BBC*. He first started using a computer about four years ago. At the time he was a complete technophobe. He didn't give up, though, for he was trying to write a book on airbrushing and the only way to achieve this goal was to use a computer. After months working with limited resources, he started doing what he really wanted to do: 3D computer graphics. He acquired 3D Studio Max and taught himself how to use the program.

His approach to lighting and his bold use of materials give his works a very unconventional look. While defining his own style, he has given up the standards of Technicolor green for grass, swimming pool blue for sea, and pink for people. He also started to make his own textures using Photoshop. This has taken two years of solid commitment, but he knew he was creating his own art. He starts work in the 3D environment, using traditional methods along the way when producing architectural pieces and storyboards.

Geoffrey Ridgway est né en Grande-Bretagne et vit à Manchester. A l'école, il n'a de bonnes notes qu'au travail du métal et en dessin. Adolescent, il part étudier la tôlerie à l'Openshaw Technical College mais s'inscrit aux cours de peinture et de peinture sur enseigne. Pendant cette période, il commence à peindre sur des motos et des scooters. Les matériels professionnels étant très rares et devant être importés des Etats-Unis, il décide de développer les siens et les utilise toujours à ce jour. A l'université, un de ses tuteurs lui demande si un emploi de peintre sur enseigne et l'enseignement de la peinture l'intéressent. Comme c'est un moyen d'étudier un art en voie de disparition, il saute sur l'occasion et acquiert trois ans d'expérience.

L'ère de la peinture personnalisée n'en étant qu'à ses balbutiements, ses clients lui demandent de véritables œuvres. Il a dû réaliser un travail de peinture sur un hors-bord sponsorisé par Budweiser. Il a travaillé depuis pour des sociétés telles que Coca-Cola, British Leyland, Harrods, McLaren et Ford. Ses œuvres ont été exposées lors de salons automobiles tels que ceux d'Earls Court ou de Genève, et montrées sur la chaîne de télévision *BBC*. Il a utilisé un ordinateur pour la première fois il y a quatre ans de cela. Véritable technophobe, il s'accroche pourtant, car il est en train d'écrire un livre sur l'aérographe et le seul moyen d'y parvenir est d'utiliser un ordinateur. Après des mois passés à travailler avec des ressources limitées, il commence à faire ce qu'il souhaite réellement : de la 3D. Il acquiert 3D Studio Max et apprend seul à utiliser le programme.

Son approche de l'éclairage et son utilisation radicale des matériaux donnent à ses travaux un aspect peu conventionnel. Tout en définissant son propre style, il abandonne les standards de couleur verte pour l'herbe, bleu piscine pour la mer et rose pour les humains. Il crée ses propres textures dans Photoshop. Tout cela lui prend deux ans de travail intensif, mais il sait qu'il est en train de créer sa propre forme artistique. Il démarre ses

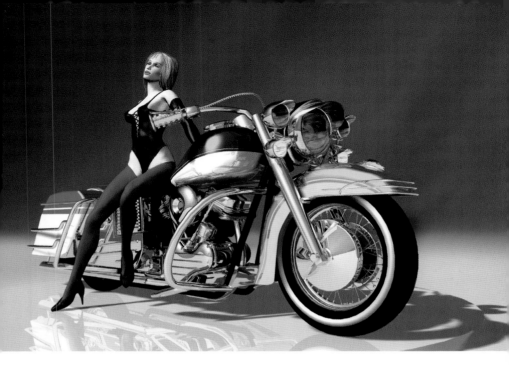

travaux dans un environnement 3D et emploie des méthodes traditionnelles de production architecturale et de storyboard.

Geoffrey Ridgway ist in Großbritannien geboren und lebt in Manchester. Er war kein sehr guter Schüler – außer in Metallarbeiten und Kunst. Als Teenager besuchte er das Openshaw Technical College, um Metallfacharbeiter zu werden, entschied sich dann aber für eine Ausbildung als Schildermaler. Während dieser Zeit begann er, Motorräder und Roller zu lackieren. Die erforderlichen Materialien waren nur schwer zu bekommen und mussten aus den USA importiert werden; daher beschloss er, eigene zu entwickeln, die er auch heute noch benutzt. Während seiner Collegezeit fragte ihn ein Tutor, ob er an einem Job als Schildermaler und Buslackierer interessiert sei. Weil dies eine Gelegenheit war, ein aussterbendes Handwerk kenenzulernen, sagte er begeistert zu und konnte drei Jahre lang Erfahrungen sammeln.
Damals begann gerade die Ära der Airbrush-Shows, und seine Kunden bedrängten ihn förmlich mit Jobs, für die er Auszeichnungen erhielt. Später bekam er den Auftrag, ein von Budweiser gesponsertes Rennboot zu lackieren. Inzwischen hat er für Firmen wie Coca-Cola, British Leyland, Harrods, McLaren und Ford gearbeitet. Seine Kunst wurde auf Automobilausstellungen in Earls Court und Genf und auch von der *BBC* vorgestellt. Am Computer zu arbeiten begann Ridgway vor vier Jahren, obwohl ihm jede Art von Technik damals regelrecht Angst bereitete. Da er ein Buch über Airbrushing schreiben wollte, gab er jedoch nicht auf. Nach monatelanger Arbeit mit recht begrenzten Mitteln fing er schliesslich an, das zu machen, was er wirklich wollte: 3D-Computergrafik. Er kaufte 3D Studio Max und brachte es sich selbst bei.
Sein eigenwilliger Umgang mit Lichteffekten und die gewagte Verwendung von Materialien machen seine Arbeiten höchst unkonventionell. Auf der Suche nach einem persönlichen Stil verabschiedete er sich von gewöhnlicher Farbästhetik und erfand mit Photoshop auch ganz eigene Texturen. Obwohl es ihn zwei Jahre harter Arbeit kostete, tat er dies in dem Bewusstsein, dass er hier seine eigene Kunstform schuf. Ausgehend von einer 3D-Umgebung, verwendet er für architektonische Darstellungen und Storyboards jedoch auch traditionelle Techniken.

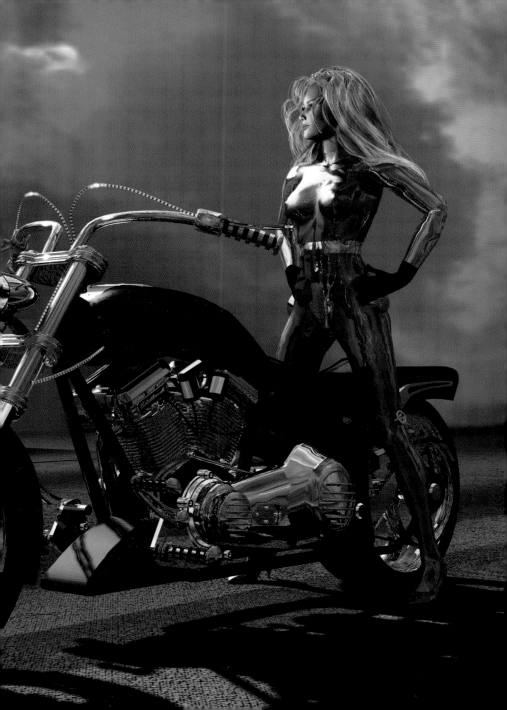

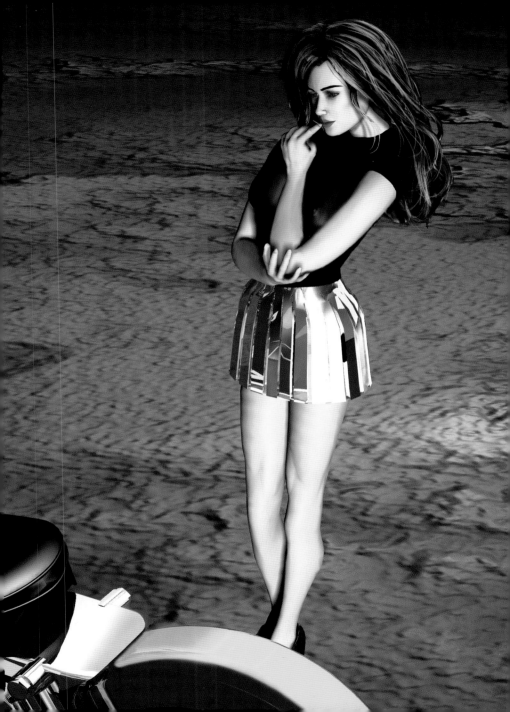

e-mail:	http://www.	Country:	Contact:	Copyright:	Software:
oasis-hill @earthlink.net	soupbubble.com	United States	530 RT 517 Sussex NJ, 07461	© Glenn Dean	Maya Adobe Photoshop

HOLLYWOOD STARS READY TO GO

Glenn Dean had a great introduction to the dynamics and possibilities of art by serving as a studio assistant to acclaimed photo-realist Chuck Close in the early seventies. After that he did airbrush and traditional painting for many years. His illustration work has covered everything from major advertising campaigns and movie posters to promotional work for a number of authors, including Michael Crichton, Scott Turow, and John Grisham.
A few years ago he took a break from illustration to write and design the computer game *Morpheus*. This represented his move from traditional media to computer graphics. He started to experiment and improve his digital modelling skills by studying traditional sculpture techniques, which led him to become an assistant sculptor on the enormous tiger sculptures that now adorn the new Detroit stadium. Dean begins work on a model in a number of ways. A typical start would be to immerse himself in photo references. From there, he models in traditional media such as clay or sculpey. He sketches curved lines to delineate detail where needed and to support smooth animation. After photographing front and side views of the physical model with as long a camera lens as possible, he loads the pictures into the corresponding view planes. He starts lofting patches to match the curve lines drawn on his sculptures. A bit of distortion occurs because of the difference between the physical camera view and the orthographic projection of the software view. He corrects this later while tweaking points. He then uses a rotating camera that takes thin-slice orthographic views all around the model. He composes these into an unwrapped cylindrical map that he uses as a guide for hand painting the texture maps. This is where his major experience comes in – the early years working for Chuck Close, hundreds of airbrush paintings, and the thousands of texture maps developed for *Morpheus*. He does not use projected photographs for any of the maps. They are all hand-painted in Photoshop. He then produces the models using Maya's IPR, a very useful tool for a traditionally-based painter.

C'est un emploi d'assistant auprès du célèbre photographe Chuck Close au début des années 1970 qui a fait découvrir à Glenn Dean les possibilités et la dynamique de l'art. Il a ensuite fait de la peinture traditionnelle et de l'aérographe pendant plusieurs années. Ses talents d'illustrateur ont été exploités dans de nombreux domaines – grandes campagnes publicitaires, affiches de films ou promotions pour des auteurs dont Michael Crichton, Scott Turow et John Grisham.
Voici quelques années de cela, il cesse d'illustrer pour écrire et créer le jeu *Morpheus*, passant des supports tra-ditionnels au graphisme sur ordinateur. Il fait des essais et améliore ses compétences de modeleur en étudiant les techniques de sculpture traditionnelle, ce qui l'amène à travailler comme assistant aux énormes tigres sculptés qui décorent maintenant le nouveau stade de Detroit.
Dean démarre de différentes manières son travail sur un modèle. Un départ typique consiste à s'immerger dans des références photographiques, puis à modeler le sujet à l'aide de matériaux traditionnels tels que l'argile. Il dessine des courbes pour délimiter les zones de détails et favoriser l'animation. Après avoir photographié le modèle physique de face et de côté avec le plus grand objectif possible, il charge les images sur ordinateur et dessine des zones de couleur correspondant aux courbes du modèle. Il se produit toujours un peu de distorsion due à la différence entre la représentation physique de l'objectif photo et la projection orthographique du logiciel. Dean corrige cette différence en ajustant les points des courbes. Il utilise ensuite une caméra rotative effectuant des prises de vue en coupe autour du modèle, puis les dispose dans un cylindre mis à plat pour faciliter l'appli-cation des textures. C'est à ce moment que son énorme expérience – les premières années passées à travailler pour Chuck Close, les centaines d'images peintes à l'aérographe et les milliers de textures développées pour

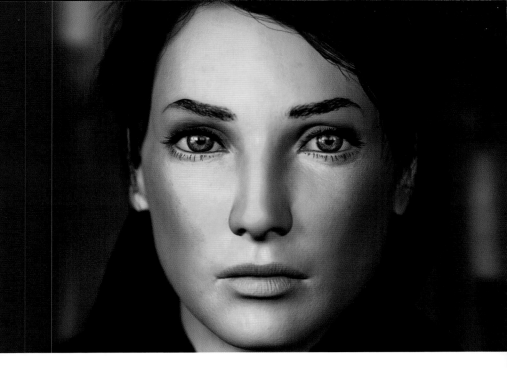

Morpheus – entre en jeu. Il n'utilise pas de photos projetées pour ses textures ; elles sont toutes dessinées dans Photoshop. Il produit enfin le modèle à l'aide de Maya.

Glenn Dean war in den frühen siebziger Jahren Studioassistent des gefeierten Fotorealisten Chuck Close und konnte dabei viel über Dynamik und Möglichkeiten der Kunst lernen. Danach beschäftigte er sich viele Jahre mit Airbrushing und traditioneller Malerei. Er hat Illustrationen für größere Werbekampagnen, Kinoplakate sowie zahlreiche Autoren wie Michael Crichton, Scott Turow und John Grisham erstellt. Ende der 90er Jahre verabschiedete er sich für eine Weile von der Illustration, um das Computerspiel *Morpheus* zu schreiben und zu gestalten. Damit wechselte er von konventionellen Techniken zur Computergrafik. Er begann zu experimentieren und seine digitalen Modellierkünste zu verbessern, indem er sich mit klassischer Bildhauertechnik beschäftigte. So war er als Assistent an den riesigen Tiger-skulpturen beteiligt, die nun das neue Stadion von Detroit schmücken.
Dean verfolgt verschiedene Zugänge zur Arbeit an einem Modell. Typischerweise vertieft er sich zunächst in Referenzfotos und modelliert anschließend mit traditionellen Materialien wie Ton oder Plastilin. Auf diesen Objekten malt er Höhenlinien auf, um die Einarbeitung von Details zu ermöglichen und die Animation zu erleichtern. Nachdem er das physische Modell von vorn und von den Seiten mit einer möglichst langen Brennweite fotografiert hat, lädt er die Bilder in die entsprechenden Sichtebenen. Gemäß den Konturlinien, die er auf seinen Skulpturen einge-zeichnet hat, erstellt er dann ein Modell. Dabei kommt es wegen des Unterschieds zwischen der Perspektive der physikalischen Kamera und der senkrechten Software-Ansicht zu einer leichten Verzerrung, die er später, wenn er die Objektpunkte justiert, korrigieren muss. Mit einer rotierenden Kamera, nimmt Dean ein Lückenloses Bild seines Modells auf und montiert es zu einer zylindrischen Karte, die ihm bei der Texturierung als Vorlage dient. Hier kommt ihm seine große Erfahrung zugute – die frühen Jahre mit Chuck Close, Hunderte von Airbrush-Arbeiten und unzählige Texturen für *Morpheus*. Für keine der Texturen benutzt er Fotoprojektionen, alle werden in Photoshop von Hand gemalt. Anschließend produziert Dean die Modelle in Maya mit IPR – einem für Maler mit klassischem Hintergrund sehr nützlichen Tool.

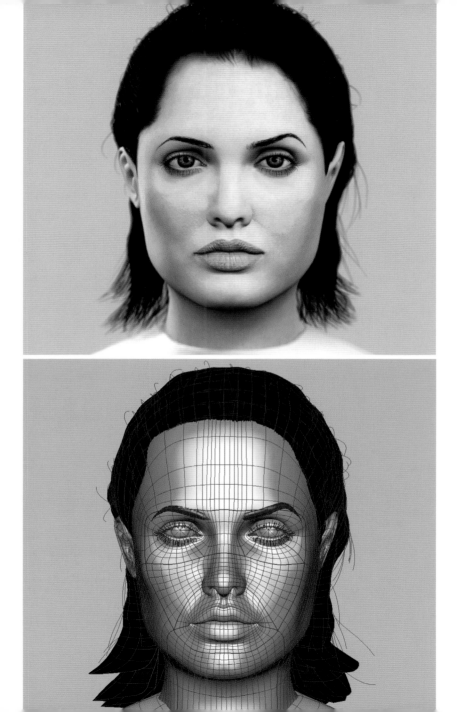

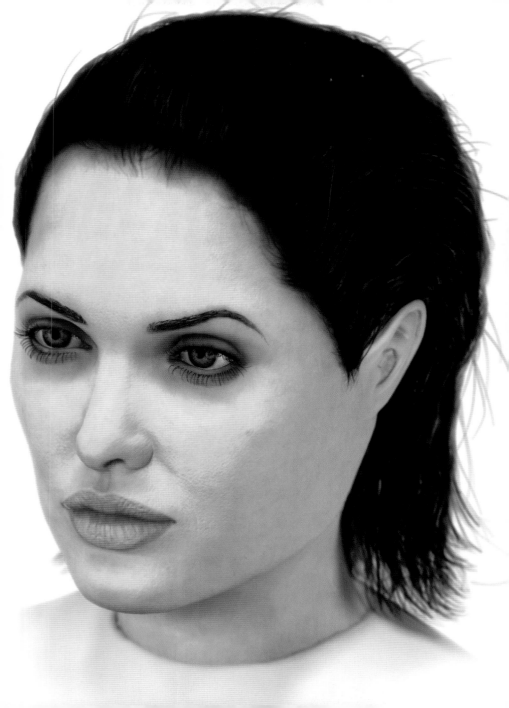

GREG CARTER

e-mail:	http://www.	Country:	Contact:	Copyright:	Software:
cyberpig @mindspring.com	cyberpiggy.com	United States	60020 Beardsley Cout, Raleigh NC 27609	© 2001 Greg Carter	3D Studio Max Adobe Photoshop

SCI-FI CLUBBERS AND GAMERS

Greg Carter studied art and psychology in the United States and works as a freelance illustrator and artist. His works are a blend of traditional and science-fiction styles and reflect the many techniques he has developed over the years. Several factors, of which the technological is only one, contribute to the making of his images. He is an artist first, not a "computer guy", and simply picked up the computer as a tool. His artistic background comes from fine art, painting in particular, with influences ranging from Schnabel and Borofsky to Basquiat. In computer graphics he has created his own direction and transformed his personal iconography.

He creates his images on Power PCs, using Photoshop to assemble parts from other specialized programs. For 3-D figures he uses Poser, for environments Bryce. For miscellaneous 3-D elements he uses 3D Studio Max. Occasionally he augments the images with scans, but by and large the images are painted in Photoshop, using filters to simulate surface texture mapping. He makes extensive use of plug-ins such as KPT and Alienskin. Images are done in partially transparent composite layers after basic forms have been drawn in with air brush, paint brush, and gradient fill tools. Photoshop is where the real fun happens.

He has developed a special relationship with Alien Skin and Curious Labs. His preferred way of working is to subordinate the peculiarities of each application to his overall vision, and avoid being obvious in the usage of the software. Carter has worked for Reebok, *Sports Illustrated*, Warner Brothers, Discovery Channel, and *Bloomberg Magazine*, as well as for South Peak Interactive an animator. He has also written articles for *Desktop Publishers* and *Digital Imaging* magazines. His works have been exhibited at Maxibition/New York, SIGGRAPH - Digital Salon, *HOT-WIRED*, *MacWorld*, and the *Duke University Gallery*, among others.

Greg Carter a étudié les beaux-arts et la psychologie aux Etats-Unis. Il travaille actuellement en tant qu'illustrateur et artiste free-lance. Ses travaux sont un mélange de styles traditionnels et de science-fiction, et reflètent les nombreuses techniques qu'il a développées au cours des années. Plusieurs facteurs, dont la technologie n'en est qu'un, contribuent à la création de ses images. Il est avant tout un artiste, pas un « informaticien », et se sert de l'ordinateur comme d'un outil. Son parcours artistique découle des beaux-arts, de la peinture en particulier, et est influencé notamment par Schnabel, Borofsky ou Basquiat. Il a créé sa propre direction graphique et transformé son iconographie personnelle.

Il crée ses images sur PowerPC avec Photoshop pour assembler des éléments venant d'autres programmes spécialisés. Il utilise Poser pour créer les personnages 3D et Bryce pour constituer les environnements. Il utilise également 3D Studio Max pour réaliser les différents éléments 3D. Il agrémente occasionnellement ses images de photos numérisées, mais elles sont dessinées la plupart du temps dans Photoshop à l'aide de filtres pour simuler les textures. Il fait un emploi intensif des plug-ins KPT et Alien Skin. Ses images sont réalisées en couches partiellement transparentes, dès que les formes de base sont dessinées à l'aide de l'aérographe, de pinceaux ou de dégradés.

Il a élaboré une relation spéciale avec Alien Skin et Curious Labs. Sa manière préférée de travailler est de subordonner les particularités de chaque application à sa vision globale, et d'éviter de faire un usage trop visible des logiciels. Carter a travaillé pour Reebok, *Sports Illustrated*, Warner Brothers, Discovery Channel et *Bloomberg Magazine*, et en tant qu'animateur pour South Peak Interactive. Il a également écrit des articles pour les magazines *Desktop Publishers* et *Digital Imaging*. Ses travaux ont été exposés à Maxibition/New York, SIGGRAPH - Digital Salon, *HOT-WIRED*, *MacWorld* et à la *Duke University Gallery*.

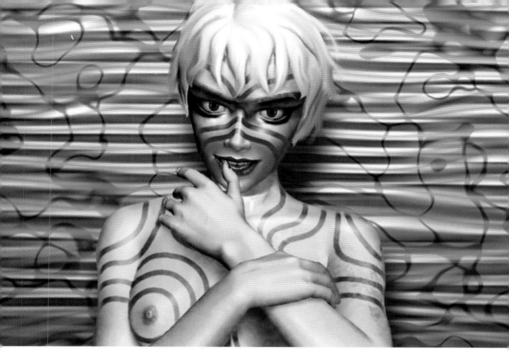

Greg Carter hat in den USA Kunst und Psychologie studiert und arbeitet freiberuflich als Illustrator und Künstler. Seine Arbeiten sind eine Mischung aus traditionellen Stilrichtungen und Sciencefiction und spiegeln die vielen Techniken wider, die er im Laufe der Jahre entwickelt hat. Zur Entstehung seiner Bilder tragen verschiedene Faktoren bei, von denen der technische Aspekt nur einer ist. In erster Linie sieht er sich als Künstler, nicht als „Computermensch", denn der Computer ist für ihn lediglich ein Werkzeug. Die darstellenden Künste, vor allem die Malerei, bestimmen seinen künst-lerischen Hintergrund: er zeigt Einflüsse von Schnabel über Borofsky bis zu Basquiat. In der Computergrafik hat er sich seine eigene Richtung und seine persönliche Bildsprache geschaffen. Er entwirft seine Bilder auf dem Apple Power-PC und nimmt Photoshop, um dort Teile aus anderen Spezialprogrammen zusammenzuführen. Für 3D-Figuren bevorzugt er Poser, für Landschaften Bryce; sonstige 3D-Elemente erstellt er in 3D Studio Max. Gelegentlich nutzt er auch Scans, aber normalerweise werden die Bilder in Photoshop gemalt und die Oberflächentexturen mit Filtern simuliert. Er verwendet ausgiebig Plug-ins wie KPT und Alienskin. Die Grundformen zeichnet er zunächst mit Airbrush-, Pinsel- und Verlaufs-Tools, dann werden die Bilder in teilweise transparenten Ebenen erstellt. Die Photoshop-Arbeiten machen Carter besonderen Spaß. Zu Alien Skin und Curious Labs hat er eine eigenwillige Beziehung entwickelt: Carters Gesamtvision steht im Vordergrund, und die einzelnen Software-pakete haben sich dieser Vision unterzuordnen, so dass ihre jeweiligen Charakteristiken nicht hervorstechen. Carter hat für Reebok, *Sports Illustrated*, Warner Brothers, Discovery Channel sowie das *Bloomberg Magazine* gearbeitet und war Animator für South Peak Interactive. Er hat außer-dem Artikel für die Magazine *Desktop Publishers* und *Digital Imaging* geschrieben. Seine Arbeiten wurden unter anderem auf der Maxibition in New York, dem SIGGRAPH-Digital Salon sowie von *HOT-WIRED, MacWorld* und *der Duke University* vorgestellt.

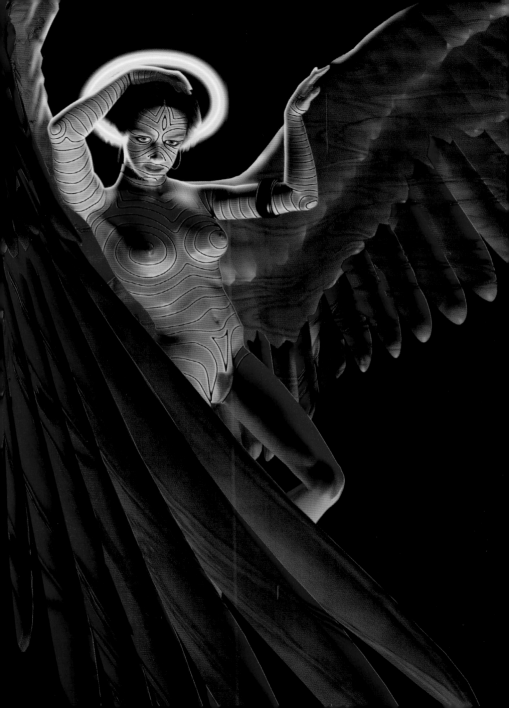

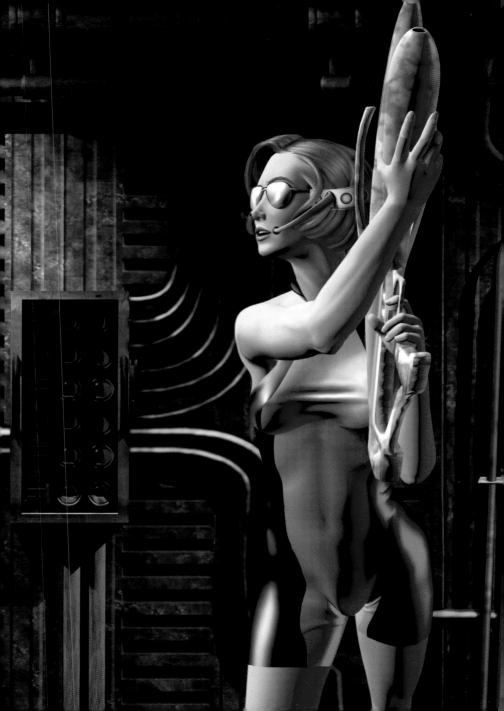

e-mail:
hid2@
pop06.odn.ne.jp

http://www2.
http://www2.ocn.
ne.jp/~hidyboy

Country:
Japan

Contact:
Shamaison-
Kamikitazawa
3F-305, 1-33-19
Kamikitazawa,
Setagaya-ku,
Tokyo, Japan
156-0057

Copyright:
© 2001 HiD
Yanaguishima

Software:
Softimage
Adobe
Photoshop
Painter
Shade

PIXEL BASED DANCERS

Yanagishima was born in Aichi province in Japan in 1969, and currently lives and works in Tokyo. He began using CG professionally when he got a position in the game industry 13 years ago. Later on, he quit his job and established the CG Studio HiD, where he focused on modelling and animation for game production companies. After four years of solo experience he returned to a big Tokyo-based game producer. Eleven years ago a personal computer magazine triggered his desire to get acquainted with 3D CG when he saw his first 3D CG picture in it. Inspired, he began by specialising in metallic textures with semi-transparent layers, then later working towards creating people after having illustrated humans on a hobby level for quite some time. Yanagishima began constructing character models using Shade after some trial experiments with other tools. Later he started creating animated works using Softimage 3D, which he also used to produce game movies. He believes there is a strong need to tap 2D skills in order to improve modelling, because in his opinion the ability to recognise forms is greatly improved by two-dimension drawing. Currently, both his work and his hobbies focus on 3-D and 2-D creations; the tools that he uses to make flat images are Painter and Adobe Photoshop. Animating characters has become part of his daily life, and interestingly almost every one of them has a feeling of dance about it – a theme that has been very much his own for a long time. Also unmistakable are the faces that recall Japanese youth, with their love of American-style clothes. The backgrounds to the two characters presented in the next pages were produced with Adobe Photoshop, which is able to create a feeling of movement.

Yanagishima est né en 1969 dans la province d'Aichi. Il vit actuellement et travaille à Tokyo. Il commence à faire du graphisme en tant que professionnel lorsqu'il obtient un emploi dans l'industrie du jeu, il y a de cela 13 ans. Il quitte son emploi quelque temps après pour créer son propre studio de modelage et d'animation, HiD, et travaille avec des grandes sociétés de production de jeux. Au bout de quatre ans, il revient travailler pour un éditeur de jeux de Tokyo. Un magazine informatique lui a donné l'opportunité de découvrir la graphisme 3D, il y a de cela onze ans. Une image 3D de ce magazine l'inspire. Il se spécialise au départ dans les textures métalliques semi-transparentes, puis démarre la création de personnages, par ailleurs un hobby depuis longtemps. Yanagishima crée maintenant ses personnages à l'aide du logiciel Shade, après avoir essayé d'autres outils, et les anime avec le logiciel Softimage 3D, utilisé aussi dans la production d'animations pour des jeux. Il pense que des connaissances 2D sont nécessaires pour améliorer le modelage et que les formes sont plus reconnaissables à partir d'images en deux dimensions. Son emploi et son hobby sont liés aux créations en 2D et en 3D, et il utilise les logiciels Painter et Photoshop pour réaliser ses images. Les personnages animés font partie de son quotidien et ont tous une attitude de danseur. C'est son thème de prédilection depuis longtemps. Les visages de ses personnages ressemblent à ceux des jeunes Japonais, mais les vêtements suivent la mode américaine.

Yanagishima wurde 1969 in der japanischen Provinz Aichi geboren. Derzeit lebt und arbeitet er in Tokyo. Während seiner Tätigkeit in der Spiele-Industrie begann er 1988 mit CG zu arbeiten. Später gründete er das CG-Studio HiD und konzentrierte sich auf Modellierung und Animation für Spiele-Hersteller. Nach vier Jahren Selbstständigkeit kehrte er kürzlich zu einem der großen Spiele-Hersteller zurück. Einem PC-Magazin ist es zu verdanken, dass Yanagishima vor elf Jahren zur 3D-Computergrafik fand. Inspiriert durch ein 3D-Bild in einer Zeitschrift, spezialisierte er sich zunächst auf semi-transparente Metallic-Texturen und machte sich später daran, Menschen zu erschaffen – das Zeichnen des menschlichen Körpers war lange sein Hobby gewesen. Er erstellt

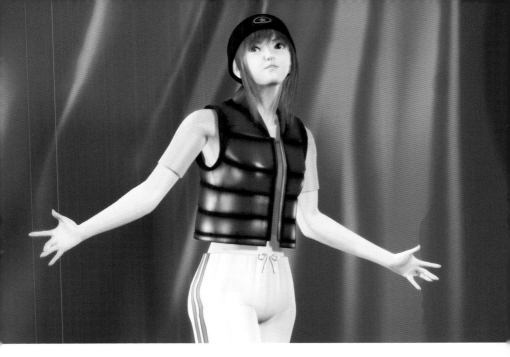

seine Charaktere mit Shade, hat aber auch mit anderen Tools Erfahrungen gesammelt.
Bei den Animationen, deren Produktion er bald darauf aufnahm, benutzte er Softimage 3D, ein Programm, das er auch zur Produktion von Filmszenen in Spielen verwendete. Seiner Meinung nach muss man gute 2D-Kenntnisse haben, um das Modellieren optimieren zu können, denn die Fähigkeit, Formen zu erkennen, werde durch das Zeichnen in zwei Dimensionen deutlich verbessert. Momentan konzentriert er sich sowohl in seiner Arbeit als auch hobbymäßig auf 3D- und 2D-Kreationen. Als Tools für flächige Bilder benutzt er Painter und Adobe Photoshop. Die Animation von Charakteren ist mittlerweile Teil seines täglichen Lebens, und fast alle wirken, als würden sie tanzen – ein Thema, das ihn seit langem beschäftigt. Ihre Gesichter erinnern an japanische Jugendliche, ihre Kleidung an deren Vorliebe des amerikanischen Stils. Den Hintergrund der beiden auf den folgenden Seiten abgebildeten Charaktere hat Yanagishima mit Adobe Photoshop erstellt, um das Gefühl der Bewegung zu vermitteln.

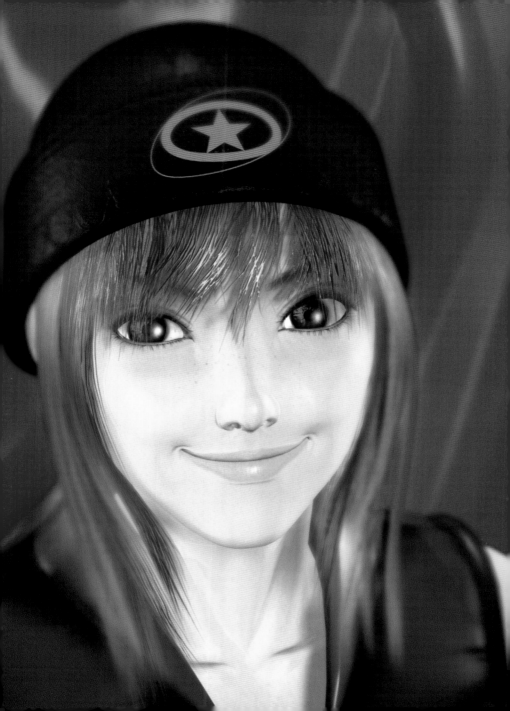

e-mail: http://www002. Country: Contact: Copyright: Software:
hir@pc4.so- upp.so-net.ne.jp Japan 1-3-4-202 © 1994-2001 Maya
net.ne.jp /cfh/ Sekimachi-kita, Cyberfactory-H Strata 3D Pro
 Nerima-ku, Tokyo Hiro Nakano Adobe
 177-0051 Photoshop

INTERACTIVE GAME BABES

Hiro Nakano was born in 1968 in Tokyo, Japan. He graduated from Chubi Central Art School in 1991, and is currently a lecturer on three-dimensional computer graphics modelling at Niigata Design School. At present he is mainly interested in images that combine original mechanisms and characters in order to convey his own personal view of a virtual world. His goal is to produce a creative multi-layered world in which he will be able to further expand his work by drawing on such resources as digital movies and the internet. He currently uses a Macintosh system together with Strata3D Pro and Photoshop software.

Nakano is always looking for original views of the world, and with this in mind he started creating a series of beauties in 1994. In his search for the original 3-D characters necessary for his interpretation of the new world, he came up against the challenge of working with 3-D software to model artificial bodies. Since few creators were working at that time on the concept of modelling digital beauties, it was impossible for him to find any references. As a result, he developed his own style after learning basic figure modelling techniques.

In those days, the characters (known as "beauties" in Japan) in comics and other animation forms were first moulded into 3-D objects that have a special aesthetic charm. These were then transformed into 2-D characters, original objects with realistic, beautifully shaped proportions and smooth heads void of any such details as nostrils. Hiro Nakano picked up on the originality of these figures and started introducing his own characters. Once the direction had been determined, making beauties using 3-D software progressed naturally. Today, he is a much- published professional in Japan, with his characters featured widely in the print media, including *Digital Image Gallery 1996-2001*, *Virtual Beauty: How to Make a Complete Beauty 2*, *Strata Bakyuun!*, *Strata Star*, *CG Arts Gallery*, and others.

Hiro Nakano est né en 1968 à Tokyo au Japon. En 1991, il sort diplômé de l'école des beaux-arts Chubi et donne aujourd'hui des conférences sur le modelage en 3D à l'école de design Niigata. Son centre d'intérêt actuel favorise les images combinant des mécanismes et des personnages reflétant sa vision personnelle d'un monde virtuel. Son but est de produire un monde complexe dans lequel il peut s'épanouir grâce aux films numériques et à Internet. Il utilise actuellement un ordinateur Macintosh équipé des logiciels Strata3D Pro et Photoshop.

Hiro Nakano est toujours à la recherche de visions originales du monde, et c'est sur la base de ce raisonnement qu'il crée une série de beautés en 1994. A la recherche de personnages 3D originaux nécessaires à son interprétation du monde nouveau, il s'attelle à la tâche difficile de travailler avec des logiciels 3D pour modeler des corps artificiels. Peu de créateurs travaillant alors sur le concept des beautés numériques, il lui est impossible de trouver des références. Il devra développer son propre style après avoir appris les techniques de modelage de base.

A cette époque, les personnages des dessins animés et d'autres formes d'animation (appelés des « beautés » au Japon) sont d'abord modelés en objets 3D dans des plastiques spéciaux. Ils sont transformés en personnages 2D partiels, mais conservent des caractéristiques réalistes. Leurs proportions sont agréablement déformées et les visages ne possèdent pas de détails tels que les narines. Hiro Nakano mise sur son originalité pour créer ses propres personnages. Une fois la direction déterminée, la création des personnages à l'aide de logiciels 3D progresse naturellement. Aujourd'hui, Hiro Nakano est un professionnel dont les personnages sont largement publiés au Japon dans de nombreux ouvrages tels que *Digital Image Gallery 1996-2001*, *Virtual Beauty: How to Make a Complete Beauty 2*, *Strata Bakyuun!*, *Strata Star* et *CG Arts Gallery*.

Hiro Nakano wurde 1968 in Tokyo geboren. Er absolvierte die Chubi Central Art School, die er 1991 abschloss, und ist heute an der Niigata-Designschule Dozent für 3D-Modellierung. Momentan gilt sein Hauptinteresse Bildern, deren Kombination aus Techniken und Charakteren seine persönliche Sicht einer virtuellen Welt darstellen. Sein Ziel ist es, ein vielschichtiges, kreatives Universum zu erschaffen, in dem er seine Arbeiten mithilfe von Digitalfilmen und dem Internet weiter ausdehnen kann. Zurzeit benutzt er einen Macintosh mit Strata 3D Pro und Photoshop.

Hiro Nakano strebt ständig nach originellen Perspektiven, aus denen er die Welt betrachten kann, mit diesem Motiv begann er 1994 seine Serie von „Beauties". Auf der Suche nach 3D-Charakteren für diese persönliche Sicht seiner neuen Welt fing er an mittels 3D-Software künst-liche Körper zu modellieren. Damals arbeiteten nur wenige Künstler an Digital Beauties, weswegen keinerlei Vorlagen existierten. So erlernte er die Grundlagen des Figurenmodellierens und ent-wickelte anschließend seinen eigenen Stil.

Damals wurden die Charaktere in Comics und anderen Animationsformen in Japan „Beauties" genannt zunächst als 3D-Objekte mit einem besonderen ästhetischen Charme geformt. Sie wurden dann in 2D-Charaktere verwandelt, in Objekte mit realistischen, wunderschön modellierten Proportionen und Köpfen ohne Details wie zum Beispiel Nasenlöchern. Nakano setzte bei dieser Originalität an und fügte nach und nach eigene Charaktere hinzu. Nun war die Richtung eingeschlagen und die Arbeit an den Beauties entwickelte sich organisch weiter.

Heute ist Hiro Nakano ein in Japan viel veröffentlichter Profi, und seine Charaktere sind fast überall zu finden: in *Digital Image Gallery 1996-2001*, *Virtual Beauty: How to Make a Complete Beauty 2*, *Strata Bakyuun!*, *Strata Star*, *CG Arts Gallery* etc.

INO KAORU

e-mail:
inokaoru
@hotmail.com

http://www1.
odn.ne.jp/ino/

Country:
Japan

Contact:
Wakabaku,
Chiba-shi
Chiba 264-0023

Software:
Picture Publisher

DIGITAL MANGA

It has been eight years since Ino Kaoru began drawing pictures on the computer. The advances in the manga magazines in Japan allowed many artists like him to change their production system. Manga comics constitute one of the most traditional schools in the country, and have influenced all the new generation of computer graphics. His first computer was a PC 9801, with a 16 colour environment and a top on-screen output of 800 x 600 dots. Since then, he has experienced increasing pleasure in the field of CG as both machines and software have improved. A photograph is usually enough to start with when producing his beautiful female characters. However, the characters in his computer-generated pictures often have elements like horns or wings that are rarely encountered in normal photographs. CG has not only been the central focus of his creative work, but also his most important tool. The speed and convenience of present-day computers allow him to draw the full benefit from the digital process. Kaoru mainly uses Picture Publisher software. His approach to composing CG images consists in making the elements, such as eyes, eyebrows, eyelashes, nose and mouth, in different layers. In extreme cases he has made up to 300 elements for one single picture, but thankfully the software has allowed for such extremes and requires little memory to run the file. He also finds he can expresses his ideas well by combining the effects of elements and filters - a typical method in CG work. When composing textures, he always works directly in the computer, which is faster and far more accurate than hand drawing on paper. Ino Kaoru's language is very much two-dimensional, so that all the works produced for the manga magazines keep their feelings and expressions, even though printed in black and white.

Cela fait huit ans qu'Ino Kaoru dessine des images sur ordinateur. L'avancée des mangas au Japon a permis à de nombreux artistes de tenter leur chance dans le domaine de la production. Les mangas sont une des écoles les plus traditionnelles de ce pays et ont influencé la nouvelle génération de graphistes. Son premier ordinateur est un PC 9801 en 16 couleurs et d'une résolution d'écran maximale de 800 x 600. Il a pris grand plaisir à réaliser des images depuis, grâce à l'avancée des machines et des logiciels. Pour produire ses images de jolies femmes, une photo suffit comme point de départ. Le graphisme sur ordinateur lui permet d'exprimer des choses impossibles à voir sur une photo, telles que des femmes dotées de cornes ou d'ailes. Le graphisme est un outil et non le thème principal de ses créations. Ses avantages et la vitesse lui permettent d'utiliser des processus numériques et d'en bénéficier. Ino Kaoru utilise principalement le logiciel Picture Publisher. Sa méthode de création consiste à créer de nombreux objets sur des calques, tels que les yeux, les sourcils, les cils, le nez et la bouche. Dans les cas les plus extrêmes, il a créé jusqu'à 300 objets pour une seule image, puisque Picture Publisher le permet et ne consomme pas trop de mémoire. Il exprime également ses concepts à l'aide d'effets de composition et de filtres. Ce sont des processus typiques pour exprimer les textures des objets, ce qui est plus rapide et plus précis que les dessins à la main sur papier. Ino Kaoru s'exprime surtout en deux dimensions, et tous ses travaux produits pour les mangas ont gardé ses sentiments et ses expressions, même après avoir été transformés en noir et blanc.

Ino Kaoru hat vor acht Jahren begonnen, Bilder am Computer zu kreieren. Sein Erfolg in den japanischen Manga-Comic-Magazinen ermöglichte es ihm wie vielen anderen Künstlern, sich eigene Produktionssysteme anzuschaffen. Manga Comics gehören zu den traditionsreichsten *Comics* im Land und haben die gesamte neue Generation der Computergrafik beeinflusst. Ino Kaorus erster Computer, ein PC 9801, bot eine Bildschirmauflösung von 800 x 600 Punkten bei 16 Farben. Dank des Fortschritts in Hard- und Software ist sein

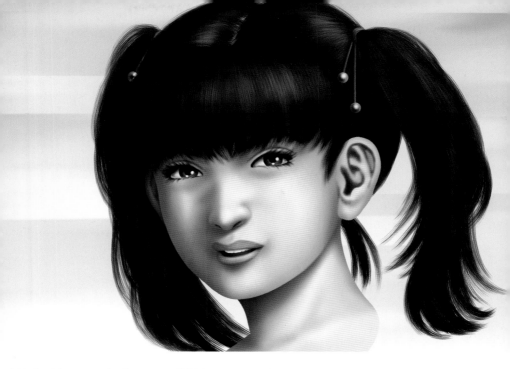

lebhaftes Interesse an der Computergrafik bis heute ungebrochen.

Für seine bildhübschen weiblichen Charaktere reicht ein Foto als Ausgangspunkt. Da computergenerierte Bilder Darstellungen erlauben, die weit über die Möglichkeiten von Fotos hinausgehen, kann Ino Kaoru seine weiblichen Figuren zum Beispiel auch mit Hörnern oder Flügeln ausstatten. CG ist nicht nur sein zentrales Arbeitsgebiet, sondern auch sein wichtigstes Werkzeug – außerdem profitiert er von der Bedienerfreundlichkeit und Schnelligkeit aktueller Rechner. Ino Kaoru benutzt besonders häufig Picture Publisher. Er erstellt viele Objekte, wie Augen, Brauen, Wimpern, Nase und Mund, in Schichten. Im Extremfall entwickelt er fast 300 Objekte für ein einziges Bild; mit Picture Publisher ist dies jedoch mit wenig Speicherplatz möglich. Er kombiniert die Effekte von Objekten und Filtern, eine typische Methode im CG-Bereich. Auch die Texturen erstellt er mit dem Computer präziser und schneller als von Hand auf Papier. Ino Kaorus Sprache ist eher zweidimensional orientiert; daher bleiben die Atmosphäre und die Gesichtsausdrücke seiner für die Manga-Magazine produzierten Arbeiten – auch wenn sie in Schwarz-Weiß übertragen werden – erhalten.

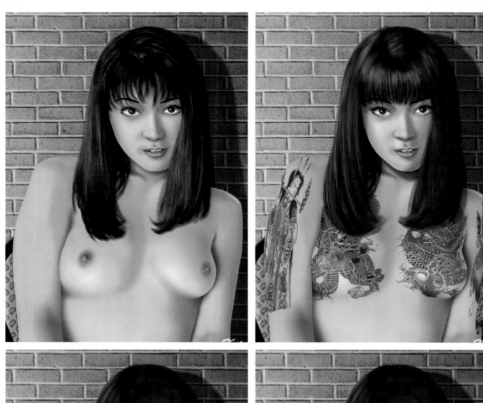
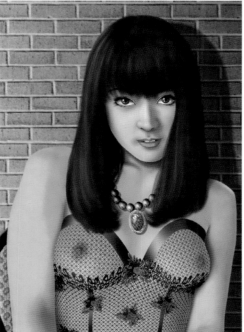
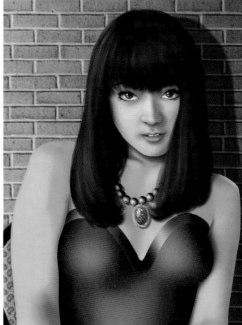

JUNKO KUBOTA

e-mail:	http://www7.	Country:	Contact:	Copyright:	Software:
june020 @big.or.jp	big.or.jp /~june020/	Japan	171-0021 3-7-20-204 Nishi Ikebukuro, Toshimaku, Tokyo	© 2002Junko Kubota	3D Studio Max Adobe Photoshop

EUROPEAN MEDIEVAL FROM JAPAN

Junko Kubota was born in 1970 in Ehime Prefecture, Japan. She studied oil painting and graduated from Tama Art University. In the early days of CG, she used an AMIGA on her video art and authoring. Her experimental interactive work for the CD-ROM *Four-Sight* was released by Synergy Geometry. (It was also exhibited at Milia, the largest international trade fair for multimedia in Europe.) Later, she took part in "The Public Trial - Kinetics of Criminal Psychology" as a CG staff member. She has been active as a freelance 3DCG artist in Japan since 2000. In an attempt to move and animate the images she had previously put on canvas, Kubota began to create her own 3DCG after realising that it was the cutting-edge resource for new professionals. No different to the original CG professionals, artists with traditional fine arts backgrounds embraced this new media and developed their own language for it. Kubota's first references when coming up with a concept are photographs or picture collections. She then utilises Metasequia modelling software to construct the person's body, and imports the finished data for the human body model into 3D Studio Max. This is also used to create clothing, hair and other small elements. After the basic figure is complete, Character Studio, the 3D Studio Max plug-in, is used to determine the posture, place figures, set the minor parameters and render. Rendering is usually a repetitive exercise done for the purpose of fine adjustment. The rendered data is then imported into Photoshop to undergo colour adjustment. Kubota sometimes creates an illusionary effect in her works by introducing a mysterious environment, where 2-D and 3-D coexist. Junko Kubota's works have been published in leading printed media, such as *Designer's Workshop, Graphics World, CG World, CD-ROM FAN, MEDIAFRONT, ASAHI Personal Computer Magazine, FOCUS Magazine, Ehime Shimbun*, and others.

Junko Kubota est née en 1970 à la préfecture d'Ehime au Japon. Elle a étudié la peinture à l'huile et a obtenu un diplôme de l'université des beaux-arts Tama. Au début du graphisme sur ordinateur, elle utilise un Amiga pour créer des images. La partie interactive du CD-ROM *Four-Sight*, édité par Synergy Geometry, est le résultat de cette tentative. (Il a également été présenté au Milia, le plus important salon multimédia international d'Europe.) Elle prend ensuite part au projet The Public Trial – Kinetics of Criminal Psychology, en tant que graphiste. Elle travaille depuis 2000 comme graphiste 3D free-lance au Japon.
Dans une tentative d'animer ses images peintes auparavant sur toile, Junko Kubota s'essaie au graphisme 3D après avoir réalisé que le graphisme est la ressource de pointe disponible pour les professionnels. Peu différents des véritables professionnels du graphisme, les artistes de formation traditionnelle adoptent ce nouveau support et développent leurs propres techniques.
Junko Kubota se réfère d'abord à des photos ou des collections d'images pour déterminer un concept. Elle utilise le logiciel de modelage Metasequia pour réaliser le personnage qu'elle importe ensuite dans 3D Studio Max. Ce logiciel est également utilisé pour créer les vêtements, les cheveux et autres accessoires. Lorsque le personnage est terminé, Character Studio, un plug-in de 3D Studio Max, est utilisé pour déterminer la pose, placer les objets et effectuer le rendu. La phase du rendu est souvent un exercice répétitif pour déterminer les meilleurs ajustements. L'image est ensuite ouverte dans Photoshop pour recevoir les ajustements couleur. Elle crée souvent un effet d'illusion en ajoutant un espace mystérieux où la 2D et la 3D coexistent.
Les travaux de Junko Kubota ont été publiés dans des publications importantes telles que *Designer's Workshop, Graphics World, CG World, CD-ROM FAN, MEDIA FRONT, ASAHI Personal Computer Magazine, FOCUS Magazine* et *Ehime Shimbun*.

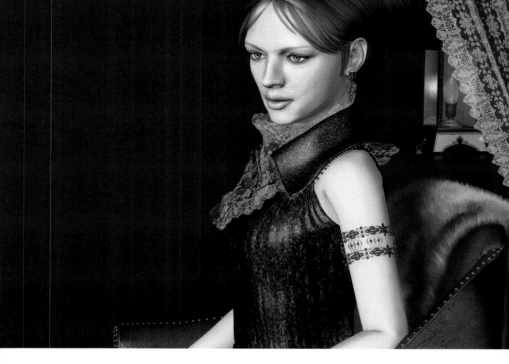

Junko Kubota wurde 1970 in der Nähe von Ehime (Japan) geboren. Sie studierte an der Tama Art University und machte ihren Abschluss in Malerei. In der Anfangszeit der Computergrafik benutzte sie für ihre Videokunst einen Amiga. Die interaktiven Arbeiten aus ihren Kunstexperimenten wurden auf der CD-ROM *Four-Sight* (Synergy Geometry) veröffentlicht und auf der Milia, der größten internationalen Multimediafachmesse in Europa, ausgestellt. Später war sie als Computergrafikerin an dem Projekt "The Public Trial – Kinetics of Criminal Psychology" beteiligt. Seit 2000 arbeitet sie als freiberufliche 3D-Grafikerin.

Um die Bilder, die sie zuvor auf der Leinwand realisiert hatte, bewegen und animieren zu können, begann Junko Kubota selbst, 3D-Computer-grafiken zu erstellen; sie hatte erkannt, dass immer mehr Spezialisten diese Hilfsmittel nutzten. Wie die CG-Profis übernahmen auch Künstler mit klassischem Hintergrund dieses neuartige Medium und entwickelten darin ihre eigene Sprache.

Junko Kubota geht gewöhnlich von Fotos oder Bildersammlungen aus, um ein Konzept zu entwerfen. Mit Metasequia modelliert sie den menschlichen Körper. Sie importiert die Modell-daten nach 3D Studio Max und entwickelt dort Kleider, Haare und weitere Elemente. Ist die Basisfigur fertig gestellt, benutzt Junko Kubota Character Studio, ein 3D Studio Max Plug-in, um Posen festzulegen, Figuren zu platzieren und das Rendern zu steuern. Das Rendern ist lediglich ein repetitiver Vorgang zur Feinabstimmung. Die gerenderten Daten werden dann zur Farbab-stimmung in Photoshop importiert. Manchmal erzeugt Junko Kubota in ihren Arbeiten einen illusionistischen Effekt, indem sie einen mysteriösen Grenzbereich schafft, in dem 2D und 3D nebeneinander existieren. Junko Kubotas Arbeiten wurden in führenden Printmedien wie *Designer's Workshop*, *Graphics World*, *CG World*, *CD-ROM FAN*, *MEDIA FRONT*, *ASAHI Personal Computer Magazine*, *FOCUS Magazine*, *Ehime Shimbun* und anderen veröffentlicht.

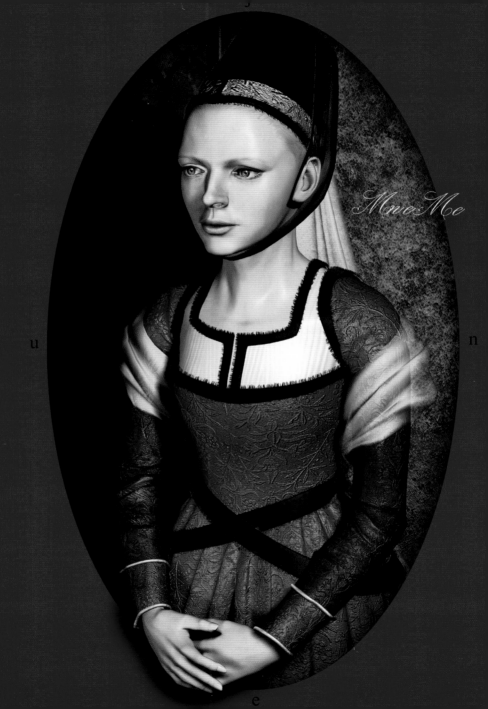

e-mail:	http://	Country:	Contact:	Copyright:	Software:
JYL	users.swing.be	Belgium	Bvd d'Avroy,	© JYL	Adobe
@swing.be	/JYL		238a,		Photoshop
			bte 43 Liège		

DIGITAL FEMME FATALE

Jean-Yves Leclercq was born in Mons, Belgium, in 1971. He was professional airline pilot for a major Belgian Airline, but had suddenly to stop due to a health problem. He now works part time as a flight dispatcher and draws in his free time. He has always drawn, and though he has some formal art training, he is mostly an autodidact. He began with traditional airbrush five years ago, but dropped it when he discovered computer graphics in 1999.
He always starts from a picture. He shoots the theme from which he wants to make the illustration using a digital camera, the perfect tool for quickly transferring an image to the computer. He then makes free-hand sketches, and modifies the proportions and eventually some details or accessories. The basic sketch is enlarged from A4 to A3, or even to A2 to work on the details. Outlines are scanned and then coloured in Photoshop. He uses a Wacom A4 graphic tablet to simulate a more natural drawing and colouring approach.
It takes about 40 hours to color a 300 DPI image. The technique is very similar to airbrush, with the advantage being that one can save masks and work on multiple layers. The most difficult work is the pencil drawing, for it is decisive for image quality. The rest is just a matter of patience and working gradually at each step.
Leclercq has published his entire works in the French magazine *Taboo* and his images have been used by the Web site provider *Cybermedia.NL*. His work has also been featured in Web galleries such as *www.fantasya.net* and *www.erotixart.com*.

Jean-Yves Leclercq est né en 1971 à Mons en Belgique. Il fut pilote de ligne pour une importante compagnie aérienne belge, mais dut interrompre son activité pour des raisons de santé. Il travaille maintenant à mi-temps comme aiguilleur du ciel et dessine pendant son temps libre. Il a toujours dessiné, et est essentiellement autodidacte, bien qu'il ait eu une formation artistique. Il abandonne l'aérographe de ses débuts lorsqu'il découvre le graphisme sur ordinateur en 1999.
Son travail démarre toujours à partir d'une photo. Il capte le thème qu'il souhaite donner à son illustration avec un appareil photo numérique, l'outil parfait pour transférer rapidement des photos sur ordinateur. Il réalise ensuite des esquisses à main levée, modifie les proportions et éventuellement certains détails ou accessoires. L'esquisse est agrandie d'A4 en A3 ou en A2 pour faciliter la retouche des détails, puis les contours sont numérisés et mis en couleur dans Photoshop. Il utilise une tablette Wacom A4 pour simuler un dessin et un coloriage plus naturels.
Il passe environ 40 heures à mettre une image 300 dpi en couleur. Sa technique est très similaire à l'aérographe, avec l'avantage en plus de pouvoir enregistrer des masques et travailler sur plusieurs couches. Le plus difficile est le dessin au crayon ; la qualité de l'image en dépend entièrement. Le reste n'est qu'une question de patience et de travail graduel à chaque étape.
Leclercq a publié tous ses travaux dans le magazine français *Taboo* et ses images ont été utilisées par le fournisseur de sites Web *Cybermedia.NL*. Ses travaux ont été exposés dans des galeries Web telles que *www.fantasya.net* et *www.erotixart.com*.

Jean-Yves Leclercq wurde 1971 im belgischen Mons geboren. Er war Pilot einer großen belgi-schen Fluglinie, musste seine Stelle jedoch wegen gesundheitlicher Probleme aufgeben. Heute arbeitet er in der Flugabfertigung und zeichnet in seiner Freizeit. Trotz einer gewissen künstlerischen Schulung ist er vor allem Autodidakt. Vor fünf Jahren begann er mit traditionellem Airbrushing, entdeckte aber 1999 die Computergraf:k.
Seine Arbeit beginnt immer mit einem Foto. Er fotografiert das Thema der geplanten Illustration mit einer

Digitalkamera – dem perfekten Werkzeug, um ein Bild schnell auf den Computer zu übertragen. Dann fertigt er Handskizzen an und modifiziert die Proportionen und Details oder Accessoires. Zur Ausarbeitung der Details vergrößert er die Grundskizze von A4 auf A3 oder sogar auf A2. Die Umrisse scannt Leclercq ein und koloriert sie dann in Photoshop. Er benutzt ein Wacom-A4-Grafiktablett, um Zeichenstil und Farbgebung natürlich wirken zu lassen.

Für das Colorieren eines 300-dpi-Bildes benötigt er etwa 40 Stunden. Die Technik ähnelt der des Airbrush, hat jedoch den Vorteil, dass man weniger Schablonen benötigt und mit mehreren Schichten arbeiten kann. Der anspruchsvollste Arbeitsschritt ist das Bleistiftzeichnen – die Qualität des Bildes hängt vollständig davon ab. Der Rest ist lediglich eine Geduldsfrage und erfordert eine kontinuierliche Arbeitsweise.

Leclercqs Arbeiten wurden in der französischen Zeitschrift *Taboo* veröffentlicht, vom Website-Provider *Cybermedia.NL* benutzt und sind außerdem in Webgalerien wie *www.fantasya.net* und *www.erotixart.com* zu sehen.

KAKOMIKI

e-mail:
gomap
@sf6.so-net.ne.jp

http://www003.
upp.so-net.ne.jp/
kakomiki/

Country:
Japan

Contact:
Park Hights #103,
1-12-5
Shinmaikohigashi
machi, Chita-shi,
Aichi, 478-0036

Copyright:
© Kakomiki

Software:
Shade
Adobe
Photoshop

CYBER ELECTRIC POP STARS

Kakomiki has mainly created his female 3DCG characters as a hobby, while his actual full-time work requires him to operate highly technical machinery at a printing company in Japan. He created his model Sayaka as the embodiment of his ideal woman, with sweet-looking eyes, a slender body and an innocent air. In short, the epitome of the young Japanese schoolgirl. Kakomiki developed Sayaka with the aim of having a completely digital model that can interact and participate any medium. Once he has finalised all the basic steps to create his figure, such as detailed modelling, and creating suitable texture maps and a range of exclusive accessories, the next step is to make his virtual idol fully animated. It took over two months to produce the first samples, and the animation steps take even longer.

Like most Japanese artists who have embraced 3-D, Kakomiki uses Shade software for all the modelling, texturing and rendering. The post-work in 2-D is done with Adobe Photoshop, where he can correct colours, adjust lights and enhance individual elements, and render them with greater precision. Even though Shade gives the work a very detailed and finalised look, a digitally generated model never loses the appearance of being a CG-produced image. This has not proved a problem in Japan because the market and the consumers have accepted and fostered virtual people for some years now. Sayaka is no different, and she finds it perfectly normal to be treated as a real person.

Kakomiki réalise principalement des personnages 3D féminins pendant ses loisirs. Il travaille sur des équipements d'impression hautement techniques dans une imprimerie au Japon. Kakomiki a développé le personnage Sayaka pour permettre à un modèle entièrement numérique d'interagir et évoluer sur tous les supports. Le personnage est d'abord modelé en détail, habillé de textures et d'accessoires exclusifs ; puis l'étape suivante consiste à animer cette idole virtuelle. Comme de nombreux artistes japonais réalisant des travaux en 3D à des fins non professionnelles, Kakomiki utilise le logiciel Shade pour effectuer le modelage, l'habillage et le rendu. La post-production 2D est réalisée avec Photoshop pour corriger les couleurs, ajuster l'éclairage et améliorer les parties sur lesquelles le rendu n'est pas suffisamment précis. Le modèle Sayaka reflète l'idéal féminin de Kakomiki ; un regard doux, un corps délicat et un air d'innocence. Ses travaux sont également la représentation caractéristique des écolières japonaises.
Le logiciel Shade est particulièrement adapté au modelage et au rendu. Bien que le résultat obtenu soit très détaillé, un modèle numérique ressemble encore à une image graphique. Au Japon, ce n'est pas un problème car le marché accepte les personnages virtuels depuis plusieurs années. Sayaka n'échappe pas à cette règle et est traitée comme une véritable personne. La production des premières images a pris plus de deux mois de travail et la phase d'animation en prendra encore plus.

Seine weiblichen 3D-Computergrafik-Charaktere sind für Kakomiki vor allem eine Freizeitbeschäftigung; beruflich ist er in einer japanischen Hightech-Druckerei tätig. Kakomiki schuf die Figur „Sakaya" als Verkörperung seiner Idealfrau: mit sanften Augen, schlanker Figur und unschuldigem Lächeln – kurz, als Ebenbild des japanischen Schulmädchens. Er har Sakaya in der Absicht entwickelt, eines Tages über ein voll funktionsfähiges digitales Model zu verfügen, das in sämtlichen Medien integriert und eingesetzt werden kann. Dazu muss sein Virtual Idol animiert sein, und Kakomiki schließt gerade die dazu notwendigen Basisarbeiten ab: detailliertes Modellieren, passende Texture-Maps und exklusive Accessoires. Es dauerte über zwei Monate, bis die ersten Muster fertig waren, und die Animationsarbeiten werden sogar noch aufwändiger sein.

Wie die meisten japanischen Künstler, die im 3D-Bereich tätig sind, verwendet auch Kakomiki Shade zum Modellieren, Texturieren und Rendern. Die Nachbearbeitung in 2D erfolgt in Adobe Photoshop; hier korrigiert er Farben, passt das Licht an und arbeitet Details präzise heraus.

Shade eignet sich besonders gut zum Rendern und Modellieren, die Arbeiten sehen perfekt und detailgenau aus. Zwar wirken auch digital generierte Modelle nach wie vor computererzeugt, aber in Japan ist dies unproblematisch, da Markt und Verbraucher virtuelle Menschen schon lange akzeptieren und mögen – Sayaka wird wie ein natürlicher Mensch behandelt.

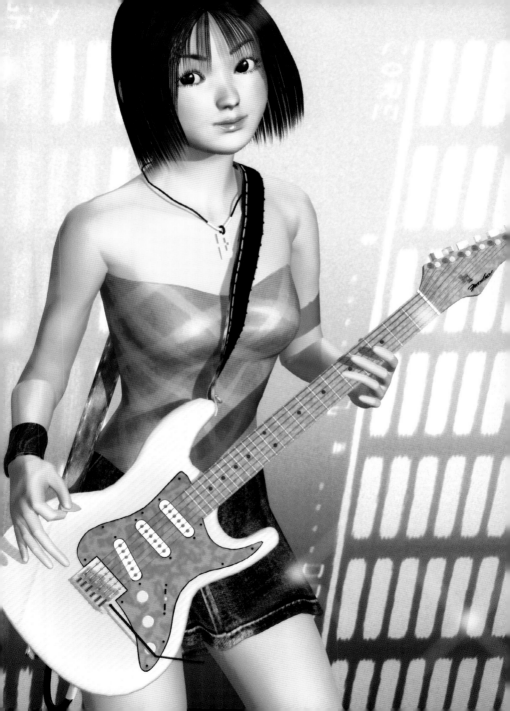

e-mail:	http://www.	Country:	Copyright:	Software:
nemopo	din.or.jp	Japan	© Kazuaki	Metasequia
@din.or.jp	/~nemopo/		Nemoto	

CYBER TEENAGERS

She does not have a name yet. She is still an obscure actress, but her designer hopes that soon she will be famous and one day the greatest star worldwide. Her creator, Kazuaki Nemoto, has always thought in terms of fame with regard to the CG market in Japan, and his characters presented in the next pages are already starting to move in that direction.

Nemoto's main task as a professional has been creating graphics for computer games and selling them to large game distributors. In this way, he uses both 2-D and 3-D applications to construct cars, backgrounds, accessories, and parts of characters. The original prototype of the young digital model was born in spring 1999, and was Nemoto's first 3DCG creation. It was too ugly at first to be specified as a female, or even a human, but with consecutive improvements her appearance grew more pleasing.

For his digital beauty, Nemoto uses the modelling software Metasequia. In order to capture the uneven surface of a human's face, the wrinkles, shape of ears, and pattern of eyebrows, he studied his own face by looking in a mirror. However, his finished work has anything but that appearance. The model is totally 3-D generated, which is already extremely time-consuming when the artist goes into even the minimum of details. And the closer the image gets to a real human being, the further artists like Nemoto want to go in building a new world of real super-models. Elements in the human body such as ears, nose, eyes and the like are still difficult to reproduce accurately, not to mention movement, facial expressions, speech and so on. Working non-stop, Kazuaki Nemoto keeps trekking on to revolutionise the field.

Elle n'a pas encore de nom. C'est une actrice inconnue, mais son concepteur espère qu'elle deviendra une star et peut être la plus renommée dans le monde entier. Kazuaki Nemoto, son créateur, a toujours pensé que ses personnages connaîtront la gloire sur le marché du graphisme japonais. Sa tâche principale en tant que professionnel a été de créer des images pour des jeux et de les vendre à des distributeurs. Il utilise ainsi des applications 2D et 3D pour créer des voitures, des paysages, des accessoires et des parties de personnages. Le prototype d'origine du jeune modèle numérique est né début 1999. C'est la première création graphique 3D de Nemoto, trop laide au départ pour ressembler à une femme ou même à un être humain. Il travaille dur pour améliorer son apparence et utilise le logiciel de modelage Metasequia pour créer sa beauté numérique. Pour dépeindre la surface inégale d'un visage humain, les rides, la forme des oreilles et la répartition des sourcils, il étudie ces détails sur son propre visage dans le miroir. Son œuvre ne lui ressemble pourtant pas du tout. Le modèle est totalement généré en 3D, ce qui est une tâche extrêmement longue si l'artiste peaufine ces détails. Plus les images ressemblent à de véritables humains, plus des artistes comme Kazuaki Nemoto veulent créer un nouveau monde de modèles super-réels. Les zones de notre corps, telles que les oreilles, le nez, les yeux et autres, sont encore difficile à reproduire fidèlement, ainsi que les mouvements entraînés par l'expression, la parole, etc. Sans cesser de travailler, Nemoto continue sa révolution.

Sie hat noch keinen Namen. Heute ist sie eine unbekannte Schauspielerin, aber ihr Designer hofft, dass sie eines Tages ein Star und weltberühmt sein wird. Ihr Schöpfer, Kazuaki Nemoto, hat seine Arbeit stets unter dem Gesichtspunkt betrachtet, sich auf dem japanischen Computergrafik-Markt einen Namen zu machen. Die auf den Folgeseiten dargestellten Charaktere sind ein erster Schritt in diese Richtung.

Nemoto produziert Illustrationen für Computerspiele und verkauft sie an große Hersteller. Er benutzt 2D- und 3D-Anwendungen, um Autos, Hintergründe, Accessoires und Teile der Charaktere zu erstellen. Der ursprüngliche

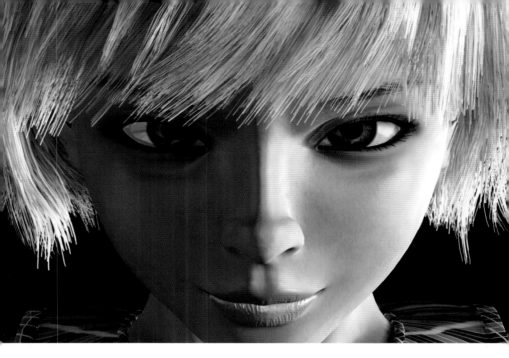

Prototyp des jungen Digitalmodells wurde im Frühjahr 1999 geboren und war Nemotos erstes mit 3D-Computergrafiker geschaffenes Werk. Die Figur war zu hässlich, um als weiblich oder auch nur als menschlich bezeichnet werden zu können, aber er arbeitete daran, und nach und nach wurde ihre Erscheinung immer hübscher. Nemoto benutzt für seine Digital Beauty Metasequoia. Um die Unebenheiten eines menschlichen Gesichts, Falten, die Form der Ohren und den Augenbrauenschwung abzubilden, studiert er sein eigenes Gesicht im Spiegel; die fertige Arbeit sieht ihm jedoch kein bisschen ähnlich. Das Modell ist vollständig 3D-generiert – eine extrem zeitraubende Angelegenheit, wenn der Künstler sehr detailgetreu arbeitet. Je mehr die Bilder echten menschlichen Wesen ähneln, desto mehr reizt es Künstler wie Kazuaki Nemoto, eine neue Welt der hyperrealen Models zu schaffen. Immer noch lassen sich einige Körpeteile wie Ohren, Nase oder Augen sowie Bewegungen, Gesichtsausdrücke, Sprache etc. nicht präzise reproduzieren, aber der unermüdlich arbeitende Nemoto hat seine Fähigkeiten noch längst nicht ausgeschöpft.

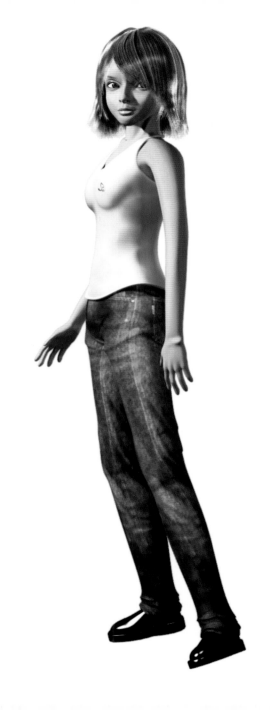

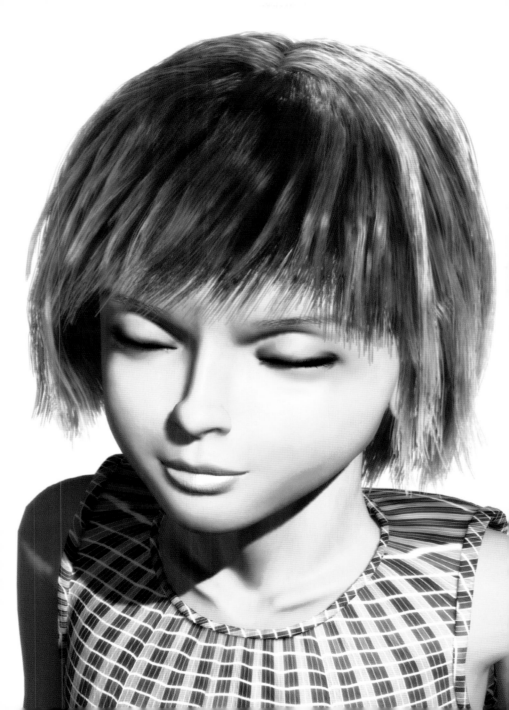

DIGITAL ACTIVE TEENAGERS

Yoshimizu was born in Tokyo in 1973. He graduated with a degree in economics from Nihon University and started at Namco, one of the leading game companies in the world, in 1997. Since then, he has been involved in the production of art and animation for many world famous games on CD, including *Rage Racer*, *Klonoa*, *Ace Combat*, and *R4-Ridge Racer*. Among the several short stories he has also published is the popular Japanese comic book *Peanuts*. Yoshimizu expresses great confidence that characters created by 3DCG will be widely popular in the near future. He feels that this will make a pleasant contrast to the obscurity of the field in the early 90s, at the time when he began to design. He grew up in the 80s, when the computer game boom was just beginning. For this generation, games are a symbol of modernity and part of everyday life. The first characters illustrated by computer animation moved freely about the games, and that attracted thoughtful people to this new world. At home, he started producing models and later used them as the basis for animations. Each step took its time since both hardware and software were undergoing constant development. After sending some résumés and getting some interviews, he was hired by Namco and luckily received the opportunity to create CG movies for Playstation from its very beginning. It was at that point that he happened to create the character Reiko Nagase. It was quite by chance, but she nevertheless became world-famous as an image character in the *Ridge Racer* series. Japan has been fascinated since the 70s by "idols" - the beautiful young females who deluge the mass media all nation-wide. Yoshimizu was working with characters when suddenly the influence of game CG animations led to an explosion of CG movies and characters. Since he was strongly attracted by the potentialities of computer graphics and characters, he resigned from the company to work as a freelancer. He has kept on creating a wide variety of pictures and characters ever since.

Yoshimizu est né en 1973 à Tokyo. Il sort diplômé en économie de l'université Nihon en 1997 et travaille pour Namco, une des plus importantes sociétés de jeux dans le monde. Depuis lors, il participe à la production d'animations et de dessins pour des jeux sur CD, dont *Rage Racer*, *Klonoa*, *Ace Combat* et *R4-Ridge Racer*. Il a également publié de nombreuses histoires courtes, dont le populaire *Peanuts* au Japon. Yoshimizu est certain que les personnages créés en 3D seront très populaires dans un futur proche, ce qui contraste agréablement avec l'état des lieux au cours des années 1990, lorsqu'il a commencé à dessiner. Il a grandi dans les années 1980, lorsque les jeux sur ordinateur gagnaient en popularité. Pour cette génération, les jeux symbolisent la modernité et sont devenus partie intégrante du quotidien. Les personnages illustrés par des animations se déplacent librement dans les jeux, ce qui a attiré de nombreuses personnes vers cet univers. Il a commencé à produire des personnages chez lui, puis à les animer. Ces étapes prenaient du temps car les matériels et les logiciels étaient en pleine évolution. Après avoir postulé auprès de nombreuses sociétés et passé des entretiens, il est embauché par Namco, où on lui donne l'opportunité de créer des animations pour Playstation. Il crée ensuite par hasard le personnage Reiko Nagase. Elle deviendra extrêmement populaire dans le monde entier comme héroïne du jeu *Ridge Racer*. Les Japonais sont fascinés par les « idoles » depuis les années 1970. Les « idoles » sont de belles jeunes femmes submergeant littéralement les médias. Attiré par le potentiel de l'ordinateur et des personnages, Yoshimizu quitte la société pour travailler en free-lance. Il a créé un grand nombre d'images et de personnages depuis lors.

Yoshimizu wurde 1973 in Tokyo geboren. Er studierte Wirtschaftswissenschaften an der Nihon-Universität und ging 1997 zu Namco, einem der weltweit führenden Spielehersteller. Seitdem war er an Animation und Grafik

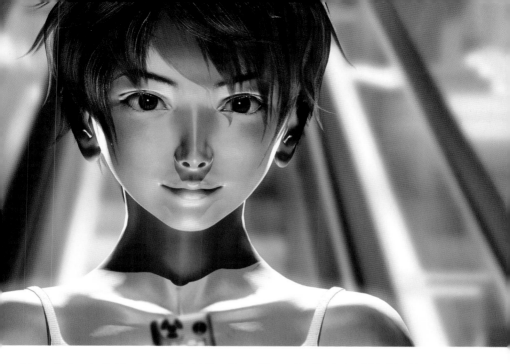

vieler weltbekannter Spiele wie zum Beispiel *Rage Racer*, *Klonoa*, *Ace Combat* und *R4-Ridge Race* beteiligt. Er hat auch diverse Kurzgeschichten, darunter die japanischen Peanuts-Comics, veröffentlicht. Yoshimizu ist zuversichtlich, dass die mit 3D-Computergrafik entworfenen Charaktere schon in naher Zukunft sehr populär sein werden – ein angenehmer Kontrast zu den trüben Aussichten, die Anfang der Neunziger herrschten, als er mit seiner Arbeit begann.

Während Yoshimizu heranwuchs, ging in den achtziger Jahren der Boom der Computerspiele – die für die heutige Generation ganz alltäglich geworden sind – gerade erst los. Die ersten Charaktere, die sich dank Computer-Animation frei bewegen konnten, tauchten in Spielen auf und weckten bei aufmerksamen Beobachtern Interesse an dieser neuen Welt. Zu Hause begann Yoshimizu Modelle zu produzieren und sie später zu animieren. Da sowohl Hardware als auch Software sich ständig weiterentwickelten, nahmen die einzelnen Arbeitsschritte viel Zeit in Anspruch. Nach einigen Bewerbungen und Vorstellungsge spächen fand Yoshimizu eine Stelle bei Namco und bekam Gelegenheit, CG-Movies für Playstations zu produzieren. Dann schuf er – per Zufall – die Figur Reiko Nagase; sie spielte in der Serie *Ridge Racer* mit und wurde dadurch weltbekannt. Schon seit den siebziger Jahren ist Japan von „Idols" fasziniert, jenen bildhübschen jungen Frauen, die zuhauf in den japanischen Massenmedien auftauchen. Als der Markt der CG-Movies und CG-Charaktere unter dem Einfluss der Computerspiel-Animationen explodierte, befasste auch Yoshimizu sich gerade mit Charakteren. Da ihn die Möglichkeiten der Computergrafik auf diesem Arbeitsfeld faszinierten, kündigte er seinen Job und machte sich selbstständig. Seitdem hat er eine große Vielzahl sehr verschiedener Bilder und Charaktere geschaffen.

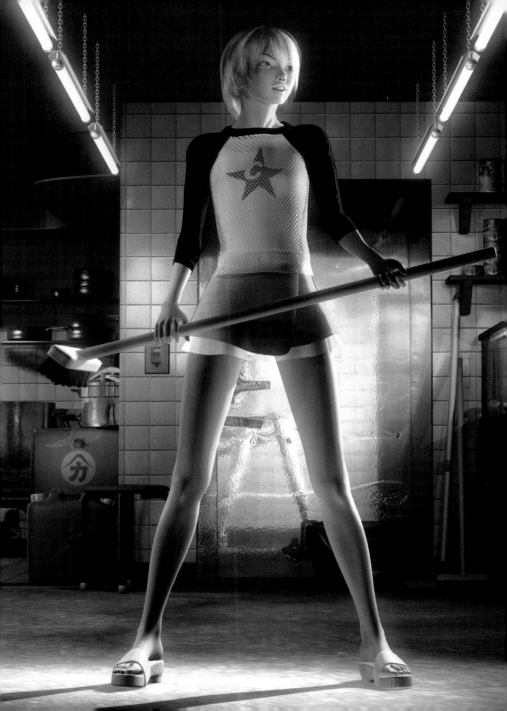

e-mail:	http://www.	Country:	Copyright:	Software:
poodoo @f3.dion.ne.jp	f3.dion.ne.jp/ ~poodoo	Japan	© poodoo cafe	Shade R4

SPORTS WOMEN MADE OUT OF BYTES

Keiji Maruyama's work in computer graphics is also a narrative about the new style of women in Japan. Modern and independent girls who think nothing of driving alone or practicing boxing are strongly present in his work. Maruyama was born and lives in Tokyo, Japan, and has been influenced by his childhood dreams. When he was a youngster it was not rare for him to carefully study the aesthetics of dolls, and the sense of a game prohibited for men has always exerted a fascination on his creative mind. 3-D computer graphics has proved a means for materialising these thoughts and dreams, for it has enabled him to create virtual idols that embody his fantasies and ideals. Maruyama uses Macintosh and the complete version of Shade R4, which offers him perfect modelling and rendering. The whole scenario of 3-D and computer graphics in Japan has created a fashion milieu in which professionals working for game and movie companies quite often achieve popular renown as artists. The designers themselves are tremendously proud of their work – for they are the creators of the next generation of entertainment. Maruyama's work has been featured on a number of CG platforms, although his characters have yet to penetrate the mass media. For him, succeeding in 3DCG is a kind of extraordinary dream, like when one thinks: "I would like to drive a car like that" or "I would like to draw attention to myself by wearing a fancy costume". The dream is becoming reality. His character Hikari is now well known on the net among Japanese artists, and his Web site Poodoo Cafe is an impressive example of how a virtual person can be treated as a real one.

Les travaux de Keiji Maruyama décrivent le nouveau style des Japonaises ; des femmes indépendantes et modernes, du type de celles qui conduisent leur voiture ou pratiquent la boxe. C'est le thème fréquent de ses travaux. Maruyama est né et vit à Tokyo au Japon. Il est influencé par ses rêves d'enfant. Etant jeune, il lui arrivait d'étudier l'esthétisme des poupées, et le sentiment d'interdit qu'éprouvent les garçons à y jouer a toujours intrigué son esprit créatif. Le graphisme en 3D est une forme de matérialisation de ces pensées et rêves, et un moyen de créer des idoles virtuelles qui incarnent ses fantasmes et ses idéaux. Keiji Maruyama utilise un ordinateur Macintosh ainsi que la version complète de Shade R4, qui lui permet de faire du modelage et des rendus parfaits. La 3D et le graphisme ont créé une mode au Japon par laquelle les professionnels travaillant pour des sociétés cinématographiques ou de jeux sont souvent considérés comme des artistes. Les designers eux-mêmes sont très fiers de leur travail et se considèrent comme les créateurs d'une nouvelle génération de loisirs. Keiji Maruyama a déjà été cité dans les médias, bien que ses personnages ne soient pas encore populaires. Le graphisme 3D est pour lui un rêve, par exemple « je voudrais conduire telle voitur», ou « je voudrais attirer l'attention en portant tels vêtements ». Son rêve est devenu réalité. Son personnage, Hikari, est maintenant très connu sur Internet parmi les artistes japonais et son site Web, Poodoo Cafe, illustre de manière impressionnante le fait qu'une personne virtuelle peut être traitée comme un être véritable.

Die CG-Arbeiten Keiji Maruyamas erzählen Geschichten – auch über einen neuen japanischen Frauentypus. Moderne und unabhängige Frauen, die nichts dabei finden, allein Auto zu fahren und zum Boxtraining zu gehen, sind in seinen Arbeiten stark vertreten. Maruyama wurde in Tokyo geboren und lebt auch dort. Geprägt ist er von seinen Kindheitsträumen: In seiner Jugend fand er Gefallen an Puppen, deren ästhetische Aspekte er genau untersuchte. Aus dem Gefühl, etwas für einen Mann Verbotenes zu tun, schöpft er auch heute noch einen Teil seiner Kreativität. Mit 3D-Computergrafik lassen sich jene Gedanken und Träume sichtbar machen und virtuelle Idole schaffen, welche die eigenen Fantasien und Ideale verkörpern. Keiji Maruyama verwendet einen Macintosh

und Shade zum perfekten Modellieren und Rendern.

Mit der japanischen 3D- und Computergrafik ist eine Szene entstanden, in der Profis aus der Spiele- und Filmindustrie öffentliche Anerkennung als Künstler finden können. Die Designer selbst sind unglaublich stolz auf ihre Leistungen – schließlich ist es ihnen gelungen, eine neue Entertainment-Generation hervorzubringen. Keiji Maruyama wurde bereits in einigen CG-Publikationen vorgestellt, doch in die Massenmedien sind seine Charaktere noch nicht vorgedrungen. Für ihn besteht das Wesen von 3D-Grafik darin, Träume Wirklichkeit werden zu lassen. Sein Charakter Hikari ist mittlerweile unter japanischen Computerkünstlern sehr bekannt, und seine Website Poodoo Cafe zeigt eindrucksvoll, dass man mit einem virtuellen Menschen genauso umgehen kann wie mit einem aus Fleisch und Blut.

e-mail:	http://www.	Country:	Contact:	Copyright:	Software:
Garvgraphx @aol.com	Garvgraphx.com	United States	PO BOX 481, Lewiston, NY 14092	© Garvgraphx	Adobe Photoshop

THE EROTIC AIRBRUSH

Keith Garvey is 37 years old and from Niagara Falls, NY. He studied at the Art Institute of Pittsburgh, and attended business school in Buffalo, NY. After graduating from college, he bounced around from one job to another, looking for work in the art field. The job never came, so he pursued other things and put his art on the back burner. In 1999, he purchased his first computer and it changed everything. He discovered the digital erotic community on the Internet - and his true calling: "digitally created art". With the computer he had both the tools to create and the vehicle to display his art. His work has been published in many reference Web sites such as *Dirtycomics.com*, *Firegirls.com*, *Debbiechan.com*, and *Ruthiesclub.com*, as well as in printed media such as *Buttman* Magazine.

His work process is simple but demands much expertise. It is a hybrid system used mostly by artists with traditional backgrounds. First, he draws sketches with pencil and paper. He uses pictures from magazines or takes Polaroid photos for reference to ensure the accuracy of the image. Once he has the basic sketch and is satisfied with the pose and composition, he scans it into his computer. He also scans whatever references he needed to come up with the sketch. At this point he is ready to paint.

He opens up the scanned images in Photoshop and drops a layer over the original sketch. He then traces off the sketch with a mouse, using life-like colours so there will be no black lines. He then transfers that layer onto a blank document, so that he has a reproduction of the original sketch on a clean white background with none of the grain or black lines from the original sketch. In the next step he sections off the body parts with the lasso tool. He then sprays them in much the same manner as he used to do with an airbrush. He keeps his reference images open next to that file on the screen, so that he can refer to them for realistic accuracy, highlights, shadows, and so on. In the end he has an original life-like image.

Keith Garvey a 37 ans et est originaire de Niagara Falls dans l'Etat de New York. Il a fait ses études à l'Art Institute de Pittsburgh et dans une école de commerce de Buffalo, New York. Après avoir obtenu son diplôme universitaire, il passe d'un emploi à l'autre, cherchant à travailler dans le domaine de l'art. Malchanceux, il continue dans une autre direction et abandonne le dessin. En 1999, il achète son premier ordinateur, découvre la communauté érotique sur Internet et ses œuvres créées numériquement. Grâce à l'ordinateur, il dispose d'un outil de création et d'un support pour véhiculer son art. Ses travaux ont été publiés dans de nombreux sites Web de référence, par exemple *Dirtycomics.com*, *Firegirls.com*, *Debbiechan.com* et *Ruthiesclub.com*, ainsi que dans des publications telles que *Buttman Magazine*.

Son processus de travail est simple mais demande des connaissances approfondies. C'est un système hybride utilisé par la plupart des artistes de formation traditionnelle. Il dessine premièrement une esquisse au crayon, sur papier. Il se sert de photos provenant de magazines ou prend une photo Polaroïd pour conserver une trace et garantir l'exactitude de l'image par la suite. Lorsque l'esquisse est terminée et qu'il est satisfait de la pose et de la composition, il la numérise et s'apprête à dessiner. Il numérise également tous les éléments qui lui ont servi de référence pour son esquisse.

Il ouvre l'image numérisée dans Photoshop et ajoute un calque sur le dessin d'origine. Il trace les contours du dessin à la souris et utilise des couleurs réalistes de manière à empêcher l'apparition de lignes noires. Il transfère alors ce calque sur un nouveau document pour continuer son travail sur un fond blanc et supprimer toute trace de l'esquisse. Il découpe ensuite les membres des personnages à l'aide de l'outil lasso et les peint à l'aérographe. Il laisse les images de référence ouvertes à l'écran pour vérifier en permanence l'exactitude des

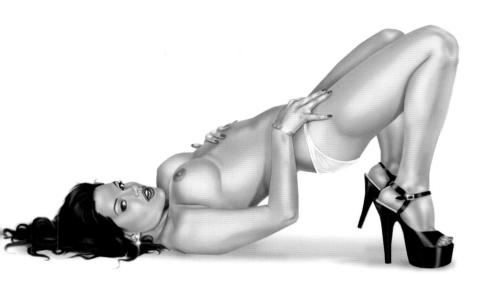

détails, de la luminosité, des ombres, etc. Il obtient alors une image très proche de la réalité en fin de réalisation.

Keith Garvey ist 37 Jahre alt und stammt aus Niagara Falls in den USA. Er hat das Art Institute in Pittsburgh und eine Business School in Buffalo besucht. Nach dem College wechselte er häufig den Arbeitsplatz und suchte vergeblich nach einer Stelle im künstlerischen Bereich. Schließlich stellte er seine künstlerischen Ambitionen zurück und orientierte sich in andere Richtungen. Sein Leben änderte sich, als er sich 1999 seinen ersten Computer kaufte. Im Internet entdeckte er die digitale Erotik und ihre Fangemeinde und damit seine eigentliche Berufung: die digitale Kunst. Mit dem Computer besaß er sowohl das Werkzeug, seine Kunst zu erschaffen, als auch das Mittel, sie zu zeigen. Seine Arbeiten sind auf vielen Referenz-Websites wie *Dirtycomics.com*, *Firegirls.com*, *Debbiechan.com* und *Ruthiesclub.com* sowie in Printmedien wie dem *Buttman Magazine* veröffentlicht worden.

Garveys Arbeitsprozess ist relativ simpel, verlangt aber viel Erfahrung und Geschick; er entspricht dem von Künstlern mit traditionellem Hintergrund. Zunächst skizziert mit Bleistift und Papier, wobei er Bilder aus Zeitschriften oder eigene Fotos als Vorlage benutzt, um die Detailtreue seines Bildes sicherzustellen. Steht die Basisskizze und ist Garvey mit Pose und Bildaufbau zufrieden, scannt er sie ein. Nachdem er alle verwendeten Vorlagen eingescannt hat, kann er mit dem Malen beginnen.

Er öffnet die eingescannten Bilder in Photoshop und legt eine Ebene über die ursprüngliche Skizze. Dann zeichnet er die Skizze in lebensechten Farben nach, bis keine schwarzen Linien mehr vorhanden sind. Diese Schicht überträgt er auf ein leeres Dokument und erhält so eine Reproduktion der ursprünglichen Skizze auf einem reinweißen Hintergrund ohne schwarze Konturen. Im nächsten Schritt werden mit dem Lasso-Tool die Körperteile ausgewählt, die Garvey dann – fast wie früher beim Airbrushing – einsprüht. Seine Referenzbilder bleiben neben dieser Datei geöffnet, so dass er ständig vergleichen und Realitätstreue, Highlights, Schatten etc. überprüfen kann. Das Endergebnis ist ein absolut naturgetreues Bild.

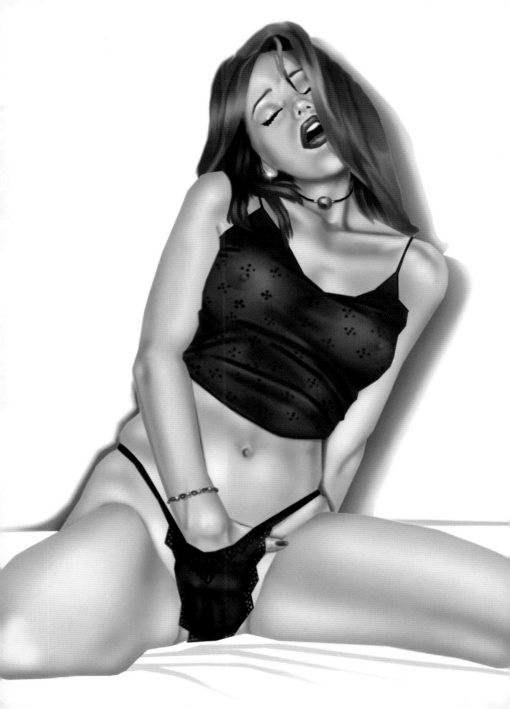

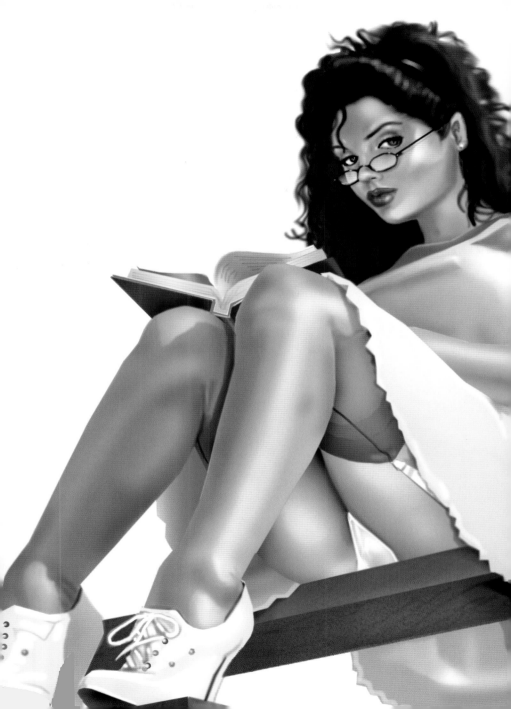

KOJI ETO

e-mail:
eto-koji@
nifty.com

Country:
Japan

Copyright:
© Koji Eto

Software:
3D Studio Max
LightWave 3D

CYBER NATIVE SCHOOLGIRLS

Koji Eto originally became involved in computer graphics and 3DCG when he started creating games. He was born in Japan in 1967, and currently works mainly with digital media, making graphics for game characters, movies, and CG illustrations. He deals with a wide range of fields, such as female characters, robots, and automobiles. Eto primarily uses LightWave 3D for modelling and 3D Studio Max for other procedures. The intuitive modelling allowed by LightWave 3D, often referred to as "kneading the clay", is just right for character design, and recently many more versions were released that have even more free-style capability, so that in many cases the work can simply be finished off with 3D Studio Max. Koji Eto considers it is very important to create and take care of the image. A character will have less personality if it does not have enough strength. He usually creates the characters in his imagination, after first having gained a clear idea of how to work toward the character that he would like to design. Eto needs around 2 to 3 weeks to finish one work. His hobby is making figures and plastic models.
There seems to be no trick in creating artificial humans. Everyone is thoroughly familiar with seeing human beings in their everyday lives, which makes each of us very sensitive to any unnatural aspects in a creation. But the first impression can be different when one sits in front of the computer and tries to simulate human movements in animation and human appearance with textures.
It has taken years to achieve a reasonable level of quality. Moreover, not only the face determines the image of the character, but also such elements as hair, clothes, and body. Taking care of each detail requires plenty of time and real mental concentration. There is still a limitation to model hair, clothes and bodies, but day by day artists are finding ways to make these elements look better.

Koji Eto s'est impliqué dans le graphisme et la 3D lorsqu'il créait des jeux. Il travaille actuellement avec les supports numériques, réalisant des images pour des jeux, des films et des illustrations graphiques. Il est né en 1967 au Japon et évolue dans un grand nombre de domaines, tels que les personnages féminins, les robots et les voitures. Eto utilise principalement LightWave 3D pour modeler et 3D Studio Max pour les autres procédures. Le modelage intuitif de LightWave 3D, souvent comparé au pétrissage de l'argile, est adapté à la conception de personnages. De nombreuses nouvelles versions ont été éditées depuis, disposant de nombreuses fonctions. Les travaux peuvent maintenant être réalisés intégralement dans 3D Studio Max. Pour Koji Eto, créer l'image et travailler sur elle est très important. Si le personnage n'a pas assez de force, sa personnalité s'en ressent. Il crée habituellement en se basant sur son imagination, dès qu'il a une idée précise de la manière d'obtenir le personnage souhaité. Eto passe environ deux à trois semaines sur son œuvre. Il réalise des personnages et des modèles plastiques pendant ses loisirs.
Créer des personnages artificiels n'est pas difficile. Nous sommes habitués à voir des êtres humains dans leur vie courante, ce qui nous permet de détecter les aspects factices d'un personnage. La première impression peut être bien différente lorsqu'on est assis devant son ordinateur pour simuler nos mouvements dans des animations et l'apparence des textures. Il faut des années pour atteindre une qualité raisonnable. De plus, les visages ne suffisent pas à déterminer l'image d'un personnage, des éléments tels que les cheveux, les vêtements et le corps sont également importants. Régler chaque détail requiert beaucoup de temps et de concentration. Il existe toujours des limites quant au modelage des cheveux, des vêtements et du corps, mais les artistes trouvent des moyens de les améliorer chaque jour.

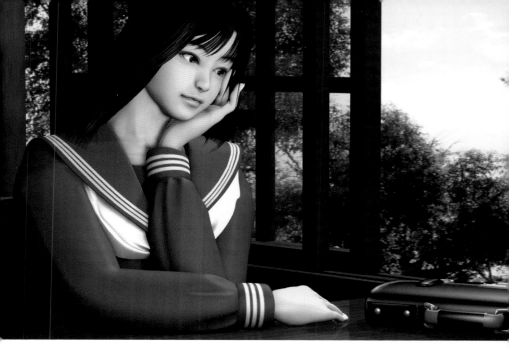

Koji Eto, geboren 1967 in Japan, beschäftigt sich mit Computergrafik und 3D seit er Spiele entwickelt. Zurzeit produziert er fast ausschließlich mit digitalen Medien grafische Arbeiten für Spiele, Filme und CG-Illustrationen. Seine Themenpalette ist vielfältig: Sie umfasst weibliche Charaktere ebenso wie Roboter oder Autos. Eto benutzt hauptsächlich LightWave 3D zum Modellieren und 3D Studio Max für andere Arbeitsschritte. Das intuitive Modellieren mit LightWave 3D, oft auch als „Modellieren mit digitalem Ton" bezeichnet, bietet sich für das Entwerfen von Charakteren an. Inzwischen gibt es zahlreiche neue Versionen mit sehr viel größerem Spielraum, so dass die Arbeit in vielen Fällen in 3D Studio Max abgeschlossen werden kann. Für Koji Eto ist der kreative und sorgfältige Umgang mit dem Bild sehr wichtig, da ein Charakter, der nicht stark gestaltet ist, auch wenig Persönlichkeit besitzt. Gewöhnlich gestaltet Eto einen Charakter zunächst in seiner Fantasie: Er braucht eine klare Vorstellung davon, wie er den Charakter, den er entwickeln möchte, am besten angeht. Er benötigt etwa zwei bis drei Wochen, um eine Arbeit zu vollenden. In seiner Freizeit produziert er Figuren und Plastikmodelle. Die Herstellung künstlicher Menschen scheint eigentlich keine Hexerei zu sein. Wir alle sehen ständig menschliche Wesen in unserem Alltag und bemerken daher sofort, wenn etwas unnatürlich wirkt. Sobald wir aber vor dem Computer sitzen und versuchen, unsere Bewegungen durch Animation und unser Aussehen mit Texturen zu simulieren, stellt sich die Sache ungleich komplizierter dar. Es hat Jahre gedauert, bis hier eine zufriedenstellende Qualität erreicht war. Außerdem wird das Erscheinungsbild eines Charakters nicht nur durch das Gesicht, sondern auch durch Elemente wie Haare, Kleidung und Körperform geprägt. Um auf alle Details zu achten, benötigt man viel Zeit und Konzentration. Haare, Kleidung und Körper lassen sich auch heute noch nicht optimal modellieren – aber die Künstler arbeiten daran und die Resultate werden von Tag zu Tag besser.

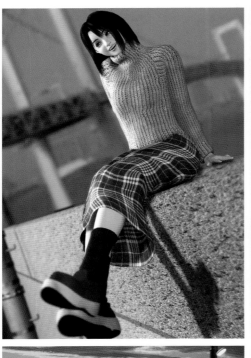
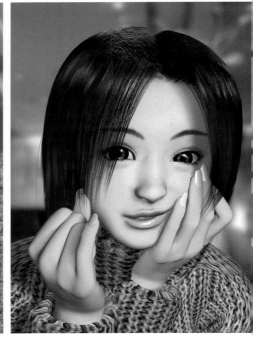

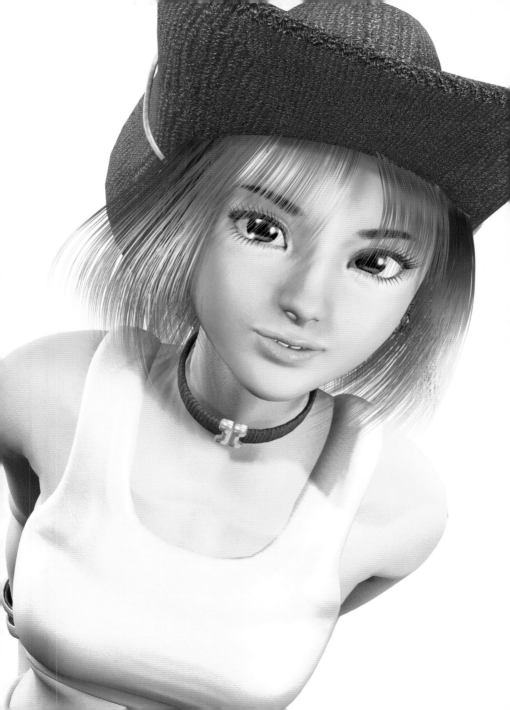

LASZLO RACZ

e-mail:	http://www.	Country:	Contact:	Copyright:	Software:
info @ralaci.hu	ralaci.hu	Hungary	1039 Tuzfold u.18 Budapest	© Lazlo Racz	Adobe Photoshop Canoma, Bryce, Photo Paint Poser

HUNGARIAN DIGITAL MODELS IN INTIMACY

Laszlo Racz was born in Hungary. His work has been published in his homeland in *Chip Magazin*, a monthly computer magazine, and in *The Magical 3D*. Laszlo's interest in 3D graphics started when 386 processors still ruled the land. At that time, dealing with graphics was a painfully slow process, especially on home computers using a software called "Fish", and most of the work had to be done in 2D. When the 586 processor series came out a few years later, he could finally start to explore 3D graphics. Over the years he has learned one program after another, and has always had fun learning, and even more fun creating. In 2000, after graduating with a B.A. from university, he took 10 months off, during which time he was free to do 3D modelling and texturing, practicing day and night.

To have full control over his work, he starts his creations from scratch. This way every detail can be changed. Often the basic concept is completely lost by the end of this process and replaced by a new one. Creating realistic female models is his main interest, and most of his works contain at least one female character. Posing and texturing a model is the most time-consuming part of the whole process, but once it is done, using it in other creations can be done quickly and easily. Building an environment around the characters is the other hard part. This process is easier when working with the right props, otherwise the concept has to be modified.

He uses Poser for character generation, Bryce for general and landscape modelling, and PhotoShop for 2D work, post-render touch-ups and image manipulation. From time to time he works with other programs such as Canoma, Corel Draw, Painter and Photo Paint. Frequently he returns to his earlier works to see if there is anything he can do to improve them, as well as to measure his own progress.

Laszlo Racz est né en Hongrie. Ses travaux ont été publiés dans *Chip Magazin*, un magazine informatique mensuel de son pays natal, et dans *The Magical 3D*. Laszlo s'intéresse à la 3D lorsque les processeurs 386 sont encore monnaie courante. A cette époque, le graphisme est un processus lent, tout particulièrement sur les ordinateurs personnels équipés du logiciel Fish.

La plupart des travaux doivent alors être réalisés en 2D. Lorsque les processeurs Pentium arrivent sur le marché quelques années plus tard, il peut enfin explorer le monde de la 3D. Il a appris au fil du temps à utiliser des programmes les uns après les autres, et s'amuse autant à apprendre qu'à créer. Après avoir obtenu en 2000 son diplôme B.A. de l'université, il cesse toute activité pendant dix mois pour se consacrer jour et nuit à la pratique du modelage 3D et des textures.

Il débute ses créations à partir de zéro pour contrôler totalement son travail. Chaque détail peut ainsi être modifié. Le concept de base est souvent complètement perdu à la fin de ce processus et remplacé par un nouveau. Son intérêt principal réside dans la création de personnages féminins réalistes ; la plupart de ses travaux en contiennent au moins un. La pose et les textures sont les tâches les plus longues du processus, mais lorsqu'elles sont terminées, leur utilisation dans une autre création est assez simple et rapide. La constitution de l'environnement autour des personnages est une autre tâche difficile. Ce processus est simplifié lorsqu'il travaille avec les bons accessoires, sinon le concept doit être modifié.

Il utilise Poser pour générer des personnages, Bryce pour le modelage général et les paysages, et Photoshop pour les travaux 2D, les retouches de post-production et les manipulations sur l'image. Il utilise de temps en temps d'autres programmes tels que Canoma, Corel Draw, Painter et Photo Paint. Il revient fréquemment sur ses travaux précédents pour voir s'il peut encore les améliorer, et pour mesurer ses progrès.

Laszlo Racz ist in Ungarn geboren. Dort wurden seine Arbeiten im *Chip Magazin*, einer monatlich erscheinenden Computerzeitschrift, und in *The Magical 3D* veröffentlicht. Raczs Interesse an 3D-Grafik begann, als es noch überwiegend 386er-Prozessoren gab. Damals war der Umgang mit Grafik, vor allem auf Home-Computern, ein langwieriger Prozess. Die Software „Fish" erlaubte fast ausschließlich 2D-Arbeit. Als später Prozessoren der 586er-Serie herauskamen, konnte sich Racz endlich auch mit 3D-Grafik beschäftigen. Im Laufe der Jahre fand er besonderen Gefallen daran, viele verschiedene Programme zu erlernen und kreativ mit ihnen umzugehen. Nachdem er im Jahr 2000 sein Studium abgeschlossen hatte, nahm er sich zehn Monate Zeit und bildete sich intensiv in 3D-Modellierung und Texturierung weiter.

Um eine möglichst große Kontrolle über das eigene Produkt zu haben, beginnt er ganz ohne Vorgaben. Auf diese Weise lässt sich auch jedes Detail verändern; oft hat Racz dann das ursprüngliche Basiskonzept am Ende des Arbeitsprozesses vollständig durch ein neues ersetzt. Sein größtes Interesse gilt realistischen weiblichen Models und so enthalten die meisten seiner Arbeiten mindestens einen weiblichen Charakter. Die Festlegung der Posen und Texturen eines Models ist der zeitraubendste Teil der gesamten Arbeit, aber sobald dies erledigt ist, lässt sich das Ergebnis in anderen Grafiken bequem wieder verwenden. Der Aufbau einer Umgebung für die Charaktere ist ein weiterer anspruchsvoller Arbeitsschritt. Wenn die Props stimmen, ist es einfacher, andernfalls muss das gesamte Konzept modifiziert werden.

Racz benutzt Poser zum Entwerfen der Charaktere, Bryce zum Modellieren - auch von Landschaften -, und Photoshop für 2D-Arbeiten, für Touch-ups nach dem Rendern und zur weiter gehenden Bildmanipulation. Zeitweise arbeitet er auch mit anderen Programmen wie Canoma, Corel Draw, Painter und Photo Paint. Oft kehrt er zu seinen frühen Arbeiten zurück, um zu überprüfen, ob er sie verbessern kann und welche Fortschritte er in der Zwischenzeit gemacht hat.

e-mail:	http://www.	Country:		Copyright:	Software:
admin @ancientfuture.co m.au	wicked- womyn.com	Australia		© Leanne Parker	Poser Bryce Paint Shop Pro

AUSTRALIAN DIGITAL TOP MODELS

Leanne Parker was born in Newcastle in 1969. She attended art classes at school from a very early age, but in computer graphics she is an autodidact. She bought herself a Commodore 64 early on, which took little time to learn to use, and later trained in 3D using thousands of tutorials available on the internet. She has worked as a designer and also as a Web designer, creating sites on digital art and naturalist themes. She created "Ancient Future Designs" to make her art commercially available. The Web Site Brothers awarded Ancient Future Designs a Level 5 award for Artistry and Design in November 1999, and Parker was featured on their front page. As her skills in CGI, ASP and Java improved, she began to make Web site templates. She also slowly developed techniques in 3D, using Bryce and Poser, and recently has begun testing 3D models for other creators before they are put on sale. She also dedicates much of her time to texturing.
She always starts her images from scratch. Textures, on the other hand, are inspired by women's magazines and catwalk shows. The process is quite simple. She decides first how complex the pose is going to be, and then which model she will use. The look of the model's face is also important. Once she has decided on Posette or Victoria (two different models types within Poser), she loads them up and begins. Camera focus, lighting, posing and sometimes clothing are all important factors. She works more with nudes, since most 3D clothing does not look real even when worked upon properly. She uses Poser for 3D models and Bryce for environments and when a scene requires a lot of props. Once the scene is rendered, it is saved in tiff format and taken into Paint Shop Pro. Any elbows or knees that need a little fixing get seen to at this stage. Shadows may also get painted in. She makes the effort to get the scene rendered as best as she can in the 3D software in order to avoid a lot of post-production in 2D.

Leanne Parker est née en 1969 à Newcastle. Elle a étudié le dessin à l'école dès son plus jeune âge, mais reste une graphiste autodidacte. Elle acquiert un ordinateur Commodore 64 et apprend très vite à s'en servir, puis s'essaie plus tard à la 3D avec l'aide de milliers de travaux dirigés obtenus sur Internet. Elle a travaillé en tant que designer et designer Web, créant des sites sur les thèmes du dessin et du naturalisme. Elle crée une société, Ancient Future Designs, pour vendre ses dessins. En novembre 1999, le site Web Brothers lui a décerné un prix pour son talent artistique. Ses connaissances en programmation CGI, ASP et Java s'améliorant, elle crée des maquettes de sites Web. Elle développe des techniques 3D à l'aide de Bryce et de Poser et teste des modèles 3D pour d'autres éditeurs avant qu'ils ne soient mis en vente. Elle passe également une grande partie de son temps à réaliser des textures.
Elle commence toujours ses images à partir de zéro. Les textures sont inspirées de magazines féminins ou de défilés de mannequins. Le processus de création est assez simple. Elle décide d'abord de la complexité de la pose et du modèle à utiliser. L'expression du visage du modèle est également importante. Une fois son choix fait entre Posette et Victoria (les différents modèles fournis avec Poser), elle charge le modèle et commence son travail. Elle réalise principalement des nus car les vêtements ne sont pas suffisamment réalistes, même lorsqu'ils sont dessinés correctement. Elle utilise Poser pour réaliser les modèles 3D et Bryce pour les environnements ou lorsque les scènes requièrent de nombreux accessoires. Une fois le rendu de la scène effectué, il est enregistré au format TIFF et ouvert dans Paint Shop Pro. Les détails des genoux et des coudes sont alors retouchés et les ombres sont dessinées. Elle essaie d'obtenir le meilleur rendu possible dans le logiciel de 3D pour éviter une longue post-production en 2D.

Leanne Parker wurde 1969 in Newcastle geboren. Schon als kleines Kind besuchte sie den Kunstunterricht, als Computergrafikerin ist sie jedoch Autodidaktin. Sie kaufte sich früh einen Commodore 64 und lernte mit Hilfe zahlreicher Internet-Tutorials mit 3D umzugehen. Inzwischen hat sie als Designerin und Webdesignerin gearbeitet, Websites über digitale Kunst und naturalistische Themen erstellt und schließlich ihre eigene Firma Ancient Future Designs gegründet, um ihre Kunst kommerziell vermarkten zu können. Die Web Site Brothers verliehen ihr im November 1999 einen Preis für künstlerische Gestaltung und Design und setzten Leanne Parker auf ihre Titelseite. Als ihre Kenntnisse in CGI, ASP und Java umfangreicher wurden, begann sie Website-Templates zu gestalten. Außerdem hat sie eigene 3D-Techniken mit Bryce und Poser entwickelt und testet jetzt fremde 3D-Modelle, bevor sie auf den Markt kommen. Sie investiert auch viel Zeit in die Texturierung.

Parker beginnt ihre Bilder stets ohne jegliche Vorgaben, lässt sich jedoch für ihre Texturen von Frauenzeitschriften und Modenschauen inspirieren. Das Arbeitsverfahren ist relativ simpel. Sie entscheidet zunächst, wie komplex die Pose wird und mit welchem Model sie arbeiten will; der Gesichtsausdruck des Models ist dabei ebenfalls wichtig. Hat sie sich für Posette oder Victoria (zwei unterschiedliche Modelltypen in Poser) entschieden, lädt sie sie und beginnt ihre Arbeit. Blickwinkel der Kamera, Licht, Pose und gegebenenfalls die Kleidung sind dabei wichtige Faktoren. Parker arbeitet allerdings vor allem mit nackten Körpern, da 3D-Kleidung selbst nach sorgfältigster Bearbeitung meist nicht sehr echt wirkt. Sie benutzt Poser für 3D-Modelle und Bryce für Umgebungen und Szenen mit vielen Props. Ist die Szene gerendert, wird sie im TIFF-Format gespeichert und nach Paint Shop Pro übertragen. Hier werden Ellbogen oder Knie überarbeitet oder Schatten hineingemalt. Parker ist jedoch bemüht, die Szene schon optimal in der 3D-Software zu rendern und so wenig wie möglich in 2D nachzubearbeiten.

MAGDALENA VASTERS

e-mail:
magda
@vasters.de

http://www.
vasters.de

Country:
Poland

Contact:
Brückenstrasse
54,
50996 Cologne,
Germany

Copyright:
© Magdalena
Vasters
2000-2001

Software:
Poser
Bryce
Adobe
Photoshop

DIGITAL SURREAL

Magdalena Vasters was born in 1975 in Gdansk, Poland, where she lived until 1999. Today she lives in Cologne, Germany, and works as a Web designer and programmer. Her life and art are ruled by emotions and temperament. She has always been a dreamer and has been influenced by surrealists such as Salvador Dalí, Zbigniew Beksinski and H.R. Giger. She has been a self-taught professional in the digital field since 1995. She set out on her adventure in digital art with Photopaint 4 and Photostyler five years ago, and the Bryce 2 demo version allowed her to begin exploring 3D art. Although she has used various software, Bryce has always remained her most heavily-used tool. About two years ago she started to dedicate more time to digital art, incorporating Bryce 3D into her daily work. Other important tools have been Poser, Photoshop and the Wacom graphics tablet, which she uses to simulate natural drawing. Most of her images start with the main human character, in Poser, and then she comes up with the idea for the rest of the picture.

The main character is usually rendered naked and without hair, and then exported to Photoshop for further editing. Most of her works are created with a lot of drawing and effects, which need long hours of work, and it takes her 2 to 5 days to complete one image. She makes some digital drawings without the help of 3D software. In this case the creative process takes place solely in Photoshop and starts with a basic sketch done directly in that program.

Magdalena Vasters est née en 1975 à Gdansk en Pologne, où elle a vécu jusqu'en 1999. Elle vit aujourd'hui à Cologne en Allemagne et travaille en tant que programmeur et designer Web. Sa vie et son art sont gouvernés par son tempérament et ses émotions. Elle a toujours été une rêveuse et est influencée par des artistes surréalistes tels que Salvador Dalí, Zbigniew Beksinski et H.R. Giger. C'est une professionnelle autodidacte depuis 1995. Son aventure dans le graphisme numérique débute avec Photostyler et Photopaint 4, il y a cinq ans de cela. La version de démonstration de Bryce 2 lui permet également de s'essayer au dessin en 3D. Elle a utilisé différents logiciels, mais Bryce reste l'outil privilégié. Elle passe désormais plus de temps à dessiner et incorpore Bryce 3D dans son travail quotidien. Ses autres outils importants sont Poser, Photoshop et une tablette graphique Wacom, utilisée pour simuler un dessin plus naturel.

Elle commence par créer le personnage principal dans Poser, puis elle imagine le reste de l'image. Le rendu est effectué sur le personnage principal habituellement nu et sans cheveux, puis est exporté dans Photoshop pour être retouché. Ses travaux contiennent de nombreux dessins et effets qui nécessitent de longues heures de labeur. Il lui faut entre deux et cinq jours pour terminer une image.

Elle réalise quelques images sans l'aide de logiciels de 3D. Dans ce cas, le processus créatif se déroule entièrement dans Photoshop et débute par une simple esquisse dessinée directement dans ce logiciel.

Magdalena Vasters wurde 1975 in Danzig, Polen, geboren, wo sie bis 1999 lebte. Heute wohnt sie in Köln und arbeitet als Webdesignerin und Programmiererin. Ihr Leben und ihre Kunst werden von Gefühlen und Temperament beherrscht. Sie war schon immer eine Träumerin und wurde von Surrealisten wie Salvador Dalí, Zbigniew Beksinski und H.R. Giger beeinflusst. Die Autodidaktin ist seit 1995 Profi auf digitalem Gebiet. Ihre Auseinandersetzung mit der digitalen Kunst begann sie vor fünf Jahren mit Photostyler und Photopaint; mit einer Demoversion von Bryce tauchte sie in die 3D-Kunst ein. Sie hat bereits mit unterschiedlicher Software gear-

beitet, Bryce war jedoch schon das Tool, das sie am häufigsten verwendete. Vor ungefähr zwei Jahren begann sie, der digitalen Kunst mehr Zeit zu widmen, und integrierte Bryce 3D in ihre tägliche Arbeit. Weitere wichtige Tools sind Poser, Photoshop und das Grafiktablett, mit dem sie einen natürlichen Zeichenstil simuliert. Die meisten ihrer Bilder beginnen mit dem Charakter der menschlichen Hauptperson, den sie in Poser entwirft; anschließend entwickelt sie die Idee für den Rest des Bildes. Die Hauptfigur rendert sie normalerweise nackt und ohne Haare und exportiert ihn dann zur Weiterbearbeitung nach Photoshop. Die meisten der Bilder enthalten umfangreiche Zeichenarbeiten und aufwändige Effekte, deren Fertigstellung zwei bis fünf Tage benötigt. Einige digitale Zeichnungen erstellt Vaster ohne 3D-Software. Dann arbeitet sie ausschließlich in Photoshop und beginnt mit einer Basisskizze, die sie direkt im Programm anlegt.

MAKOTO HIGUCHI JP

e-mail:	http://www.	Country:	Contact:	Copyright:	Software:
mac-hg@	asahi-net.or.jp	Japan	2-7-11-403	© MAKOTO	Poser
a-net.email.ne.jp	/~gi9m-hgc/		Kawaguchi-shi,	HIGUCHI	3D Studio Max
			Saitama		

JAPANESE POP SINGER SEEKS FAME

Makoto Higuchi is a Tokyo-based architect who works as a city planner and a 3DCG creator, while simultaneously being a representative of Focus Design Limited in Japan. He produces 3DCG animation mostly using Shade and LightWave 3D. He has appeared and showcased his techniques in Japanese publications such as *Shade Professional 3D Super Techniques* and *LightWave3D 6 Super Techniques*. Higuchi creates his works with SGI workstations and Windows PCs with well-charged memories for rendering and modelling. For post-production he uses a Power Macintosh running Adobe Photoshop.

Recently, he has created one of the most popular virtual idols in the CG magazine scene in Japan called Ai ("love" in Japanese), and given her many idealised human attributes such as a height of 162 cm, age 17, and swimming as her hobby. The other character is Nasuka, who is 19 years-old, 165 cm tall and really talented at combative sports, with impressive physical abilities and potentially supernatural powers. Higuchi wants his idols to have endless possibilities and new stages in their development.

He views his digital work as a form of fine art, and never wants to categorise it as 3DCG, since drawing females by computer has become a unique field of work in itself. The makers of Japanese TV animation also share this approach. Currently, Higuchi is in the process of finding a signature technology for 3DCG and ensuring rights for a future generation of artists. He has challenged the limitations of CG: as the technology improves, the creations may soon have artificial intelligence and perhaps appear right next to us, released from computer screens like holograms. They may even work as interfaces in our communication tools. Makoto Higuchi intends to keep on creating lots of attractive digital models from this constantly evolving complex world. His work has been widely published and televised in Japan.

Makoto Higuchi est un architecte de Tokyo. Il travaille en tant qu'urbaniste et graphiste 3D, et pour la société Focus Design Limited. Il produit des animations 3D à l'aide des logiciels Shade et LightWave 3D. Ses techniques ont paru dans des publications japonaises telles que *Shade Professional 3D Super Techniques* et *LightWave 3D 6 Super Techniques*. Higuchi crée ses œuvres sur stations de travail SGI et sur ordinateurs PC dotés de beaucoup de mémoire pour effectuer les modelages et les rendus. Il utilise un ordinateur Power Macintosh équipé du logiciel Photoshop pour effectuer la post-production. Il a récemment créé une des idoles virtuelles les plus populaires du Japon, appelée Ai (ce qui signifie amour en japonais) et dotée de caractéristiques idéales pour le public : 1 mètre 62, 17 ans et pratiquant la natation pendant ses loisirs. Un autre personnage est Nasuka, 19 ans, 1 mètre 65, pratiquant un sport de combat, dotée de capacités physiques impressionnantes et potentiellement de super-pouvoirs. Makoto Higuchi souhaite des possibilités illimitées pour ses idoles.

Il considère l'art numérique comme une forme de beaux-arts et ne le catégorise pas dans le graphisme 3D, car la création de personnages féminins sur ordinateur est un travail unique en son genre. Les créateurs japonais d'animation pour la télévision partagent cette approche. Higuchi travaille actuellement sur un projet de signature électronique pour protéger les droits des œuvres 3D de la future génération d'artistes.

Il défie les limitations du graphisme. Les limitations persistent malgré les améliorations des ordinateurs et les nouvelles fonctions potentielles des logiciels, mais avec l'évolution de la technologie, les créations seront bientôt dotées d'intelligence artificielle et apparaîtront à nos côtés, projetées hors de l'écran sous forme d'hologrammes. Elles seront des interfaces avec nos outils de communication.

Higuchi continue de créer des modèles numériques attrayants à partir de cette complexité en constante évolution. Il a été publié et diffusé de nombreuses fois au Japon.

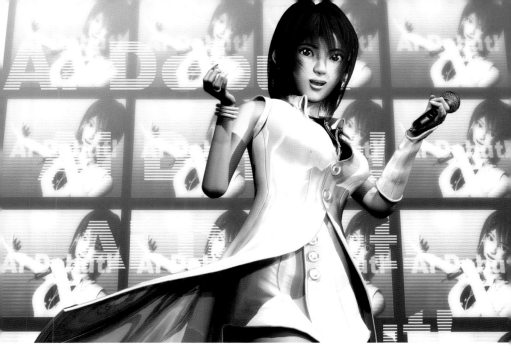

Makoto Higuchi arbeitet als Architekt, Städte-planer und 3D-Computergrafiker in Tokyo; außerdem vertritt er Focus Design Limited in Japan. Er erstellt seine 3D-Animationen vor allem in Shade und LightWave 3D. In japanischen Publikationen wie *Shade Professional 3D Super Techniques* und *LightWave 3D 6 Super Techniques* hat er seine Techniken bereits vorgestellt und erläutert. Higuchi kreiert seine Arbeiten auf SGI-Workstations und Windows-PCs mit reichlich Arbeitsspeicher zum Rendern und Modellieren. Zur Nachbearbeitung benutzt er einen Power Macintosh mit Adobe Photoshop.

Vor kurzem hat Makoto Higuchi die Figur Ai (japanisch für Liebe) geschaffen, ein unter den Lesern japanischer CG-Magazine sehr populäres Virtual Idol - nicht zuletzt dank ihrer vielen positiven menschlichen Eigenschaften. Sie ist 1,62 m groß, 17 Jahre alt und schwimmt gern. Das Gegenstück dazu ist Nasuka, 19 Jahre alt, 1,65 m groß – eine sehr talentierte Kampfsportlerin mit beeindruckenden körperlichen Fähigkeiten und potenziell übernatürlichen Kräften. Higuchi möchte seinen Idols ungegrenzte Möglichkeiten geben und plant für sie bereits neue Entwicklungsschritte.

Seine digitalen Arbeiten betrachtet Higuchi als Form der darstellenden Kunst und mag die Bezeichnung 3D-Computergrafik nicht, da sich das Zeichnen und Malen von Frauen mit dem Computer zu einem eigenständigen Arbeitsfeld entwickelt hat. Die japanischen TV-Animatoren teilen seinen Ansatz. Momentan sucht Higuchi nach einer Technologie, mit der 3D-Computergrafiken elektronisch signiert und die Urheberrechte künftiger Künstlergenerationen gewahrt werden können. Makoto Higuchi ist bis zu den derzeitigen Grenzen der Computergrafik vorgestoßen. Mit zunehmendem technischen Fortschritt könnten seine Geschöpfe schon bald künstliche Intelligenz besitzen und wie Hologramme, vom Bildschirm befreit, plötzlich neben uns auftauchen. Sie könnten sogar als Schnittstellen zu unseren Kommunikationsgeräten fungieren.

Higuchi will noch viele attraktive – und immer komplexere – digitale Models entwerfen. Er hat zahlreiche Veröffentlichungen vorzuweisen und ist häufig im japanischen Fernsehen zu sehen.

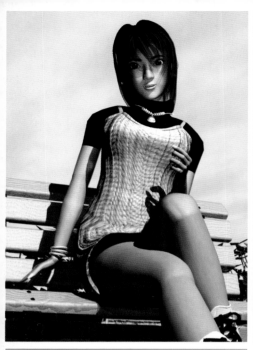
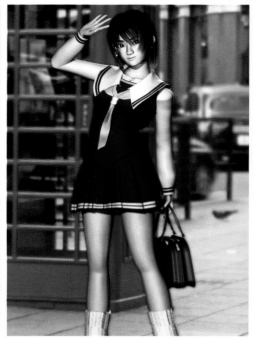
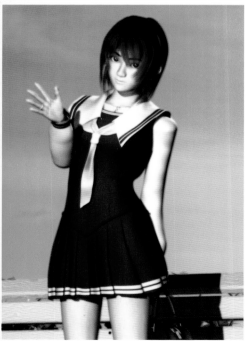
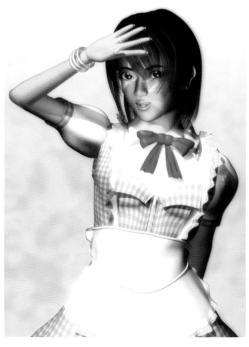

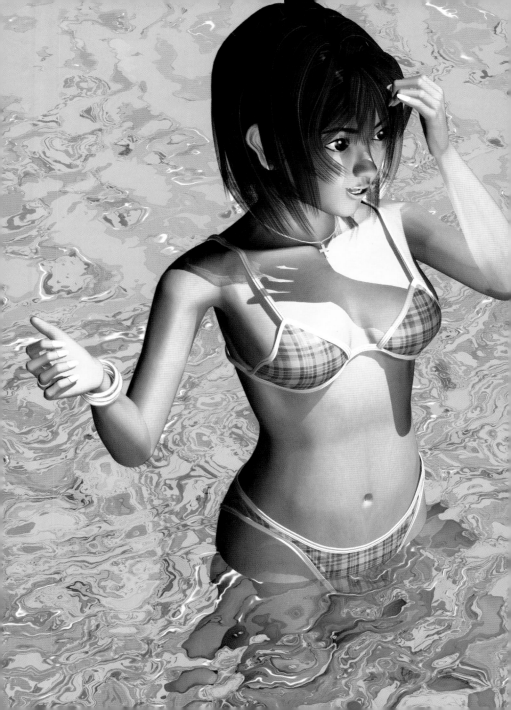

MARCIN ZEMCZAK PL

e-mail:	http://	Country:	Contact:	Copyright:	Software:
mzemczak @supermedia.pl	crommcruac. rulez.pl	Poland	Ul. I Armii Wojska Polskiego 4/109 43-300 Bielsko Biala	© Marcin Zemczak (Cromm Cruac)	Adobe Photoshop 3D Studio Max

CYBER BULL FIGHTERS

Marcin Zemczak was born in 1972. He did not attend art school, and the only graphics-related subject that he has studied is technical drawing. He has always worked with computers and currently works as a Web designer for one of the larger Internet providers in Poland. He has always considered 3D computer-generated images a hobby. His experience with 3D began in 1985, in the era of machines like the ZX Spectrum. He experimented with the VU-3D program, then a long break from 3D followed during which he improved his 2D graphics skills. Working for the advertising market improved the quality of his work, since he gained experience in composition and managing vector and photo editing programs. When 3D Studio came out, he used it extensively to make video clips. Lately he has focused chiefly on 3D still images, though he still works on animation as well. His work won awards from the science fiction magazine *Nowa Fantastyka* in 1995.
Zemczak never sketches; he prefers to create the pictures directly on the computer. The main concept comes from his mind and he starts with single objects created in 3D Studio Max. The figures are often created in Poser and then imported into 3D Studio Max, where textures are applied. Once the basic scene is complete and rendered, he jumps into Photoshop for 2D retouching, effects and adjustments.

Marcin Zemczak est né en 1972. Il n'a pas fréquenté les beaux-arts et le seul sujet lié au graphisme qu'il ait étudié est le dessin industriel. Il a toujours travaillé avec un ordinateur et occupe actuellement un poste de designer Web chez l'un des plus importants fournisseurs d'accès Internet de Pologne. Il a toujours considéré la génération d'images 3D par ordinateur comme un hobby. Il débute la 3D en 1985 à l'époque des ordinateurs ZX Spectrum. Il essaie le programme VU-3D, puis arrête la 3D quelque temps pour améliorer ses compétences 2D. Son passage à la publicité a amélioré la qualité de ses travaux puisqu'il est aujourd'hui passé maître dans la composition et l'utilisation des programmes vectoriels et de retouche d'image. Lorsque 3D Studio est publié, il l'utilise énormément pour réaliser des vidéo-clips. Il réalise désormais principalement des images 3D, mais continue de travailler sur des animations. Le magazine *Nowa Fantastyka* lui a décerné un prix en 1995 pour ses travaux.
Zemczak ne dessine jamais ; il préfère créer les images directement sur ordinateur. Il imagine le concept principal et débute à partir d'objets simples dans 3D Studio Max. Les personnages sont quelquefois créés dans Poser puis importés dans 3D Studio Max pour l'habillage. Lorsque la scène est terminée et le rendu effectué, il ouvre l'image dans Photoshop pour effectuer les retouches et les ajustements, et ajouter des effets.

Marcin Zemczak wurde 1972 geboren. Er hat nie eine formale Kunstausbildung erhalten, sondern technisches Zeichnen gelernt. Er arbeitete schon immer mit Computern und ist zurzeit Webdesigner bei einem der großen Internetprovider in Polen. Computergenerierte 3D-Bilder sind sein Hobby. Seine erste 3D-Erfahrung stammt aus dem Jahr 1985, der Ära solcher Geräte wie dem ZX Spectrum. Damals experimentierte er mit VU-3D. Es folgte eine längere Phase, in der er sich nicht mehr mit 3D beschäftigte, sondern seine 2D-Grafikkenntnisse verbesserte. Er arbeitete in der Werbebranche, sammelte Erfahrung im Bildaufbau und im Umgang mit Vektor- und Bildbearbeitungsprogrammen und verbesserte die Qualität seiner Arbeiten. Als 3D Studio herauskam, benutzte er es ausgiebig für Videoclips. Momentan konzentriert er sich primär auf 3D-Standbilder, beschäftigt sich aber auch noch mit Animation. 1995 gewann er einige Preise der Sciencefiction-Zeitschrift *Nowa Fantastyka*. Zemczak verzichtet auf Skizzen; er entwirft seine Bilder lieber direkt im Computer. Ausgehend von einem gedanklichen Basiskonzept erstellt er zunächst einzelne Objekte in 3D Studio Max. Die Figuren entstehen meist

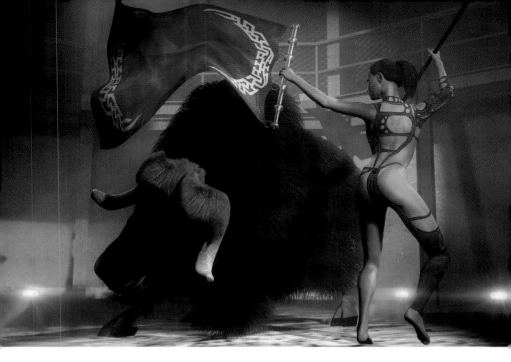

in Poser und werden dann in 3D Studio Max importiert, wo Texturen hinzukommen. Ist die Basisszene vollständig und gerendert, wechselt Zemczak zu Photoshop, und es folgen 2D-Retusche, Effekte und Feinabstimmung.

e-mail:	http://www.	Country:	Contact:	Copyright:	Software:
mhb3d @aol.com	members.aol.com /mhbfolio	United Kingdom	2 Mansfield Drive, Merstham, Surrey, RHI3JX	MHB © 2001	3D Studio Max Adobe Photoshop

CLOSE-UPS

Mark Harrison-Ball first got interested in 3D while studying General Design as a university student. He was introduced to 3D Studio, which seemed to be quite difficult to use when it was DOS-based. At that time he was modelling robots and lamps. When he progressed to using 3D Studio Max, visualizing his work came more easily. After graduating in 1997, he worked with 3D while freelancing. He quit Web design and moved to IT, which gave him more time to concentrate on developing style and direction in his 3D work. Attention to detail and Photoshop skills are his two greatest assets, allowing him to produce effective texture mapping and make his 3D models look more realistic. He usually spends more time on creating his textures, since they are key to the quality of the work. Ball is currently working on animating some of his models, a very difficult task to bring off effectively.

Before he starts any 3D project, Ball spends a lot of time collecting resource material from magazines, Web sites, and even television. He also uses his own face, looking at the details and taking photos as well. This all gives him an idea of the necessary colour tones, lighting and presentation. For human faces he starts with polygon modelling for the eye, then the mouth, and finally the nose. The nose is always challenging to construct, and it is still difficult to find one that has been modelled correctly. After that he models the shape of the head using a sphere. Finally all the elements are brought together and holes are cut in the sphere for the mouth, nose, ears and eyes. The next step is texturing, and before doing it properly, he unwraps the mesh and spends a long time moving vertices around to get rid of any overlapping, particularly around the eyes and mouth. Then he uses Textporter, a plug-in for 3D Studio Max, and brings this into Photoshop as a template. Ball uses an Athlon 1.2 computer with 1.2 GB of RAM. He also uses a Wacom graphics tablet, essential for doing any serious texture work.

Mark Harrison-Ball s'intéresse pour la première fois à la 3D pendant ses études universitaires de « design général ». Il découvre 3D Studio, qui lui semble difficile d'emploi, la version étant alors sous DOS. Il modèle à l'époque des robots et des lampes. Passant à 3D Studio Max, son travail devient beaucoup plus proche de lui. Après l'obtention de son diplôme en 1997, il travaille en free-lance et fait de la 3D. Il arrête le design Web et s'oriente vers l'informatique, ce qui lui laisse plus de temps pour se concentrer sur le développement d'un style et d'une direction pour ses travaux en 3D. Son attention aux détails et ses compétences Photoshop sont ses deux plus grands atouts et lui permettent de produire des textures et de rendre ses modèles 3D plus réalistes. Il passe généralement beaucoup plus de temps sur la création de ses textures puisqu'elles sont vitales pour la qualité de ses images. Ball travaille actuellement à l'animation de ses modèles, une tâche très difficile.

Avant de commencer un projet 3D, Ball passe du temps à rassembler des éléments à partir de magazines, de sites Web, et même de la télévision. Il utilise aussi son propre visage, regarde les détails et prend des photos. Cela lui donne une idée des tons à utiliser, de l'éclairage et de la présentation.

Pour les visages, il modèle en premier les yeux, la bouche, puis le nez à l'aide de polygones. Le nez est toujours difficile à réaliser et il n'est pas aisé d'en trouver un correctement modelé. Après cela, il modèle la forme de la tête à l'aide d'une sphère puis place les éléments du visage. La phase suivante consiste à appliquer les textures. Pour ce faire, il déroule le mesh et déplace les verticales pour retirer toutes les superpositions, notamment autour de la bouche et des yeux. Il utilise ensuite Textporter, un plug-in de 3D Studio Max et ouvre le modèle dans Photoshop. Ball utilise un ordinateur Athlon 1.2 équipé de 1,2 Go de RAM. Il utilise également une tablette graphique Wacom, essentielle pour les travaux avec textures.

Während seines Kunststudiums begann sich Mark Harrison-Ball für den 3D-Bereich zu interessieren. Er lernte 3D Studio kennen, fand die Anwendung jedoch schwierig, da es noch auf DOS basierte. Damals modellierte er Roboter und Lampen – mit 3D Studio Max konnte er dann seine Arbeiten leichter visualisieren. 1997 schloss er sein Studium ab und beschäftigte sich freiberuflich weiter mit 3D. Er stieg von Webdesign auf IT um und gewann dadurch mehr Zeit, sich auf die Entwicklung eines persönlichen Stils für 3D-Arbeiten zu konzentrieren. Dank seiner beiden größten Stärken – Detailgenauigkeit und überragende Photoshop-Kenntnisse – ist sein Textur-Mapping so überzeugend, dass seine 3D-Modelle absolut realistisch wirken. Normalerweise verwendet er die meiste Zeit auf seine Texturen – sie sind der Schlüssel zur Qualität seiner Produktionen. Momentan arbeitet Harrison-Ball an einer überzeugenden Animation einiger seiner Modelle.

Bevor er mit einem 3D-Projekt beginnt, durchforstet Harrison-Ball aufmerksam Zeitschriften, Websites und sogar das Fernsehen nach Anregungen. Er benutzt auch sein eigenes Gesicht, studiert die Details und macht Fotos. So erhält er eine Vorstellung davon, welche Farbtöne und welches Licht er verwenden kann.

Ein menschliches Gesicht beginnt er mit Polygon-Modellierung für das Auge, dann gestaltet er den Mund und schließlich die Nase, deren Modellierung besonders anspruchsvoll ist. Deshalb existieren bisher kaum überzeugende Modelle. Anschließend modelliert er, von einer Kugel ausgehend, die Form des Kopfes. Schließlich fügt er alle Elemente zusammen und schneidet für Mund, Nase, Ohren und Augen Löcher in die Kugel. Es folgt das Texturieren, wozu er zunächst das Drahtmodell auseinander wickelt und so lange die Konstruktion hin- und herschiebt, bis alle Überlappungen, vor allem um den Mund und den Augen, verschwunden sind. Dann nimmt er Textporter, ein Plug-in für 3D Studio Max, und überträgt alles als Template nach Photoshop. Harrison-Ball besitzt einen Athlon Computer mit 1,2 GB RAM. Außerdem benutzt er ein Grafiktablett – ein Tool, das für ernst zu nehmende Texturarbeit unentbehrlich ist.

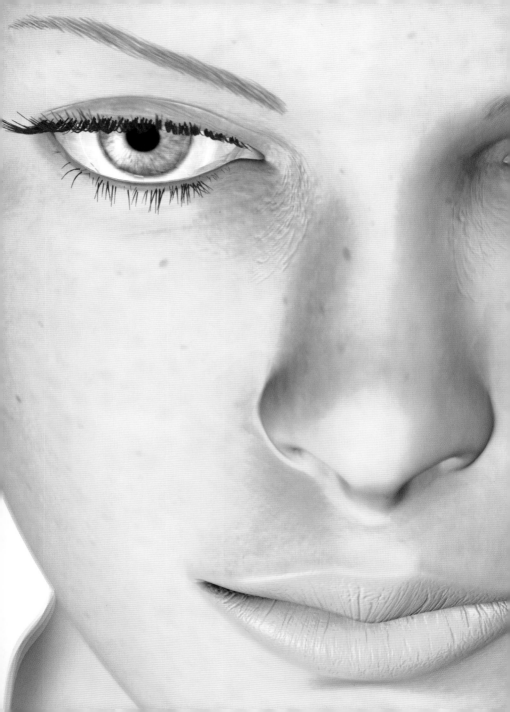

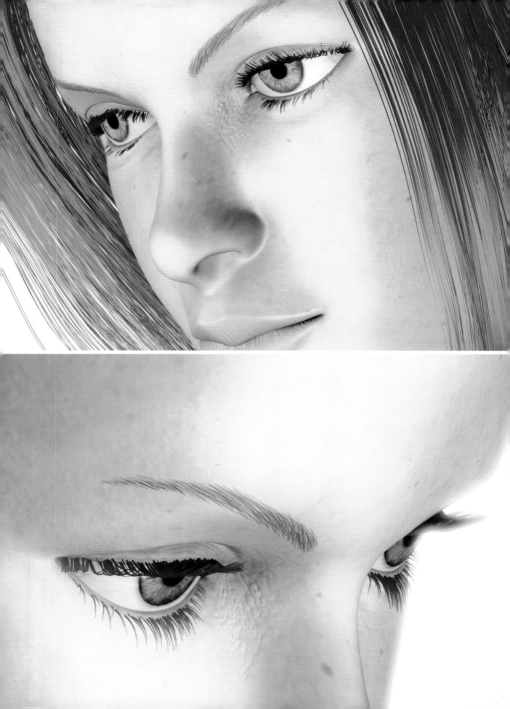

e-mail:	http://www1.	Country:	Contact:	Copyright:	Software:
elfe-mo@	linkclub.or.jp	Japan	5391-18	© 3DCG	Shade
land.linkclub.or.jp	/~elfe-mo/		Yoshino-cho	Collection	Adobe
			Kagoshima-shi		Photoshop
			Kagoshima-ken,		
			892-0871		

JAPANESE MUSCLES AND GRACE

Masaaki Ohkubo was born in November 1958 in Kagoshima, in southern Japan. Upon graduating from the University of Tsukuba, he became a teacher and engaged in creative activities. Ohkubo does not name his works, an approach he has taken in an attempt to generate original interpretations of his pieces from the viewers, without forcing his own concept upon them. His images depict everything from the sweet loving girl next door to the woman body builder, and incorporate many variations in lighting and colour.
In Japan, virtual idols all tend to have the same facial expressions, because facial expressions are technologically one of the most time-consuming phases in character creation. However, the models in Ohkubo's work have always been given interesting expressions, even unconventional ones such as the evil look on the face of the woman in her bed (featured in this book).
Ohkubo uses Shade software, the leading 3-D modelling program in Japan, and retouches his illustrations using Adobe Photoshop. Shapes created in 3D CG are usually cold, regardless of the type of software used, and it is quite a difficult task to add textures, lighting and detailed modelling to make them more attractive. It can take him up to a month just to create a body and another 10 days to complete the remaining phases of the artwork. His preoccupations include the narrative, a balance of light and shade, human facial expressions, lighting, correlation and harmony between the body lines, anatomical expression, and setting the colour theme.

Masaaki Ohkubo est né en novembre 1958 à Kagoshima dans le sud du Japon. Après avoir obtenu son diplôme de l'université de Tsukuba, il devient professeur et se livre à des activités créatives. Masaaki Ohkubo ne nomme pas ses travaux. Cette approche tente de générer une interprétation originale auprès des spectateurs sans imposer ses propres concepts. Ses images représentent différents aspects féminins, de la douce fille amoureuse à la femme culturiste, avec de nombreuses variations de couleurs et de luminosités.
Au Japon, les « idoles virtuelles » tendent à posséder les mêmes expressions faciales, car leur création est l'une des tâches les plus longues. Dans le cas des travaux de Masaaki Ohkubo, les modèles ont toujours des expressions intéressantes, voire peu conventionnelles, telles que le regard méchant de cette femme dans son lit. Masaaki Ohkubo utilise Shade, le principal logiciel de modelage 3D du Japon, et retouche ses illustrations dans Photoshop. Les formes créées en graphisme 3D sont généralement froides quel que soit le logiciel utilisé, et il est très difficile d'ajouter des textures, des détails et l'éclairage pour les rendre attrayantes. La création d'un corps peut durer jusqu'à un mois, et dix jours supplémentaires sont nécessaires pour terminer toutes les phases. Le récit, l'équilibre des lumières et des ombres, les expressions faciales, la corrélation et l'harmonie entre chaque ligne du corps, les expressions anatomiques et le thème de couleur font partie de ses préoccupations.

Masaaki Ohkubo wurde im November 1958 im südjapanischen Kagoshima geboren. Nach Abschluss seines Studiums an der Tsukuba-Universität wurde er Lehrer, war aber auch künstlerisch aktiv. Ohkubo gibt seinen Arbeiten keine Titel – er will dem Betrachter nicht sein Konzept aufzwingen, sondern ihm Freiraum für eigenständige Interpretationen lassen. Die Bandbreite seiner Charaktere reicht vom süßen, jungen Mädchen von nebenan bis zur Bodybuilderin, und sein Werk ist durch eine große Vielfalt im Einsatz von Licht und Farbe gekennzeichnet.
Viele virtuelle Idole aus Japan unterscheiden sich im Gesichtsausdruck nur wenig voneinander. Das liegt daran, dass es technisch sehr zeitaufwändig ist, Gesichtszüge zu gestalten. Masaaki Ohkubos Models haben jedoch immer ein interessantes und manchmal sogar ungewöhnliches Mienenspiel – man beachte nur den bösen

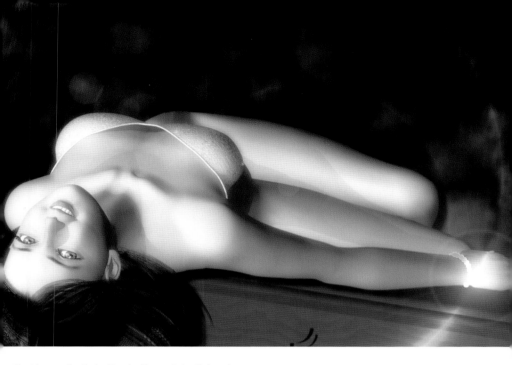

Gesichtsausdruck der Frau im Bett auf den Folgeseiten.
Ohkubo benutzt Shade, in Japan die führende 3D-Modelliersoftware, und retuschiert seine Illustrationen mit Photoshop. Unabhängig von der verwendeten Software strahlen digitale Objekte eine gewisse Kälte aus, und es ist relativ schwierig, ihnen durch Textur, Licht und detailliertes Modellieren größere Attraktivität zu verleihen. Ohkubo benötigt bis zu einem Monat, um einen Körper zu gestalten, und weitere zehn Tage zum Abschluss der übrigen künstlerischen Arbeiten. Sein besonderes Augenmerk gilt dem Erzählerischen, dem Gleichgewicht von Licht und Schatten, dem menschlichen Gesichtsausdruck, der Beleuchtung, der stimmigen und harmonischen Linienführung bei den Körperkonturen und den Farbeinstellungen.

e-mail:
mike
@mworx.com

http://www
mworx.com

Country:
Germany

Copyright:
© Michael Koch

Software:
3D Studio Max
Mental Ray
Combustion
Adobe
Photoshop

INDIAN-STYLE GIRLS IN POLYGONS

Michael Koch is a freelance artist and animator from Mainz, Germany. His main focus is on character design and animation for television and film. He is a member of the Discreet Max Support Forum staff, a beta tester for various graphics software and hardware, and author of numerous articles on 3D animation techniques. He came in contact with computer-generated 3D images for the first time in 1994, when he was doing graphics for game companies. He quickly set up his own company, Mindworx, and in the years that followed he developed an interesting and varied portfolio, including Web design for Nestlé and animation sequences for BMW. In 1988 he worked on the production of *Das Biest im Bodensee* for Germany's biggest TV channel, RTL. It was the first German creature movie for television to feature an entirely digital monster. In the same year he also co-authored the book *Inside 3D Studio Max 2*. As a guest advisor at the Filmakademie Baden-Wuerttemberg, he contributed to the development of advanced facial character arrangement and animation techniques within the Virtual Character Research project, and created the award-winning image "Prêt-à-Porter". Recently, he has produced a CG image of the surface of Mars that was projected onto the 70-meter wide screen at the EXPO 2000 world exposition.

When it comes to production, Koch generally uses a combination of 3D Studio Max, Mental Ray, Combustion, After Effects and Photoshop. The process of playing with 3D software always generates ideas and effects that can be worked out later. He has been published in printed media such as *3D World Magazine*, *3D Artist Magazine*, *Design4 Magazine* and *Digital Designer*, among many others. He has also received various awards and honours, including the Animago 3D Award and the Big Kahuna Award. Some Web sites recently featuring his work are *raph.com*, *cgw.com*, *3drender.com*, *max3d.com* and *3dcafe.com*.

Michael Koch est un artiste et un animateur free-lance de Mayence en Allemagne. Il se concentre sur la conception et l'animation de personnages pour la télévision et les films. C'est un membre du Discreet Max Support Forum, un bêta testeur de logiciels et de matériels graphiques, et l'auteur de nombreux articles sur les techniques d'animations 3D. Il entre pour la première fois en contact avec l'ordinateur en 1994, lorsqu'il réalise des images pour des sociétés de jeux. Il crée rapidement sa propre société, Mindworx, et dans l'année qui suit, développe un portefeuille varié et intéressant comprenant du design Web pour Nestlé et des séquences d'animation pour BMW. En 1998, il travaille à la production du film *Das Biest im Bodensee* pour RTL, la plus importante chaîne de télévision allemande. C'est le premier film allemand télévisé à montrer une créature entièrement numérisée. La même année, il coproduit le livre *Inside 3D Studio Max 2*. Conseiller à la Filmakademie Baden-Württemberg, il contribue au développement de techniques d'animation et d'arrangements faciaux au sein du projet Virtual Character Research, et crée la célèbre image « Prêt-à-porter ». Il a récemment produit une image de la surface de Mars qui a été projetée sur un écran de 70 mètres lors de l'exposition mondiale EXPO 2000.

Koch utilise 3D Studio Max, Mental Ray, Combustion, After Effects et Photoshop pour réaliser ses œuvres. Le processus de test des logiciels graphiques génère toujours des idées et des effets qu'il peut utiliser ultérieurement. Ses travaux ont été publiés dans des magazines tels que *3D World Magazine*, *3D Artist Magazine*, *Design4 Magazine* et *Digital Designer*, entre autres. Il a également reçu de nombreux prix et honneurs, dont l'Animago 3D Award et le Big Kahuna Award. Certains sites Web, tels que *raph.com*, *cgw.com*, *3drender.com*, *max3d.com* et *3dcafe.com*, ont récemment publié ses travaux.

Michael Koch ist freischaffender Künstler und Animator und stammt aus Mainz. Sein Schwerpunkt liegt auf Charakterdesign und -animation für Film und Fernsehen. Er ist Mitarbeiter beim Discreet Max Support Forum, Beta-Tester für Grafiksoftware und -hardware und Autor zahlreicher Artikel über 3D-Animationstechniken. 1994 kam er zum ersten Mal mit computergenerierten 3D-Bildern in Berührung, als er für einige Firmen Grafiken für Spiele erstellte. Er gründete bald eine eigene Firma, Mindworx, und hat seitdem ein interessantes und vielseitiges Portfolio entwickelt, unter anderem mit Webdesign für Nestlé und Animationssequenzen für BMW. 1988 war er an der RTL-Produktion *Das Biest im Bodensee* mit dem ersten deutschen rein virtuellen TV-Ungeheuer beteiligt. Im selben Jahr war er Koautor des Buchs *Inside 3D Studio Max 2*. Als Gastdozent der Filmakademie Baden-Württemberg arbeitete er im Rahmen des Forschungsprojekts „Virtual Character" an der Entwicklung individueller Charaktere und an neuen Animationstechniken und schuf das preisgekrönte Bild „Prêt-à-Porter". Sein CG-Bild der Marsoberfläche wurde auf der EXPO 2000 auf eine 70 Meter breite Bildwand projiziert.

Für die Produktion verwendet Koch gewöhnlich eine Kombination aus 3D Studio Max, Mental Ray, Combustion, After Effects und Photoshop. Im spielerischen Umgang mit 3D-Software entstehen ständig Ideen und Effekte, die später ausgearbeitet werden können. Koch hat in Printmedien wie *3D World Magazine*, *3D Artist Magazine*, *Design4 Magazine* und *Digital Designer* publiziert. Außerdem erhielt er diverse Preise und Ehrungen – unter anderem den Animago 3D Award und den Big Kahuna Award. Zurzeit sind seine Arbeiten zum Beispiel auf den Websites raph.com, cgw.com, 3drender.com, max3d.com und 3dcafe.com zu sehen.

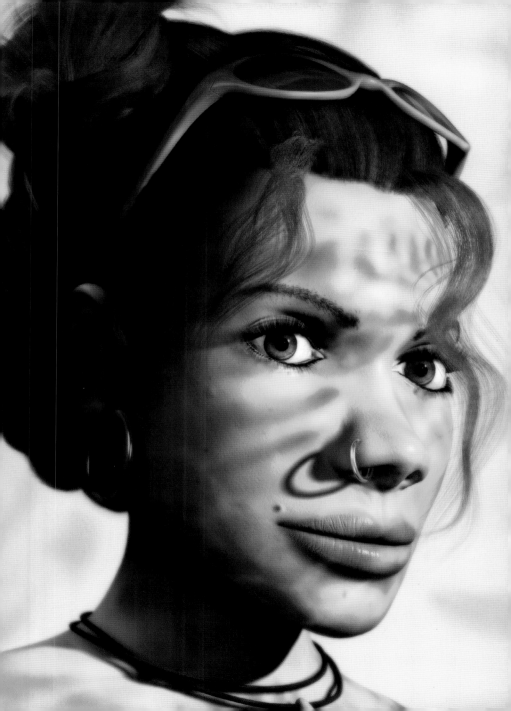

MICK S. & MIKE M.

e-mail:
artists
@arqangel.com

http://www.
arqangel.com

Country:
Canada

Contact:
2665 Millpond
Terr. Victoria, B.C.
V9B6A4

Copyright:
© Above
Design Ltd.

Software:
LightWave 3D

SUPER HERO: SUPER DIGITAL POWER!

Mick Szirmay was born and raised in western Canada and attended schools that excelled in their arts programs. He took every art class he could, from music to photography and film. He ended up, however, earning a degree as an electronics technician with a specialty in telecommunications. A few years later, he was introduced to the Macintosh and used all his time to learn computer graphics and its tools on the computer. He was working for an educational software company dealing with both graphics and soundtrack when he met Mike Merryweather. They formed a multimedia design company, Above Design Ltd., and are currently working with a Hollywood production company designing the look and feel of a motion picture due to start filming in September 2001. Mike Merryweather had focused on technical support for a couple of years when he quit his job and realized that computer graphics was what he wanted to do.

He earned a diploma in computer graphics and animation and was hired as a graphics assistant to Mick Szirmay. *ArqAngel*, their four-hand project, has been called the future of comics' entertainment. It has drawn the attention and praise of comic book fans and artists worldwide and delights web surfers with its 3D artwork, advanced Flash animation, and incredible sci-fi stories. *ArqAngel* tells the adventures of Jone, teenage heir to the Arqian Throne - a whole science fiction story which they created. To design an episode of *ArqAngel*, they start by sketching the concepts on paper. From there Szirmay and Merryweather go separate ways. Szirmay starts working on the character's basic look, while Merryweather designs the scenery and models any elements needed for the shot. Once the basics are done, they do a quick composite and see where they will need to add elements and details. They mainly use LightWave 3D, since it is one of the best applications for Macintosh users designing in three dimensions.

Mick Szirmay est né et a grandi au Canada. Il a étudié dans des écoles réputées pour leurs programmes artistiques et a suivi tous les cours possibles, de la musique à la photo et au cinéma. Il obtient toutefois un diplôme de technicien en électronique avec une spécialisation en télécommunications. Quelques années plus tard, il découvre le Macintosh et l'utilise pour apprendre le graphisme et ses outils. Il travaille dans le domaine du graphisme et du son pour un éditeur de logiciels éducatifs lorsqu'il rencontre Mike Merryweather. Ils fondent Above Design Ltd., une société de design multimédia, et travaillent actuellement pour une société de production de Hollywood à la conception de l'aspect d'un film dont le tournage débutera en septembre 2001. Mike Merryweather a travaillé quelques années sur le support technique avant de quitter son emploi et réaliser que le graphisme était ce qu'il voulait vraiment faire. Il obtient un diplôme de graphisme et d'animation et prend un emploi d'assistant graphique auprès de Mick Szirmay.

ArqAngel, leur projet, est considéré comme le futur de la bande dessinée. Il a attiré l'attention et reçu les éloges des fans de bandes dessinées et d'artistes du monde entier, et ravi les visiteurs du site Web par sa 3D, ses animations Flash et son incroyable aventure de science-fiction. *ArqAngel* est une fiction qu'ils ont entièrement créée. Elle décrit l'aventure de Jone, une adolescente héritière du trône arquien.

Le processus utilisé pour la conception d'un épisode d'*ArqAngel* débute par des esquisses des concepts sur papier. Szirmay et Merryweather travaillent ensuite séparément. Szirmay travaille sur l'aspect de base des personnages tandis que Merryweather conçoit la scène et modèle les éléments nécessaires à la prise de vue. Une fois les éléments de base créés, ils réalisent une rapide mise en scène pour déterminer les endroits où ils devront ajouter des éléments et des détails. Ils utilisent principalement LightWave 3D car c'est une des meilleures applications 3D sur Macintosh.

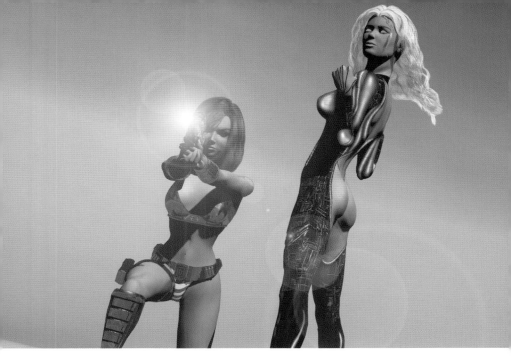

Mick Szirmay ist im Westen von Kanada geboren und aufgewachsen. Obwohl er sich in der Schule für jeglichen Unterricht in Musik, Kunst, Fotografie und Film begeisterte, wurde er zunächst Nach-richtentechniker mit einer Spezialisierung in Telekommunikation. Einige Jahre später lernte er den Macintosh kennen und widmet seitdem seine gesamte Zeit der Computergrafik und den entsprechenden Computer-Tools. Er arbeitete in einer Firma für Lernsoftware im Bereich Grafik und Soundtracks, als er Mike Merryweather traf. Sie gründeten Above Design Ltd., ein Unternehmen für Multimediadesign, und arbeiten zurzeit gemeinsam mit einer Produktionsfirma aus Hollywood an einem Kinofilm, der im September 2001 gedreht werden soll. Mike Merryweather hatte zunächst im technischen Support gearbeitet, erkannte dann aber, dass seine eigentlichen Interessen der Computergrafik galten, und absolvierte eine entsprechende Ausbildung. Mick Szirmay stellte ihn als Assistenten ein.

Ihr gemeinsames Projekt *ArqAngel* gilt als die Zukunft der Comic-Unterhaltung. Es wurde weltweit von Comic-Fans und Künstlern mit Lob überschüttet und begeistert Websurfer mit 3D-Grafik, genialer Flash-Animation und unglaublichen Sciencefiction-Abenteuern. *ArqAngel* erzählt die Abenteuer von Jone, dem jugendlichen Erben des Arqischen Throns – eine Sciencefiction-Geschich-te, die Szirmay und Merryweather selbst erfunden haben.

Der Entstehungsprozess einer Folge von *ArqAngel* beginnt mit Konzeptskizzen auf Papier. Danach arbeiten die beiden unabhängig voneinander

weiter. Szirmay gestaltet das Aussehen der Cha-raktere, während Merryweather das Szenenbild entwickelt und alle für die Aufnahme notwendigen Elemente modelliert. Stehen diese Grundlagen, benutzen sie eine Überblendung, um zu kontrollieren, wo sie Elemente und Details hinzufügen müssen. Sie verwenden vor allem LightWave 3D, eine der besten 3D-Anwendungen für Mac-User.

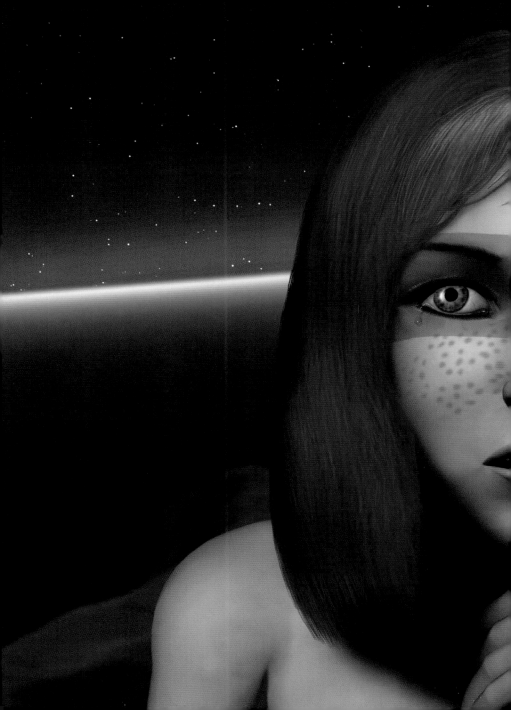

e-mail:	http://www.	Country:	Contact:	Copyright:	Software:
info @nana-fan.com	nana-fan.com	Japan	2-40-3-102 Kamiikibukuro Toshima-ku, Tokyo, 170-0012	© J.A.W.S. Nana project	Not released for this project

OUTSTANDING CAREER WANTED

Nana is one of the latest sensations in Japan. She has been the featured celebrity of a dozen magazines and has been televised all over Japan. Even the names of the artists have been kept secret in order to promote the human aspect of the model. She has been produced by the Tokyo-based digital model agency Japan Audio Visual Workshop. They also created Nana's whole background and history so as to draw people's attention to the fact that she is truly a humanoid: she can interact with us in much the same way as a super pop-star who we read about all our lives without ever getting to know personally. Nana is 17 years old (under age and in high school). She was born in Japan's rural Northeast and moved to Tokyo to attend junior high school. Her blood type is B, she is 160 centimetres tall, and her zodiac sign is Taurus. She is a CG girl who was born completely in virtual space. Nana refers to herself as a celebrity virtual child. She thinks of herself as being much cuter and purer than other virtual idols. She would like to become a supermodel, have a singing career, and of course try to become a dramatic actress and work with Hollywood directors. She has appeared in numerous publications such as *CG-iCupid*, *Tokyo One Week*, *Hot Dog*, *Sabra*, *EAT JAPAN*, among others.

It is really great to see how the boundaries between real and virtual are toppling, and how the acceptance of digital characters has started to become an everyday fact. Nana had her life planned from the very beginning, the path from birth to fame, in order to make her achievements totally equated with the classic model of media exposure. The interaction starts exactly at this point. Actors, singers and artists can hardly survive without media appeal, so in future we may see a large population of artificial people not only with, but also without jobs.

Nana fait actuellement sensation au Japon. Publiée en tant que célébrité dans une douzaine de magazines, elle a été diffusée dans tout le pays. Les noms des artistes sont tenus secrets pour maintenir le caractère humain du modèle. Elle a été produite par l'agence de modèles numériques Japan Audio Visual Workshop de Tokyo. L'agence a créé l'environnement intégral et l'histoire de Nana pour attirer l'attention du public sur le fait qu'elle ressemble en tous points à un être humain et peut interagir avec nous comme le ferait toute autre star : nous lisons quantité de récits sur celles-ci mais ne les connaissons pas personnellement pour autant. Nana a 17 ans et fréquente encore le lycée. Elle est née dans le nord-est rural du Japon et a été au collège à Tokyo. Son groupe sanguin est B. Elle mesure 1 mètre 60 et est née sous le signe du Taureau. C'est une fille numérique née dans un monde virtuel. Nana se considère comme une célébrité virtuelle. Elle pense qu'elle est plus jolie et plus pure que les autres idoles virtuelles. Elle aimerait devenir top model, faire une carrière de chanteuse, et bien sûr devenir actrice et travailler avec des réalisateurs hollywoodiens. Elle est apparue dans des publications telles que *CG-iCupid*, *Tokyo One Week*, *Hot Dog*, *Sabra* et *EAT JAPAN*. Il est agréable de voir disparaître la frontière entre le réel et le virtuel, et de constater l'acceptation grandissante des personnages numériques dans la vie courante. La vie de Nana a été planifiée depuis le début, depuis sa naissance à la gloire. Ainsi, pour qu'elle atteigne ce but, elle doit bénéficier de toute la couverture médiatique possible. L'interaction commence à ce stade. Les acteurs, chanteurs et artistes peuvent difficilement survivre sans les médias. On pourrait ainsi constater à l'avenir la présence d'une population de personnes artificielles avec et sans emploi.

Nana ist momentan in Japan der letzte Schrei. Sie wird auf allen Titelseiten gefeiert und war schon in ganz Japan im Fernsehen zu sehen. Die Namen der Künstler, die sie kreiert haben, werden geheim gehalten, damit das Model noch menschlicher erscheint. Nana wurde von der Digital-Model-Agentur Japan Audio Visual Workshop in

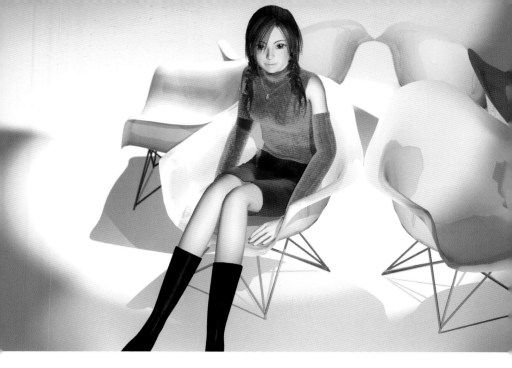

Tokyo produziert. Man schuf für sie eine eigene Welt und sogar eine Vergangenheit, um der Öffentlichkeit deutlich zu machen, dass sie wirklich menschenähnlich ist. Wir können mit ihr auf ähnliche Weise interagieren wie mit Superstars, über die wir ein Leben lang alles Mögliche lesen, ohne sie je persönlich kennen zu lernen.

Nana ist 17 Jahre alt und stammt aus dem ländlichen Nordosten Japans. Nach Tokyo ist sie gezogen, um dort die Junior High School zu besuchen. Sie hat die Blutgruppe B, ist 1,60 m groß, und ihr Sternzeichen ist Stier. Sie ist ein CG-Girl, das vollständig im virtuellen Raum entstanden ist. Nana bezeichnet sich selbst als virtuellen Kinderstar. Ihrer Ansicht nach ist sie viel hübscher und unschuldiger als andere Virtual Idols. Gern würde sie ein Supermodel werden, eine Karriere als Sängerin machen und natürlich als Schauspielerin mit Hollywood-Regisseuren arbei-ten. Nana war bisher in Publikationen wie *CG-iCupid*, *Tokyo One Week*, *Hot Dog*, *Sabra* und *EAT JAPAN* zu sehen.

Es ist faszinierend, wie die Grenzen zwischen Realität und Virtualität allmählich verschwinden und digitale Charaktere inzwischen fast selbstverständlich als Teil des Alltags akzeptiert werden. Nanas Leben ist von der Geburt bis zu ihrem Erfolg vorausgeplant; daher musste sie in den Medien ähnlich präsentiert werden wie klassische Models. Genau hier beginnt die Interaktion. Schauspieler, Sänger und Künstler können ohne Medientauglichkeit kaum überleben, und vielleicht erleben wir ja zukünftig eine Vielzehl künstlicher Menschen, von denen einige auch arbeitslos sein werden.

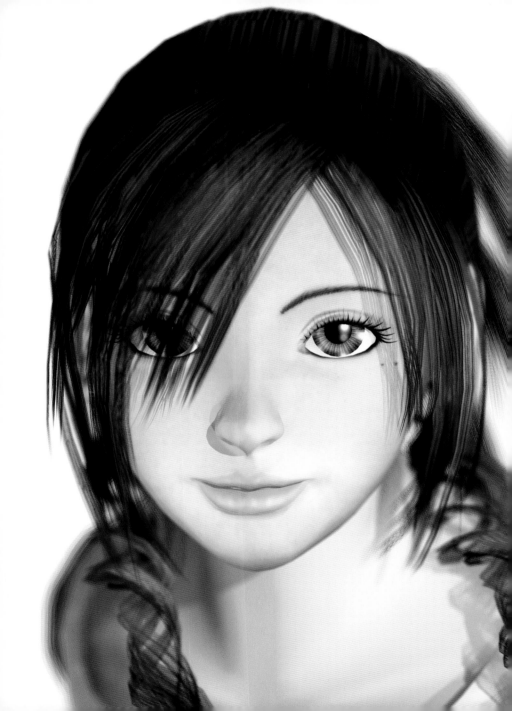

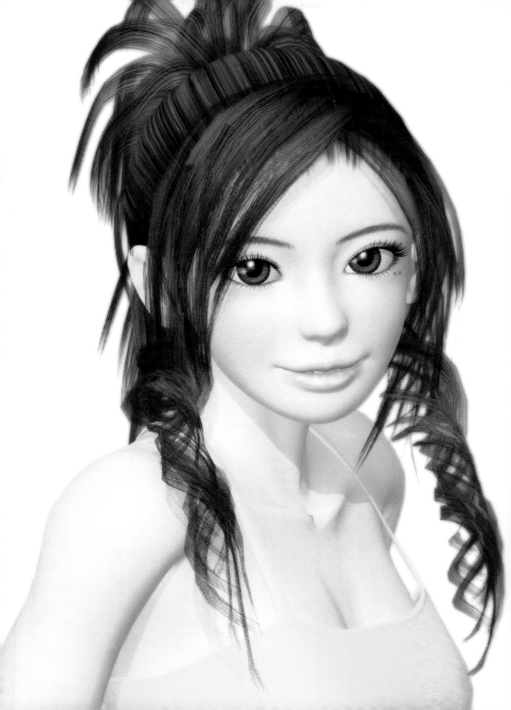

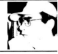

e-mail:	http://www.	Country:	Copyright:	Software:
vanquehl@yahoo.com	3dxtc.com	United States	© 2001 Vanquehl Co.	Poser

DIGITAL NUDE EXPERIMENTS

Reed VanQuehl began drawing early on, and sold his first oil painting in 1966 at the age of sixteen. He has had formal training in many traditional media such as oils, pastels, ink and charcoal. Through the 1970s he continued to do traditional art with a heavy emphasis on nudes and portraits in soft pastels.

In the early 1980s, he was contracted to develop graphics for several erotic game consumer software products. This eventually led to a strong interest in computer graphics and drawing software. Perhaps it was only natural to jump into digital art using 3D software, while still keeping a foot in traditional techniques. Currently, his digital art is composed from both 3D digitally rendered images and hand-painted traditional art. The 3D rendering allows him to get a fairly accurate representation of a scene, while the traditional media are excellent for capturing individual expression.

This hybrid technique did not come easily. Shortly after buying his first Poser program, he started to make 3D erotica and classic pin-ups without any post-production work. These images were of lifeless, plastic-looking models in unrealistic poses, but at the time he thought they looked great. Then he began experimenting with hair meshes and other ways to create more realistic hair and clothing. As this was still in the early days of Poser, few props and techniques were available. And since the props were bad, he gave up the idea of finding any better ones and devoted his efforts to retouching the images in photo-editing software.

To start a new piece, he usually visualizes or works from a theme. Once he has a pre-conception, he researches various elements of the image. This research is accomplished solely on the Internet, where he finds poses, studies photographs, and looks for suitable 3D models and surface textures. This allows him to search for a pose similar to his concept, and also collect images that have potential for future work. These real photographs serve as a guide to the 3D model's pose in Poser, and also help with the final bodywork.

Reed VanQuehl a commencé à dessiner très jeune et a vendu sa première huile à l'âge de 16 ans, en 1966. Il a étudié de nombreux supports traditionnels tels que la peinture à l'huile, les pastels, l'encre et le fusain. Il continue à faire du dessin traditionnel au cours des années 1970 en mettant l'accent sur les nus et les portraits en pastels doux.

Il développe des images pour de nombreux jeux érotiques au début des années 1980, ce qui accroît son intérêt pour le graphisme et les logiciels de dessin. Le passage à la 3D est la continuité naturelle de ses techniques traditionnelles. Ses images se composent actuellement d'images 3D et de dessins faits à la main. La 3D lui permet de représenter une scène assez fidèlement, tandis que le dessin traditionnel permet de capter les expressions individuelles.

Cette technique hybride ne lui est pas venu simplement. Très peu de temps après avoir acquis son premier logiciel Poser, il commence à réaliser des pin-up 3D classiques et érotiques sans aucun travail de post-production. Ces images sont alors des modèles sans vie, ressemblant à du plastique et dans des poses irréalistes, mais qu'il trouve superbes. Il fait des essais avec les cheveux et cherche d'autres manières de créer une chevelure et des vêtements plus réalistes. Peu d'accessoires et de techniques sont en effet disponibles au début de l'existence de Poser. Les accessoires étant vraiment de mauvaise qualité, il abandonne ses recherches et consacre ses efforts à corriger les détails dans un logiciel de retouche d'image.

Pour démarrer sur une nouvelle image, il visualise ou travaille à partir d'un thème. Dès qu'il détient le concept, il recherche les différents éléments de l'image. Cette recherche est faite uniquement sur Internet, où il trouve des poses, étudie des photos, et recherche les modèles et les textures appropriées, ce qui lui permet de rassembler

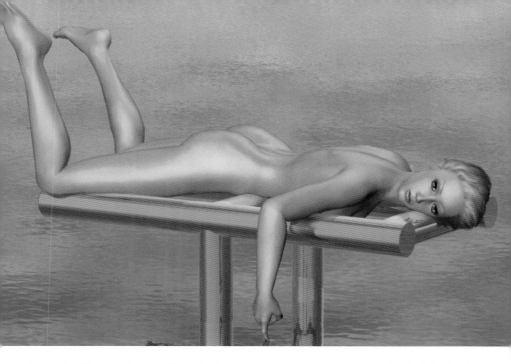

également des éléments qui pourront lui servir plus tard. Les photos sont utilisées pour guider la réalisation du personnage dans Poser et régler les détails.

Reed VanQuehl begann schon früh zu zeichnen und verkaufte 1966, mit sechzehn, sein erstes Ölgemälde. Er erlernte die klassischen Techniken wie Ölmalerei, Pastell-, Tusche- und Kohlezeichnen. Auch während der siebziger Jahre beschäftigte er sich mit traditioneller Kunst und schuf vor allem Akte und Porträts in sanften Pastelltönen.

Anfang der Achtziger bekam VanQuehl den Auftrag, Grafiken für diverse erotische Computer-spiele zu entwerfen, und entwickelte ein starkes Interesse an Computergrafik sowie Zeichen-software. Problemlos tauchte VanQuehl mit 3D-Software in die digitale Kunst ein, während er gleichzeitig an klassischen Techniken festhielt. Gegenwärtig vermischen sich in seinen Grafiken sowohl digital gerenderte 3D-Bilder als auch handgemalte traditionelle Kunst. 3D-Renderings ermöglichen ihm die präzise Darstellung einer Szene, während sich die klassischen Techniken ausgezeichnet dazu eignen, einen individuellen Ausdruck einzufangen.

Diese hybride Arbeitsweise war am Anfang nicht einfach. Kurz nachdem er sein erste Version von Poser gekauft hatte, begann VanQuehl mit 3D-Erotika und klassischen Pin-ups ohne jegliche Nachbearbeitungen. Dies waren Bilder von leblos wirkenden Modellen in unrealistischen Posen, die aussahen, als wären sie aus Plastik – damals hielt er sie jedoch für äußerst attraktiv. Dann fing er an, mit Haarsträhnen und anderen Möglichkeiten zu experimentieren, um Haare und Kleidung realisti-scher darzustellen. In den Anfangszeiten von Poser standen nur wenige Props und Techniken zur Verfügung. Da diese Props zu schlecht waren, versuchte er, seine Arbeiten in Bildbearbei-tungssoftware zu retuschieren.

Neue Arbeiten basieren oft auf bereits vorhandenen Themen, die VanQuehl. Ausgehend vom Grobentwurf sucht er dann nach verschiedenen Elemente des Bildes. Diese Suche findet ausschließlich im Internet statt; dort findet er Posen, analysiert Fotos und sucht nach passenden 3D-Modellen und Oberflächentexturen. Außerdem kann er dabei gleichzeitig Bilder sammeln, die ein Potenzial für zukünftige Arbeiten haben. Diese echten Fotos dienen als Vorlage für die Pose des 3D-Modells in Poser und helfen bei der abschließenden Nachbearbeitung.

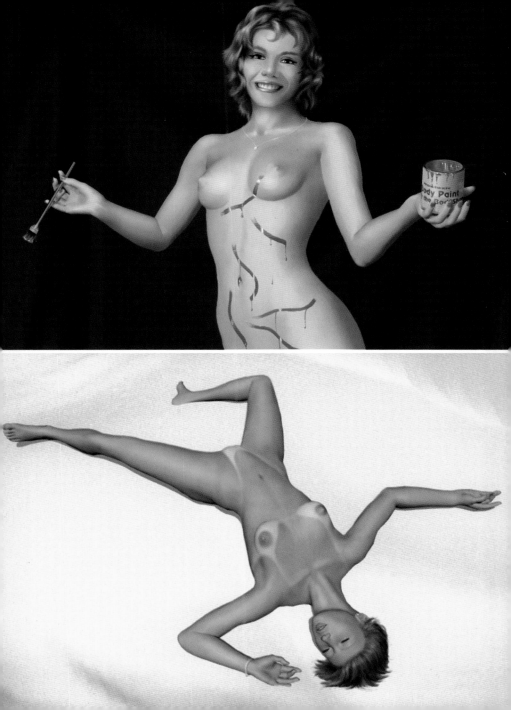

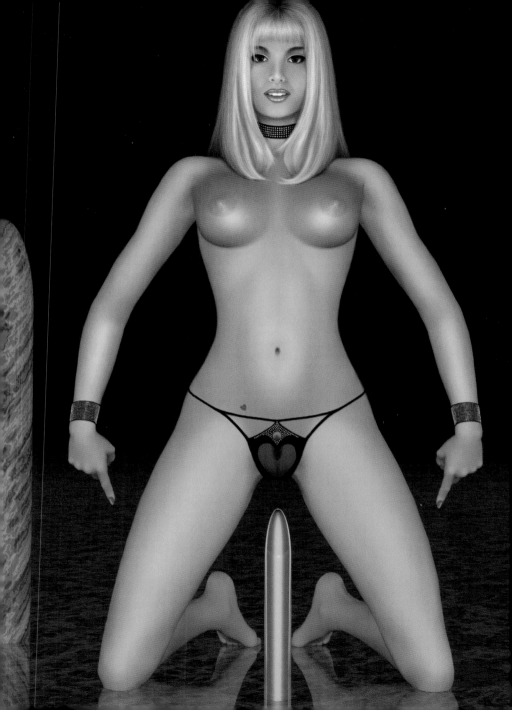

RENE MOREL

e-mail:
morelr@
sympatico.ca

http://www.
amazonsoul.com

Country:
Canada

Copyright:
© Rene Morel

Software:
Maya
Adobe
Photoshop

HYPER REALISTIC WEB MODEL

Rene Morel studied fine arts at the University of Quebec, and still paints using traditional media. He had worked for many years as a freelance illustrator in advertising using an airbrush, when a colleague introduced him to the computer graphics field. At that time a friend was working at Taarna Studios in Montreal and Morel had the chance to train with him. Within a few weeks, he started to model and texture the 3D characters for the short film *The Boxer*, which won many awards world-wide.

In 1997, after a year at Behavior Entertainment, he was hired by Square USA to work in the Hawaii office on the feature film *Final Fantasy*, for which he modelled and textured many of the main characters. Today, he works as an art director for a project that blends erotica and Sci-fi environments in a full CG production.

Morel's models have an astonishing level of realism, not only in their body shape and textures, but also in difficult aspects like hair and skin. This reflects the effort he puts into their production. He starts from scratch and uses a colour, bump and specular map. His models have between 15,000 and 20,000 polygons, 2000 textures, planar and cylindrical projection mapping, and blend shape deformers for facial expressions.

He works with Maya, and paints textures with Photoshop, projecting the maps on polygonal models later on. He can take more than 2 weeks to model and texture just a head, depending on the complexity of the work. His main objective is to make the characters look alive, and he always strives to give them a natural, organic look.

He has been featured on the cover of *Convergence* and published by *Computer Graphic World (CGW)* in an article on 3D painting. He has also been interviewed on Web sites such as *CGChannel* and *3Dvf* about his new project, *Amazon Soul*.

Rene Morel a étudié les beaux-arts à l'université du Québec et peint toujours sur supports traditionnels. Il travaille depuis de nombreuses années dans le domaine publicitaire en tant qu'illustrateur free-lance à l'aérographe lorsqu'un ami lui fait découvrir le graphisme sur ordinateur. A cette époque, un de ses amis travaillant au studio Taarna de Montréal, Morel saisit l'opportunité de se former auprès de lui. En quelques semaines, il est déjà capable de modeler et d'habiller des personnages 3D pour un court métrage, *The Boxer*, qui a remporté de nombreux prix de par le monde.

En 1997, après avoir passé un an chez Behavior Entertainment, il est engagé par Square USA pour travailler au bureau de Hawaii sur le film *Final Fantasy*, pour lequel il modèle et habille la plupart des personnages principaux. Il travaille aujourd'hui en tant que directeur artistique sur un projet mêlant environnements érotiques et science-fiction.

Les modèles de Morel ont atteint un niveau incroyable de réalisme, non seulement dans la forme des corps et des textures, mais également dans les aspects difficiles tels que la peau et les cheveux, ce qui reflète les efforts qu'il consacre à leur production. Il commence ses personnages à partir de zéro. Ses modèles contiennent entre 15 000 et 20 000 polygones, 2 000 textures, et des projections planes et cylindriques.

Il travaille dans Maya et dessine les textures dans Photoshop pour les projeter plus tard sur les polygones des modèles. Le modelage et l'habillage peuvent prendre plus de 2 semaines pour rendre un personnage réel et lui donner un aspect organique et naturel.

Il est apparu sur la couverture du magazine *Convergence* et dans un article sur la 3D du magazine *Computer Graphic World*. Des sites Web tels que *CGChannel* et *3Dvf* l'ont également interviewé à propos d'*Amazon Soul*, son nouveau projet.

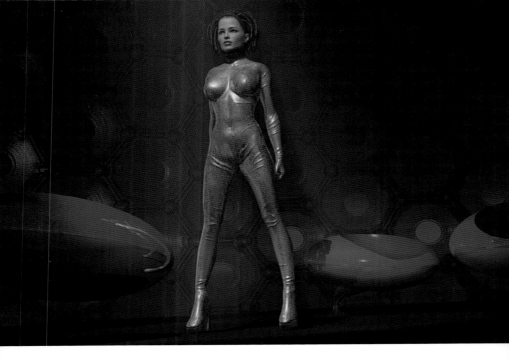

Rene Morel hat an der Universität von Quebec Kunst studiert und malt noch heute in den klassi-schen Techniken. Er hatte bereits viele Jahre mit Airbrush-Techniken als freischaffender Illustrator in der Werbung gearbeitet, als er auf die Computer-grafik aufmerksam wurde. Ein Freund arbeitete damals bei Taarna in Montreal, und Morel hatte die Möglichkeit, mit ihm zu üben. Bereits nach wenigen Wochen begann er, die 3D-Charaktere für den Kurzfilm *The Boxer*, der weltweit zahlreiche Preise gewann, zu modellieren und zu texturieren. Nach einem Jahr bei Behaviour Entertainment ging er 1997 zu Square USA, um in Hawaii für den Spielfilm *Final Fantasy* viele der wichtigen Charaktere zu entwickeln. Heute arbeitet er als Artdirector für ein Projekt, das Erotika und Sciencefiction-Umgebungen in einer reinen Computergrafik-Produktion miteinander verbindet.

Morels Modelle sind erstaunlich realistisch, und zwar nicht nur in puncto Körperform und Textur, sondern auch in schwierigen Bereichen wie Haar und Haut. Hier erkennt man, mit welcher Sorgfalt er arbeitet. Er beginnt bei Null und benutzt Color-, Bump- und Specular-Mapping. Seine Modelle bestehen aus 15.000 bis 20.000 Polygonen und 2000 Texturen. Zudem setzt er Ebenen- und Zylinderprojektionen sowie Deformer-Tools für die Mimik ein. Er arbeitet mit Maya, malt Texturen mit Photoshop und projiziert die Maps später auf die polygonalen Modelle. Je nach Komplexität der Arbeit benötigt er manchmal mehr als zwei Wochen, um einen einzigen Kopf zu model-lieren und zu texturieren. Wichtig ist ihm, dass seine Charaktere lebendig wirken. Er versucht daher immer, ihnen ein org-anisches und natürliches Aussehen zu verleihen.

Morel war auf der Titelseite von *Convergence* und seine Arbeiten wurden in der *Computer Graphic World* (*CGW*) in einem Artikel über 3D-Malerei veröffentlicht. Außerdem sind auf Websites wie CGChannel und 3Dvf Interviews über sein neues Projekt *Amazon Soul* zu finden.

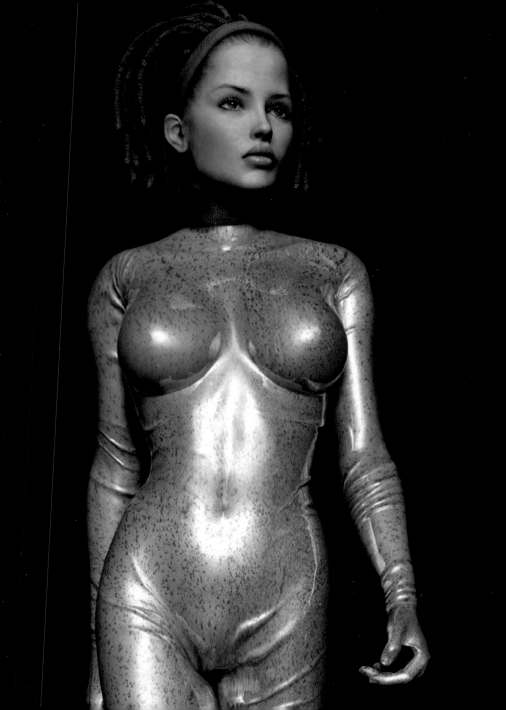

e-mail:	http://www.	Country:	Copyright:	Software:
polygons	polygons.tv	Japan	© Polygons.	Not released fot
@interlink.or.jp			Sonehati	this project

BIKINI GIRLS WITH MACHINE GUNS

Sonehati was born in Japan's Shikoku region in 1965. He studied oil painting at Tama Art University and after graduation belonged to several design studios. He learned graphic design from 1990 and started his career as a CG illustrator in 1993. His first job was as a CG producer for a set of images for a Macintosh-based 3-D software. Since then, he has been a much-sought person in the advertising and editorial fields. In 1995 he started up a brand of CG beauties, "Polygons," that were launched at the Digital Image Exhibition in Osaka. This has been his greatest success to date, and the images have been published in many international media. In 1997, he formed the team for *Harakiri Shogun*, which won a design prize at the London International Advertising Awards in 1998. IDG Communications published his first workbook, *Polygons Album*, in 1999. Sonehati also took part in a series of CG movies produced by Fuji TV, and in an exhibition event "TS2000" in New York. He was in charge of character design and visual direction for the 2001 release *Super Galdelic Hour*, a PlayStation 2 game featuring the character presented in the next pages. Sonehati has tried here to counterbalance the erotic aspect that CG characters are assuming. In recent years he has found the way that characters and games are moving towards the internet a fascinating challenge. The movements of CG characters when operating interactively under the control of internet users has a mysterious attraction to it, as if there really is cybernetic life on the Web. Soon enough Polygons, a human race with polygon skin, will live on the Internet and start walking around the world as real people. Their real stories will start then.

Sonehati est né en 1965 dans la région de Shikoku au Japon. Il a étudié la peinture à l'huile à l'université des beaux-arts Tama et fait partie de plusieurs studios de design. Il a appris le graphisme à partir de 1990 et a débuté sa carrière en tant qu'illustrateur graphique en 1993. Son premier emploi est celui de producteur graphique d'images pour un logiciel de 3D sur Macintosh. Depuis lors, il a également été sollicité pour des travaux dans les domaines publicitaires et éditoriaux. Il a créé une ligne de beautés graphiques, les « Polygons », présentées à l'exposition sur les images de synthèse d'Osaka en 1995. C'est son plus grand succès et de nombreuses publications internationales ont publié ses images. En 1997, il forme l'équipe pour *Harakiri Shogun*, qui a remporté un prix aux London International Advertising Awards de 1998. Il a publié son premier livre, *Polygons Album*, avec IDG Communications en 1999, a participé à la réalisation d'une série de films graphiques pour Fuji TV, et à l'exposition « TS2000 » de New York. Il a dirigé la conception de personnages et la direction visuelle de l'édition 2001 du jeu *Super Galdelic Hour* pour PlayStation 2. Sonehati essaie de contraster l'environnement érotique dans lequel les personnages graphiques évoluent. Il est également difficile de voir les personnages et les jeux évoluer vers Internet, mais cela suscite une mystérieuse attraction. Les mouvements des personnages réagissant par interactivité et par le contrôle des internautes, il semble qu'il existe une vie cyberné-tique sur le Web. Bientôt, les Polygons, une race d'humains dotés d'une peau en polygones, vivra sur Internet et se déplacera dans le monde de tous les jours. Leur histoire commencera alors.

Sonehati wurde 1965 im Raum Shikoku/Japan geboren. Er studierte an der Tama-Kunsthoch-schule Malerei und gehörte anschließend diversen Designstudios an. Ab 1990 erlernte er Grafik-design und begann 1993 seine Karriere als CG-Illustrator. Seine erste Arbeit war die CG-Produktion einer Serie von Bildern für eine Software auf Macintosh-Basis. Inzwischen bekommt er auch zahlreiche Anfragen aus der Werbung und dem Verlagsbereich. Sonehati entwickelte einen neuen Typus von CG-Beauties, die „Polygons", und stellte sie 1995 auf der Digital-Image-Messe in Osaka vor. Sie waren sein größter Erfolg, und viele internationale Medien veröffentlichten seitdem

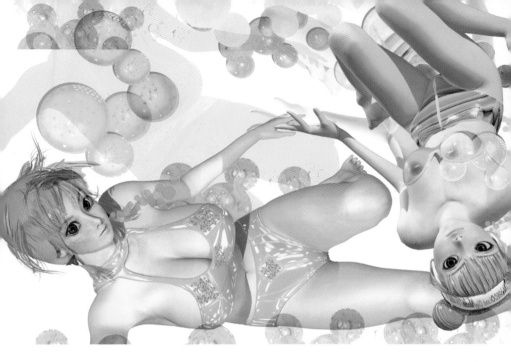

Sonehatis Bilder. 1997 gründete er das Team für *Harakiri Shogun*, mit dem er 1998 bei den London International Advertising Awards einen Designpreis gewann. 1999 veröffentlichte er sein erstes Arbeitsbuch, *Polygons Album* (IDG Communications). Ebenfalls in diesem Jahr war er an einer Reihe von CG-Movies für Fuji-TV und dem Ausstellungs-Event „TS2000" in New York beteiligt.

Bei *Super Galdelic Hour* (2001), einem PS2-Spiel, war Sonehati für das Design der Charaktere und die visuelle Regie zuständig (siehe folgende Seiten). Sonehati hat hier versucht, dem erotischen Appeal von CG-Charakteren etwas entgegenzusetzen. Die Art, wie sich Figuren und Spiele immer mehr in Richtung Internet verlagern, stellt für ihn seit einigen Jahren eine faszinierende Herausforderung dar. Die Bewegungen interaktiv agierender, von Internet-Usern gesteuerter CG-Charaktere besitzen für ihn eine mysteriöse Anziehungskraft: Es scheint, als gäbe es tatsächlich kybernetisches Leben im Web. Schon bald werden die „Polygons", künstliche Menschen mit einer Haut aus Polygonen, im Internet leben und genauso durchs Leben gehen wie reale Menschen. Dann beginnen ihre wahren Geschichten.

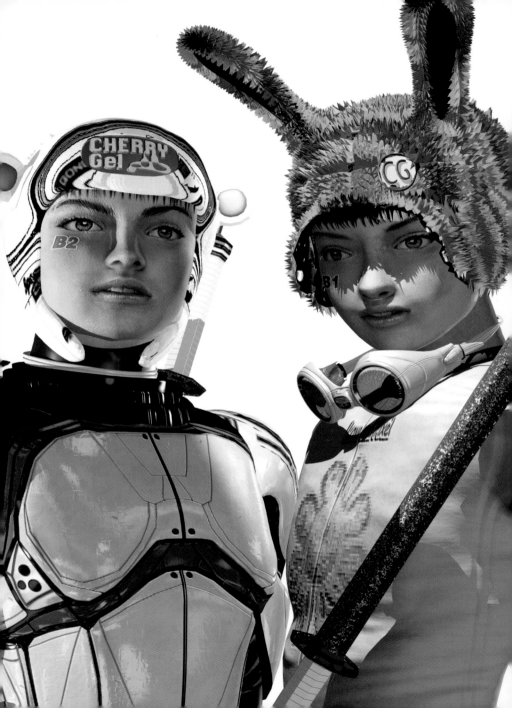

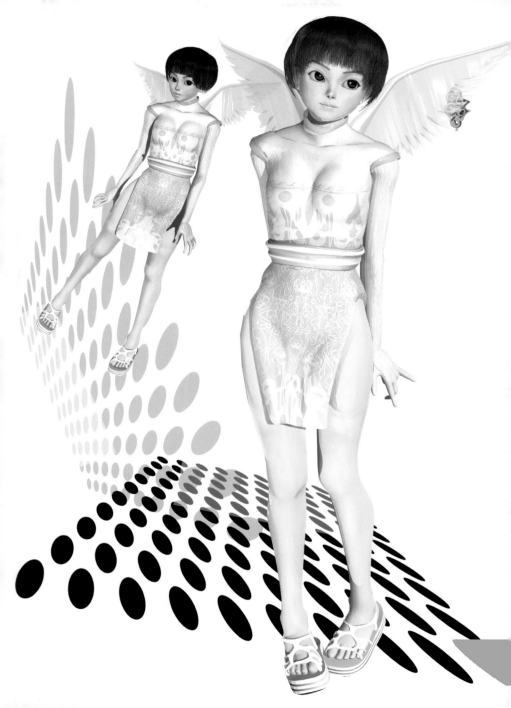

STEVEN STAHLBERG AU

e-mail:
stahlberg
@yahoo.com

http://www.
optidigit.com/
stevens

Country:
Australia

Copyright:
© Steven
Stahlberg

Software:
Maya

DIGITAL PERFECTION

Steven Stahlberg has worked for over 20 years in illustration, and his traditional background has brought him to the perfectionism of computer graphics. His digital models amaze by their detail and the expressiveness of their faces. Apart from which, the multicultural nature of his life has led him to create digital models with different ethnic characteristics, which is very rare to find among CG artists. He was born in Australia, grew up in Sweden, and lived in Hong Kong. Today, he lives and works in the United States in Austin, Texas, and produces his digital models using Alias Maya 2.5 Unlimited. His work has become a reference for 3D professionals and CG artists throughout the world, and has been published and televised by major CG media and TV stations.
Computers have fascinated him since he was a kid. As a teenager, he dreamed of a program that could do roughly what Poser does today. Unfortunately, he wasn't able to fulfil his dream until 1990, when he bought a PC with Auto CAD. After building his first model, he found Silicon Graphics and developed his skills.
For years Stahlberg has worked on a project to create the world's first truly attractive and realistic actress-singer-model of international renown. He started producing the model for the Elite Model Agency, and he reached the point about 3 years ago where he could start animating the model, in close up or in a full body shot. Stahlberg was the first artist in the world to have a virtual character sponsored by a major modelling agency. Webbie Tookay, the digital model, was presented to the world in 1999 at a press conference, and subsequently did some genuine commercial work. She has appeared on *ABC*, *BBC*, and many other TV channels worldwide, as well as in over twenty magazines and newspapers, including The *New York Times*, *The Financial Times*, and the *Wall Street Journal*. His credits and awards include an Honorary Mention at the Prix Ars Electronica in 1998 for a test animation he did in his spare time in 1996. In 2000 he had an animation included in an exhibition at the Technical Museum in Stockholm. He has taught and spoken at the Singapore Animation Festival, the CADCAM clothing convention in Treviso, Italy, and at the Multimedia University in Malacca.

Steven Stahlberg travaille sur des illustrations depuis plus de 20 ans. Sa formation traditionnelle l'a conduit à la perfection dans le domaine du graphisme sur ordinateur. Ses modèles numériques nous étonnent par les détails et les expressions de leur visage. L'aspect multiculturel de sa vie l'a amené à créer des modèles numériques dotés de caractéristiques ethniques différentes, ce qui est rare parmi les artistes numériques. Il est né en Australie, a grandi en Suède et a vécu à Hongkong. Aujourd'hui, il vit et travaille aux Etats-Unis, à Austin au Texas, et produit ses modèles numériques à l'aide d'Alias Maya 2.5 Unlimited. Il est une référence mondiale pour les professionnels de la 3D et les artistes numériques. Ses travaux ont été publiés dans les principales revues sur les arts graphiques et diffusés sur d'importantes chaînes de télévision.
Les ordinateurs le fascinent depuis son enfance. Adolescent, il rêvait d'un programme pouvant faire ce que Poser fait aujourd'hui. Malheureusement, il n'a pu commencer à réaliser son rêve qu'à partir de 1990, lorsqu'il acheta un PC équipé d'AutoCAD. Après avoir créé son premier modèle, il découvre Silicon Graphics et approfondit ses connaissances. Il a travaillé sur un projet de création du premier modèle véritablement beau et réaliste d'actrice chanteuse mondialement connue pour l'agence Elite. Terminé depuis environ trois ans, le modèle pouvait déjà être animé en gros plan ou en totalité. Steven Stahlberg est le premier artiste dans le monde dont le personnage virtuel est sponsorisé par une importante agence de modèles. Webbie Tookay, le modèle numérique, a été présenté au public lors d'une conférence de presse en 1999 et a déjà été exploité commercialement. Elle est ensuite apparue sur *ABC*, *BBC* et de nombreuses autres chaînes télévisées dans le monde, ainsi que dans plus de vingt magazines et journaux, dont le *New York Times*, le *Financial Times* et le *Wall Street Journal*. Steven

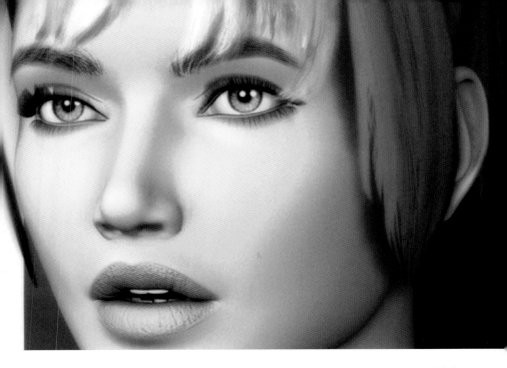

Stahlberg a reçu une mention honorifique au Prix Ars Electronica de 1998 pour une animation test réalisée pendant son temps libre en 1996. Une de ses animations a été montrée lors d'une exposition au Musée Technique de Stockholm. Il a tenu des conférences au Festival d'Animation de Singapour, au congrès d'habillage CADCAM de Trévise en Italie et à l'université Multimédia de Malacca.

Steven Stahlberg arbeitet seit Anfang 1980 als Illustrator, und sicherlich hat sein klassischer Hintergrund mit seinem Perfektionismus in der Computergrafik zu tun. Seine Models faszinieren durch Details und Mimik. Außerdem hat ihn der multikulturelle Aspekt des eigenen Lebens veranlasst, digitale Models mit unterschiedlichen ethni-schen Merkmalen zu schaffen, was unter CG-Künstlern sehr selten ist. Stahlberg wurde in Australien geboren, wuchs in Schweden auf und lebte einige Zeit in Hong Kong. Heute lebt und arbeitet er in Austin, Texas und produziert seine Arbeiten in Maya. Seine Arbeit gilt 3D-Profis und CG-Künstlern in der ganzen Welt als Vorbild und wurde in wichtigen CG-Medien und im Fernsehen vorgestellt.
Computer faszinieren ihn schon seit seiner Kindheit. Als Jugendlicher träumte er von einem Programm wie Poser. Leider konnte er sich seinen Traum erst 1990 erfüllen, als er sich einen PC mit AutoCAD kaufte. Er erstellte sein erstes Modell, entdeckte Silicon Graphics und begann sich in die Materie einzuarbeiten.
Schon seit Jahren arbeitet Stahlberg an demselben Projekt: Er will eine gut aussehende und realistische Figur schaffen, die als Schauspielerin, Sängerin und Model weltweit erfolgreich ist. Ein Model für die Agentur Elite hat er bereits erstellt. Vor drei Jahren konnte er mit der Animation beginnen, in Nahauf-nahme und auch als Full-Body-Shot. Stahlberg ist weltweit der erste Künstler, dessen virtueller Charakter von einer großen Modellagentur gesponsert wird. Webbie Tookay, das digitale Model, wurde der Welt 1999 auf einer Pressekon-ferenz vorgestellt, um danach tatsächlich einige Zeit in der Werbung eingesetzt zu werden. Sie war auf *ABC*, *BBC* und vielen anderen Fernsehkanälen in der ganzen Welt zu sehen, außerdem erschien sie in mehr als 20 Zeitschriften und Zeitungen wie der *New York Times*, der *Financial Times* und dem *Wall Street Journal*. Stahlberg erhielt beim Prix Ars Electronica 1998 eine lobende Erwähnung für eine Testanimation aus dem Jahr 1996. Eine seiner Animationen wurde 2000 im Rahmen einer Ausstellung des Technischen Museums in Stockholm gezeigt. Er hat beim Singapore Animation Festival, der CADCAM Bekleidungsmesse in Treviso und an der Multimedia-Universität in Malacca Workshops und Vorträge gehalten.

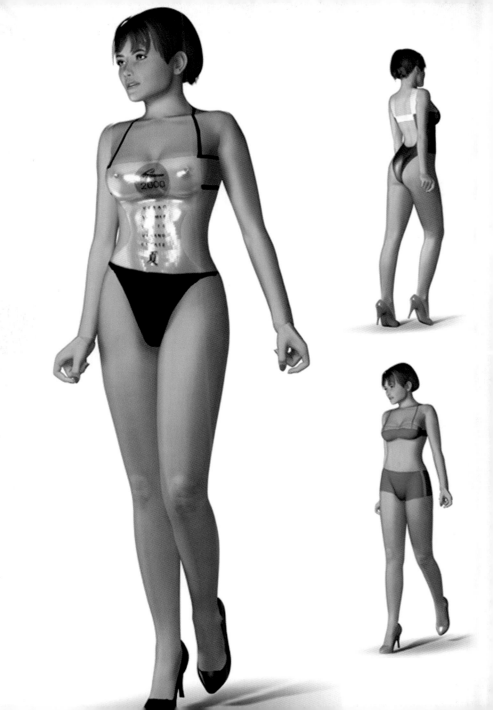

e-mail:	htww.001.	Country:	Contact:	Copyright:	Software:
yamag@	upp.so-net.ne.jp/	Japan	3-13-1-610 kai-	© YAMAG	Shade
ga2.so-net.ne.jp	yamag/index.html		gan, Minato-ku,		Professional
			Tokyo 108-0022		3D Studio Max

THE NEW JAPANESE WOMEN

YAMAG was born in 1972 and after graduating in industrial studies began work at an advertising design agency. He gained his experience in graphic design and production work while using still CG pictures to produce ads, and with that he launched his solo career as a freelance CG designer. He has an extraordinary talent for creating realistic female characters, and most of his current works consist of cute young women developed in 3DCG. YAMAG's first CG design work largely revolved around mechanics, and the technical skills he acquired proved highly appropriate for making realistic models. As with many other artists in Japan, he creates an information portfolio about the model, so as to make her less of an artificial being. A few years ago he created Ryoko, presented in the next pages, as a representative of the new generation of women in Japan; Ryoko has already achieved appreciable fame in the computer graphics world. One of the key aspects of the latest generation of digital models lies in their technical side. No details are ever released in order to keep curiosity at a peak. After she was launched on her homepage, a magazine became interested in developing her as a major character, and with that YAMAG announced that now she had received her credentials as a virtual model. So far she has been featured in books, magazines, a series of 3-D data products, video, DVD, and personalised goods displaying her visage. She is profiled as a cool and fashionable woman. YAMAG is currently promoting Ryoko among cosmetic companies and fashion magazines. Ryoko's ultimate goal is to debut in Paris as a true super-model.
YAMAG creates with Macintosh systems and Shade Professional. This software allows him to make high quality still pictures, while in order to do movie work he has shifted increasingly to 3D Studio Max. The time YAMAG needs to develop one new character is about 15 days, which is primarily taken up by the modelling phase. After that, many renderings are done to test the model and the textures.

YAMAG est né en 1972. Après l'obtention de son diplôme d'études industrielles, il travaille pour une agence de publicité. YAMAG doit son expérience en graphisme et en production aux travaux réalisés sur des images lors de la production de publicités, puis à sa carrière de graphiste free-lance. YAMAG est très doué pour créer des personnages féminins réalistes. Ses travaux actuels sont principalement développés en 3D et représentent des jeunes femmes. Sa formation technique est très pratique pour réaliser ses modèles réalistes. Comme de nombreux artistes au Japon, il crée un jeu d'informations à propos de ses modèles pour les rendre moins artificiels. Il a créé le personnage Ryoko pour représenter la nouvelle génération de Japonaises. Ce personnage est devenu assez populaire dans le monde du graphisme. L'une des caractéristiques de la dernière génération de modèles numériques est son aspect technique, qui n'est jamais divulgué pour maintenir un haut niveau de curiosité. Lorsqu'il a dévoilé Ryoko sur son site Web, un magazine lui a proposé de faire d'elle un personnage important. C'est alors que YAMAG a annoncé son profil de modèle virtuel. Elle est apparue dans des livres, des magazines, une série de produits 3D, des vidéos, des DVDs, et son visage a été utilisé sur des produits personnalisés. Elle se définit comme une femme cool et à la mode. YAMAG fait aujourd'hui la promotion de Ryoko auprès de sociétés de cosmétiques et de magazines de mode. Le but de Ryoko est de faire ses débuts de top model à Paris. YAMAG utilise un ordinateur Macintosh et le logiciel Shade Professional R3. Ce logiciel lui permet de réaliser des images de haute qualité.
Il utilise par ailleurs 3D Studio Max pour les animer. YAMAG passe environ 15 jours à créer de nouveaux personnages, ce qui consiste principalement en la phase de modelage. Après cela, de nombreux rendus sont effectués pour tester le modèle et les textures.

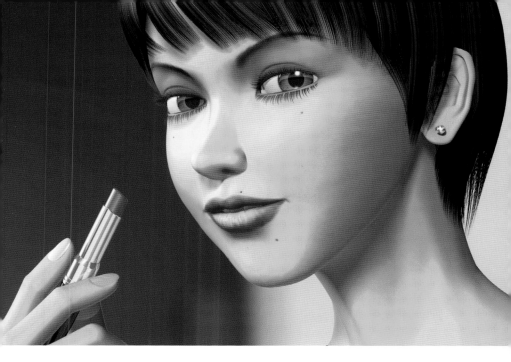

YAMAG wurde 1972 geboren und arbeitete nach dem Abschluss seines Studiums in einer Werbeagentur. Während er Anzeigen erstellte, sammelte er mit Standbildern Erfahrungen in Design und Produktion von Grafik. Später machte er sich als CG-Designer selbstständig. YAMAG ist außergewöhnlich talentiert im Entwerfen realistischer weiblicher Charaktere. Seine aktuellen Arbeiten, die er meist in 3D entwickelt, sind Darstellungen hübscher junger Frauen.

Ursprünglich war YAMAG als CG-Designer vor allem im technischen Bereich tätig; die damals erworbenen Fähigkeiten kommen ihm nun beim Entwerfen realistischer Models zugute. Wie viele andere Künstler in Japan, entwickelt er eine virtuelle Vita zu seinen Models und lässt sie so wirklicher erscheinen. Vor ein paar Jahren schuf er Ryoko – sie ist auf den folgenden Seiten zu sehen – als Vertreterin der neuen Frauengeneration in Japan. In Bereich der Computergrafik konnte sie inzwischen einigen Ruhm erlangen. Ein wichtiger Aspekt der neuesten Generation digitaler Models sind ihre technischen Daten, die geheim gehalten werden, damit die Spannung aufgeheizt bleibt. Als Ryoko auf einer Homepage vorgestellt wurde, zeigte ein Magazin Interesse, sie zu einer Hauptfigur zu entwickeln, und YAMAG erkannte, dass dies ihre „Beglaubigung" als virtuelles Model war. Seither wurde sie in Büchern, Zeitschriften, einer Serie von 3D-Produkten, auf Video und DVD abgebildet. Sie gilt als eine coole und modische Frau. Zurzeit vermittelt YAMAG Ryoko an Kosmetikunternehmen und Modezeitschriften. Ryokos großes Ziel ist es, in Paris ihr Debüt als echtes Supermodel zu geben.

YAMAG arbeitet auf einem Macintosh mit Shade Professional R3. Diese Software ermöglicht es ihm, qualitativ hochwertige Standbilder anzufertigen. Für die Produktion von Filmen geht er mehr und mehr zu 3D Studio Max über. YAMAG benötigt etwa zwei Wochen, um einen neuen Charakter zu entwickeln, wobei er die meiste Zeit auf das Modellieren verwendet. Danach rendert er das Model und die Texturen viele Male zu Testzwecken.

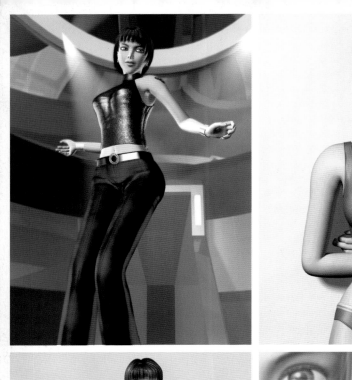
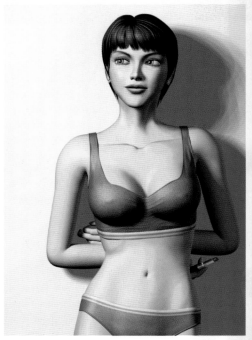

GLOSSARY

2-D

Two dimension images. Usually related to images in pixels or vectors.

Des images en deux dimensions, définies en pixels ou en courbes.

Zweidimensionale Bilder. Gewöhnlich in Verbindung mit Pixeln oder Vektoren.

3D Studio Max©

Kinetix's 3D Studio MAX© allows professionals to use modelling and animation tools with an interface with Windows conventions. It allows modelling, rendering, animation and scene composition.

Kinetic 3D Studio Max(c): 3D Studio Max permet aux professionnels d'utiliser des outils de modelage, d'animation, de rendu et de composition de scènes.

Software von Kinetix auf Windows-Plattform zum Modellieren, Rendern und zur Szenenkomposition.

3-D forums

Pages on Web sites with centres for discussing 3-D.

Forums 3D: désigne les zones de discussion des sites Web sur le sujet de la 3D.

3D-Foren: Websites, auf denen 3D-Themen diskutiert werden.

Adobe© Photoshop©

Adobe© Photoshop© has the reputation of being the professional's choice for nearly all graphic design projects. It is a still-image manipulator that allows pictures to be both created and modified. It also allows the use of filters from the software and various plug-ins.

Photoshop a la réputation d'être l'outil de choix des professionnels pour la plupart des projets graphiques. C'est un outil de manipulation permettant la création et la modification d'images, ainsi que l'utilisation de filtres et de plug-ins.

Gilt als der Standard im Profi-Bereich für fast alle Grafikdesignprojekte. Erlaubt die Erstellung und Bearbeitung von Standbildern, Photos oder synthetischen Mustern sowie den Einsatz von Filtern aus der Software und aus Plug-ins.

Adobe© Illustrator©

Adobe© Illustrator© is a tool for 2-D illustration using vector and pixel formatted images.

Illustrator est un outil d'illustration 2D pour images vectorielles et bitmap.

Tool zur 2D-Illustration mit Vektor- und Bitmap-Grafiken.

After Effects©

Software for movie editing and creating special effects, made by Adobe© Inc.

After Effects est un logiciel d'animation et d'effets visuels.

Software von Adobe© Inc zur Bearbeitung von Filmen und für Special Effects.

Alias Wavefront©

Alias Wavefront©, from Silicon Graphics, is a modelling and animation tool with an interface that gives users the creative control and intuitiveness of traditional artists' brushes and sculpting tools.

Alias Wavefront©, de Silicon Graphics, est un logiciel de modelage et d'animation doté d'une interface apportant aux utilisateurs la créativité et l'intuition des outils de sculpture et des pinceaux des artistes traditionnels.

Tochter-Unternehmen von Silicon Graphics, entwickelt Software-Lösungen zur Erstellung und Produktion digitaler Inhalte für die Unterhaltungs- und Creative-Design-Märkte; der weltweit führende Entwickler von 2D- und 3D-Graphik-Software auf Silicon Graphics Workstations. AliasWavefront© ist bekannt für seine Software mit einer photorealistischen, hochwertigen Ausgabequalität.

Alpha channels

A channel (besides the colour channels Red-Green-Blue or Cyan-Magenta-Yellow-Black) created in a program (such as Adobe© Photoshop©) to allow a specific selection and gradation of effects.

Couches Alpha: une couche (en dehors des couches de couleurs rouge-vert-bleu ou cyan-magenta-jaune-noir), créée dans un programme tel que Photoshop, permet d'effectuer des sélections et des effets spécifiques.

Alpha-Kanäle: Kanal (neben den Farbkanälen Rot-Grün-Blau

oder Cyan-Magenta-Gelb-Schwarz) in einem Programm wie Adobe© Photoshop©, um eine besondere Auswahl an Spezialeffekten hervorzubringen.

Amazon 3D Paint©

Filter for professional colorization and 3-D painting for film, video and graphic arts.

Un filtre de dessin 3D professionnel pour les films, la vidéo et le graphisme.

Filter für 2D und 3D Paint – Software im Profi-Bereich. Für Film-, Video- und Grafikarbeiten.

Amiga©

Pioneer computer with a graphic interface, which was the forerunner of computers congenial to graphic design.

Un ordinateur pionnier doté d'une interface graphique et le prédécesseur des ordinateurs destinés au graphisme.

Einer der ersten Computer mit grafischer Benutzeroberfläche.

Animation

Sequence of frames made manually or by computer that produce a movie.

Animation: une séquence d'images réalisée sur ordinateur ou manuellement pour produire un film.

Eine im Computer oder manuell erstellte Film-Sequenz bestehend aus Einzelbildern.

AutoCAD©

3-D Modelling and rendering program usually related to very technical areas such as engineering and architecture.

AutoDesk(c) AutoCAD(c): un logiciel de modelage et de rendu 3D utilisé dans les domaines très techniques tels que l'ingénierie ou l'architecture.

3D-Software von AutoDesk© zum Konstruieren am Computer. Für technische Bereiche wie Ingenieurwesen und Architektur.

Bryce©

Software that creates environments and landscapes, and allows the import of 2-D and 3-D data. Produced by Corel© Corp.

Corel(c) Corp. Bryce(c): un logiciel de création d'environnements et de paysages qui permet l'import de données 2D et 3D.

Software von Corel© Corp zum Erstellen von virtuellen Szenarien und Landschaften. Import von 2D- and 3D-Daten möglich.

CG

Related to CGI, meaning computer generated imagery or computer graphics.

Un terme désignant l'imagerie générée sur ordinateur et, par extension, le graphisme.

Computergrafik. Leitet sich von CGI (computer generated imagery) oder von computer graphics her.

Cinema 4D©

3D software from Maxon© for Windows and Macintosh, well known for its speed. The most famous version is Cinema 4D© XL, that has a fast-growing user community and has Raytracing and Radiosity-rendering for natural light simulation.

Logiciels 3D de Maxon© pour Windows et Macintosh entre autres connus pour leur grande rapidité de traitement. Les inconditionnels de Maxons Flagschiff Cinema4D XL sont de plus en plus nombreux et il propose en plus de "Raytracing" également un "Radiosity-Renderer" afin de simuler la lumière naturelle.

3D-Softwarepaket von Maxon© auf Windows und Macintosh, das unter anderem durch seine ungeheure Rechengeschwindigkeit bekannt wurde. Maxons Flagschiff Cinema4D XL hat eine schnell wachsende Fangemeinde und bietet neben Raytracing auch einen Radiosity-Renderer, um natürliches Licht zu simulieren.

Commodore C64

Old model of computer.

Un ancien modèle d'ordinateur.

GLOSSARY

Altes Computermodell.

Commodore Pet

Old model of computer.

Un ancien modèle d'ordinateur.

Altes Computermodell.

Deep Paint©

2-D paint system that offers dynamic 3-D lighting and texture control for realistic effects. The user can convert existing photos or illustrations into many medium – textured oils, bold acrylics, watercolours and so on – or create brand-new drawings. From Right Hemisphere Ltd.

Right Hemisphere Ltd Deep Paint(c): un système de dessin 2D qui offre un contrôle dynamique de l'éclairage et des textures pour obtenir des effets réalistes. L'utilisateur peut convertir des photos ou des illustrations réelles en dessins peints à l'huile, à l'acrylique, à l'aquarelle, etc., et peut donc générer de nouveaux dessins.

2D-Paint-Software von Right Hemisphere Ltd. Erlaubt dynamische 3D-Beleuchtung and Textur-Steuerung für realistische Effekte. Der Anwender kann bestehende Fotos oder Illustrationen in andere Medien verwandeln: Öl, Acryl, Aquarell etc. oder völlig neue Bilder zeichnen.

Digital Art

Related to art produced with digital resources or a combination of digital and analogue methods.

Dessin numérique: désigne des dessins produits à l'aide de ressources numériques ou à partir d'une combinaison de méthodes numériques et analogiques.

Auch: Digitalkunst, digitale Kunst, Computerkunst. Mit digitalen Ressourcen oder einer Kombination aus digitalen und analogen Methoden produziertes künstlerische Erzeugnis.

Filter

A command or software that creates an effect in an image or figure. It can be part of or be installed in the program.

Filtre: une commande ou un logiciel de création d'effets dans une image. Le filtre peut être installé dans un programme ou livré avec celui-ci.

Befehl oder Software. Bewirkt in einem Bild oder einer Figur einen visuelen Effekt. Ist Teil des Programms oder zusätzlich installiert werden, um den Funtionsumfang der Software zu erweitern.

Lighting

The adjustment and set-up of illumination in a 3-D or 2-D program.

Eclairage: la mise en place et l'ajustement de la lumière dans un logiciel 2D ou 3D.

Licht: Abstimmung und Einstellung der Beleuchtung in einer 3D oder 2D Software mit Hilfe virtueller Scheinwerfer oder Sonnen.

Lightwave3D©

LightWave3D consists of two applications: modeller and lay-out. The user creates models in the former and arranges and animates scenes in the latter. Produced by New Tech Inc.

Se compose de deux applications : Modelleur et Layout. Les utilisateurs peuvent créer des modèles dans le premier et les disposer ou les animer dans le second. Produit par New Tech Inc.

Software von New Tech Inc. Besteht aus zwei Anwendungen: In Modeller erstellt der User Modelle, und in Layout arrangiert und animiert er Szenen.

Manga comics

Traditional Japanese comics, magazines and books that usually appear weekly or monthly.

Bandes dessinées typiquement japonaises, paraissant sous forme de magazines et d'albums hebdomadaires ou mensuels.

In Japan beliebte Form der Comics. Erscheinen zum Teil. wöchentich – oft in Telefonbuchstärke.

Maya©

Maya is a production-ready software integrated within an animation system. It allows modelling, rendering and scene composition.

Maya est un logiciel intégré de production d'animation. Il permet également de modelage, le rendu et la composition de scènes.

Teure Profi-3D Software für Mac und Windows. Wird weltweit zur Erstellung von Kinofilmen und Special Effects eingesetzt.

Metasequia©

Modelling, rendering and animation software from Japan.

Un logiciel de rendu et d'animation japonais.

Software aus Japan zum Modellieren, Rendern und zur Animation.

Modelling

Construction of a 3-D model in a program. It can be done in different languages, such as polygons or NURBS.

Modelage: réalisation d'un modèle 3D à l'aide d'un programme. Il peut s'effectuer de différentes manières, à partir de polygones ou de NURBS.

Modellierung oder Modelling: Erstellen eines 3D-Modells mit Hilfe von Software. Ist in unterschiedlichen Techniken, mit unter anderem Polygonen oder NURBS, möglich.

NURBS (Non-uniform Rational B-Spline)

Non-Uniform Rational B-Spline. A type of spline that can represent more complex shapes than a Bezier spline. Spline-based modelling refers to 3-D figures with surfaces made up of mathematically derived curves (splines).

Un type de courbe pouvant représenter des formes plus complexes que les courbes de Bézier. Le modelage basé sur des courbes se réfère aux formes 3 D en tant que surfaces faites de courbes dérivées mathématiquement (splines).

Non-uniform Rational B-Spline. Digitale Darstellung einer Kurvenlinie. Genauer als eine Bézierkurve. Modellierung auf Spline-Basis wird auf Oberflächen angewandt, die mit mathemathisch abgeleiteten Kurven erzeugt sind (splines).

Paint Shop Pro©

JASC Software Inc. Paint Shop Pro© is a tool for producing, modifying and applying effects to 2-D images, as well as making animations from the frames created.

JASC Software Inc. Paint Shop Pro(c): un outil de production, de modification, d'application d'effets ou d'animation d'images 2D.

Software von JASC Software Inc. Tool zur Erstellung und Bearbeitung von 2D-Bildern, mit Effektfiltern und Animation der erstellten Frames.

Painter©

Corel© Corp. Painter is a software tool for creating 2-D painted images, as well as for modifying existing ones. It also enables one to apply effects from stippling to mosaic and to simulate realistic brushes and painting tools.

Corel(c) Corp. Painter(c): un logiciel de création ou de modification d'images 2D peintes.
Il permet d'appliquer des effets et de simuler de manière réaliste les outils de peinture traditionnels.

Herausragendes Software-Tool von Corel© Corp zum Erstellen in 2D gemalter Bilder sowie zum Modifizieren bestehender Bilder. Diverse malerische Effekte, vom Impressionismus bis zum Mosaik, außerdem realistische Simulation von Pinseln und Malwerkzeug.

Photo Paint©

Program for 2-D creation and manipulation made by Corel© Inc., which also allows effects and animation production.

Corel(c) Corp. Photo Paint(c) : un programme de création et de manipulation 2D permettant l'application d'effets et l'animation.

Programm von Corel© Inc. zum Erstellen und Manipulieren von Bildern in 2D. Mit Effektfiltern und Animation.

Plug-ins

Sofftware designed to be installed in a computer program to execute very specific functions.

Un logiciel qui peut être installé dans un programme et est destiné à traiter des données spécifiques.

Software, die zusäzlich auf dem Computer installiert wird, um einen ganze spezielle Aufgabe auszuführen.

Polygon

A polygon is any closed 2-D figure, forming in 3-D software a combination with hundreds of others to make 3-D models.

GLOSSARY

Polygone: une forme 2D close permettant, grâce à une combinaison de centaines d'autres polygones, de créer des modèles dans un logiciel 3D.

Ein Drei- oder Vieleck. Die kleinste Einheit, in die ein 3D-Objekt zerlegt wird. Bildet in 3D-Software zusammen mit Hunderten weiterer Polygone ein 3D-Modell.

Poser©

Poser is a 3-D-character animation and design tool program. Artists can create images, movies, and posed 3-D characters from a wide collection of articulated 3-D human and animal models. Produced by Curious Labs Software Company.

Curious Labs Poser(c): un logiciel de conception et d'animation de personnages 3D. Les artistes peuvent créer des images et des animations à partir d'une vaste collection de modèles 3D articulés et animés.

Poser ist ein intuitives Werkzeug, um 3D-Figuren digital zu erstellen und zu animieren. Es erlaubt Bilder, Movies und posierende 3D-Figuren aus einer Vielzahl vorgefertigter, beweglicher 3D-Menschen- und Tiermodelle zu erstellen. Hersteller: Curious Labs Software Company.

Post-production

Work done after the renderings in 3-D, as a necessity for building a better shape or adding effects to the image.

Les travaux effectués après la phase de rendu, pour améliorer les images ou ajouter des effets.

Postproduktion: Nachbearbeitung nach dem Rendern. Dabei werden Korrekturen durchgeführt oder dem Bild Effekte hinzugefügt.

Ray Dream©

3-D software for modelling, rendering, scene composition and animation produced by Fractal Design Inc.

Fractal Design Inc. Ray Dream(c): un logiciel de modelage, de rendu, de composition de scène et d'animation.

3D-Software von Fractal Design Inc. zum Modellieren und Rendern sowie zur Szenenkomposition und Animation.

Renderings

After a model is done in 3-D with polygons or NURBS, it can be rendered to create a simulation of a real object. The model is wrapped with textures or colours.

Rendu: lorsqu'un modèle est réalisé en 3D à l'aide de polygones ou de NURBS, un rendu est effectué pour créer une simulation du véritable objet. Le modèle est ensuite habillé de textures ou de couleurs.

Rendern: Nachdem ein Modell in 3D mit Polygonen oder NURBS erstellt und mit Texturen versehen wurde, kann es zur Simulation eines realen Objekts berechnet werden. Erst durch diesen zum Teil sehr langwierigen Vorgang entsteht das eigentliche Bild.

Rhino©

Rhino is a 3-D program that can create, edit, analyse, and translate NURBS curves, surfaces, and solids, and offers support for polygon meshes. Produced by Robert McNeel & Associates.

Robert McNeel & Associates Rhino(c): Rhino est un programme 3D de création, d'édition, d'analyse, de transformation de courbes NURBS, surfaces et solides, et de support de polygones.

Rhino ist ein 3D-Programm, das NURBS-Kurven, -Flächen und -Körper erstellt, aber auch Polygonmodelle unterstützt. Hersteller: Robert McNeel & Associates.

Shade©

Japanese software that allows modelling, rendering and animation. Made by Expression Tools Inc.

Expression Tools Inc. Shade: un logiciel japonais permettant le modelage, le rendu et l'animation.

Exquisite Software aus Japan zum Modellieren, Rendern und zur Animation. Hersteller: Expression Tools Inc.

Sinclair ZX81

Old model of computer.

Un ancien modèle d'ordinateur.

Altes Computermodell.

SoftImage 3D©

With a wide variety of features, SoftImage 3D© from

Microsoft© Corp. is regarded as the most powerful modelling and animation product currently available for the PC.

Microsoft(c) Corp. SoftImage 3D : disposant d'un grand nombre de fonctionnalités, ce logiciel est le produit le plus puissant de modelage et d'animation disponible sur PC.

Software von Microsoft© Corp. Besitzt eine Vielzahl von Features und gilt als sehr leistungsfähiges Modellier- und Animationsprodukt.

Texture Mapping

The process of making an image or texture into smaller images. This is used to display a texture in a 3-D object.

Habillage: le processus d'appliquer une texture sur un objet 3D.

Um die Oberflächen von 2D- oder 3D-Bildern zu gestalten, belegt oder umwickelt man sie mit Texturen – herkömmlichen, zweidimensionalen Bilddateien.

Textures

As with objects from real life, the 3-D and 2-D computer-generated images can have textures applied in order to create a realistic (or not) visualization. Textures can be used to simulate skin, plastic, metal, sky, glass, and so on.

Textures: comme tout véritable objet, les images 2D et 3D générées par ordinateur peuvent disposer de textures pour simuler (ou non) une apparence réaliste. Les textures sont utilisées pour simuler la peau, le plastique, le métal, le ciel, le verre, etc.

Texturen: Werden auf CG-Bilder in 3D- und 2D aufgebracht, um eine realistische (oder artifizielle) Optik zu schaffen. Mit Texturen lassen sich Haut, Plastik, Metall, Himmel, Glas etc. simulieren.

Touch-ups

See post-production.

Retouches: voir Post-production.

Retuschens. Postproduktion.

Virtual Idols

Character created in computers mostly in Japan, where this name first appeared. Their design is mostly based on teenagers and they are created to perform as singers, models and actors.

Idoles virtuelles: des personnages créés par ordinateur au Japon, d'où est originaire ce terme. Elles ressemblent principalement à des adolescentes et sont créées pour devenir des chanteuses, des modèles ou des actrices.

Computergenerierte Charaktere aus Japan. Sie sehen aus wie Teenager und treten als Sängerinnen, Models und Schauspieler auf.

UV-3D program

Allows artists to hand-manipulate the texture and coordinate numerous models. UV optimisation can be especially useful for game design.

UV: un programme 3D permettant aux artistes de manipuler des textures et de coordonner plusieurs modèles. Il est très utile lors de la création de jeux.

UV-Koordinaten: UV-Koordinaten geben die Position einer Textur auf einem 3D Objekt an und lassen sich mit entsprechender Software manipulieren, eine Optimierung UV-Koordinaten wird oft in der Entwicklung von Spielen angewandt.

Wacom© tablet

A device consisting of a plastic board and a digital pen, which simulates natural painting and also substitutes as a mouse.

Tablettes Wacom(c) : un périphérique composé d'une table plastique et d'un stylo numérique simulant le dessin naturel. Elles peuvent remplacer la souris.

Grafisches Werkzeug bestehend aus einem Plastiktablett und einem digitalen Stift zur Simulierung eines natürlichen Malstils und als Maus-Ersatz.

CREDITS

Akihiko Kametaka (18-23), Alceu Baptistão (24-29), Andrä Martyna (30-35), Andy Simmons (36-39), Dutch Angel (40-45), Original composition by Cassandre C. Laurie with special thanks to Eric VanDycke, Yamato and Kozaburo for generously permitting me the use of deformers and props in my images. Thanks to Thorne for tail and collar model (46-51), Christian Fröhlich (62-67), Daniel A. Cortopassi (68-73), Dan Van Winkle (74-81), Daniel Robichaud (92-85), Daniel Scott Gabriel Murray (86-91), D. Glidden (92-95), Ellie Morrin (100-105), Geoff Ridgway (126-131), Glenn Dean (132-135), Greg Carter (136-141), Hid Yanagishima (142-147), Hiro Nakano (148-151), Ino Kaoru (156-161), Junko Kubota (178-183), JYL (184-189) - Thanks to Pierre Gouzou for using 2 of his glamorous pictures, Kakomiki (196-201), Kazuaki Nemoto (212-217), Kei Yoshimizu (226-231), Keiji Maruyama (232-237), Keith Garvey (238-243), Koji Eto (256-261), Laszlo Racs (272-277), Leane Parker (284-287), Magdalena Vasters 2000-2001 (304-309), Makoto Higuchi (310-317), Marcin Zemkzac (Cromm Cruac) (324-329), Mark Harrison-Ball (330-335), Masaaki Ohkubo (336-341), Michael Koch (348-353), Mick Szirmay, Mike Merryweather (366-371), Nana J.A.W.S. (378-381), Reed VanQuehl (422-427), Rene Morel (428-433), Polygons Sonehati (452-459), Steven Stahlberg (470-477) and YAMAG (526-533)

ACKNOWLEDGEMENTS

Many thanks to the artists, without whose contributions the book wouldn't have been possible. I thank the editorial and production team in Germany, specially Annick Volk, Brigitte Löbach, Kathrin Murr, Thierry Nebois and Ute Kieseyer for working hard until the last minute, and also Yuko Aoki, without whose support and effort in Japan, *Digital Beauties* wouldn't have been so rich. A special thanks to Wenzel Spingler, for the technical proofreading. Finally, many thanks to Andy Disl for the design, and all the professionals and friends that contributed to this publication.

IMPRINT

© 2002 TASCHEN GmbH Hohenzollernring 53,
D-50672 Köln
www.taschen.com

DESIGN & LAYOUT: Sense/Net, Andy Disl and
Birgit Reber, Cologne & Julius Wiedemann
PRODUCTION: Thomas Grell
ENGLISH TRANSLATION: Chizuru Ono, Tokyo
and Kayo Suzuki, Saitama
GERMAN TRANSLATION: Karin Aiche
FRENCH TANSLATION: Marc Combes
JAPANESE TRANSLATION: Fumie Nosaka, Tokyo
and Yuko Suzuki, Saitama
JAPANESE COORDINATION: Yuko Aoki

ISBN: 3-8228-2410-0
ISBN: 4-88783-196-X (Japanese edition)
PRINTED IN ITALY